Thames & Hudson

Museum
of
Contemporary
Art

Chicago

The Museum
of
Contemporary
Art

Los Angeles

Essays by
Amada Cruz
Elizabeth A. T. Smith
Amelia Jones

Cindy Sherman
Retrospective

Cindy Sherman: Retrospective was published on the occasion of the exhibition of the same name jointly organized by The Museum of Contemporary Art, Los Angeles, and the Museum of Contemporary Art, Chicago.

This exhibition has been made possible in part by the generous support of David and Suzanne Saperstein, Genevieve and Ivan Reitman, Jeanne C. Thayer, and the Friends of MOCA.

First published in the United States of America in paperback in 1997 by Thames and Hudson Inc., 500 Fifth Avenue, New York, New York 10110

First published in Great Britain in 1997 by Thames and Hudson Ltd, London

Library of Congress catalog Card Number 97-60467

British Library Cataloguing-in-Publication data
A catalogue record for this book is available from the British Library

ISBN 0-500-27987-X

Produced by the Publications Department of the Museum of Contemporary Art, Chicago, Donald Bergh, Director, and Amy Teschner, Associate Director

Printed and bound in Germany

Contents

Foreword

It is with pleasure that our two institutions present this two-decade survey of the work of Cindy Sherman. Hailed as one of the most important artists of her generation, Sherman explores the nature and impact of representation, the manipulations of which are so fundamental to our image-based contemporary society as to seem invisible. Likewise, the themes she undertakes—from the identity issues of the early *Untitled Film Stills* to her more grotesque, recent manifestations—are so ubiquitous in current art that they are virtually unquestioned. With an almost uncanny sense of our culture's concerns, Sherman is always one step ahead, providing a mirror of our fears, expectations, and obsessions.

This exhibition has been made possible in part by the generous support of David and Suzanne Saperstein, Genevieve and Ivan Reitman, Jeanne C. Thayer, the Friends of MOCA, and Agnes Gund.

The numerous lenders to the exhibition deserve our gratitude for so generously sharing their works with a worldwide audience for an extended period of time. We are very pleased by the interest of our colleagues at the other tour venues. They are Petr Nedoma, Director at the Galerie Rudolfinum, Prague; John Hoole, Curator and Conrad Bodman, Exhibition Organizer at the Barbican Art Gallery, London; Henry-Claude Cousseau, Director and

Marie-Laure Bernadac, Curator at the capc, Musée d'art Contemporain de Bordeaux; Bernice Murphy, Director at the Museum of Contemporary Art, Sydney; and Matthew Teitelbaum, Chief Curator at the Art Gallery of Ontario, Toronto.

To Cindy Sherman we extend our thanks and appreciation for her sustained vision and truly remarkable work, which continues to inspire us and resonate within our lives.

KEVIN E. CONSEY
Director and Chief Executive Officer
Museum of Contemporary Art
Chicago

RICHARD KOSHALEK
Director
The Museum of Contemporary Art
Los Angeles

Lenders to the Exhibition

The Birmingham Museum of Art, Alabama
The Eli and Edythe L. Broad Collection, Los Angeles
The Eli Broad Family Foundation, Santa Monica
Eileen and Michael Cohen, New York
Charles-Henri Filippi, Paris
Philip and Beatrice Gersh, Beverly Hills
Raymond and Elizabeth Goetz, Lawrence, Kansas
The Carol and Arthur Goldberg Collection
The Marieluise Hessel Collection on permanent loan to the Center for
 Curatorial Studies, Bard College, Annandale-on-Hudson, New York
Audrey and Sydney Irmas
Linda and Jerry Janger, Los Angeles
Mike Kelley, Los Angeles
Ellen Kern, New York
Rita Krauss, New York
Susan and Lewis Manilow, Chicago
Metro Pictures, New York
Barbara and Howard Morse, New York
Museum of Contemporary Art, Chicago
The Museum of Contemporary Art, Los Angeles
The Museum of Modern Art, New York
Palm Collection, Inc.
Per Skarstedt Fine Art, New York
Howard Rachofsky, Dallas
Robert and Jane Rosenblum, New York
Saatchi Gallery, London
Robert Shiffler Collection and Archive, Greenville, Ohio
Gary Sibley, Dallas
Sandra Simpson, Toronto
William and Ruth True, Seattle

Cindy Sherman

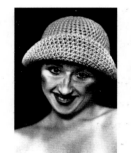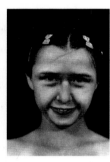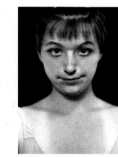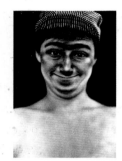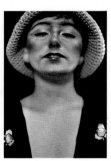

figure 1 2 3 4 5

Movies, Monstrosities, and Masks:

Twenty Years of Cindy Sherman

AMADA CRUZ

> Along with our parents, the mass media raised us, socialized us, entertained us, comforted us,
> deceived us, disciplined us, told us what we could do and told us what we couldn't. And
> they played a key role in turning each of us into not one woman but many women—a pastiche
> of all the good women and bad women that came to us through the printing presses,
> projectors, and airwaves of America. This has been one of the mass media's most important
> legacies for female consciousness: the erosion of anything resembling a unified self.
>
> —Susan J. Douglas [1]

figures 1–5
Cindy Sherman
Untitled A–E, 1975
Collection Museum of
Contemporary Art,
Chicago, Gift of Lannan
Foundation

Cindy Sherman began her now famous series *Untitled Film Stills*
twenty years ago at the end of 1977. Those small black-and-white pho-
tographs of Sherman impersonating various female character types
from old B movies and film noir spoke to a generation of baby boomer
women who had grown up absorbing those glamorous images at
home on their televisions, taking such portrayals as cues for their future.
With each subsequent series of photographs, Sherman has imitated and
confronted assorted representational tropes, exploring the myriad
ways in which women and the body are depicted by effective contempo-
rary image-makers, including the mass media and historical sources
such as fairy tales, portraiture, and surrealist photography.

Born in New Jersey and raised in suburban Long Island, Sherman
attended the State University College at Buffalo, New York, where she
initially studied painting. In an interview with Noriko Fuku, she speaks of
her college years. Her paintings at the time were self-portraits and
realistic copies of images she found in magazines and photographs. She
failed the requisite introductory photography course because of her
difficulties with the technological aspects of making a print, and she cred-
its her next photography teacher with introducing her to conceptual
art, which had a liberating effect on her. It was at this time that Sherman
first encountered contemporary art, via fellow students such as
Robert Longo. [2]

In a prophetic 1975 series of five photographs she produced while at college, *Untitled A–E*, Sherman attempted to alter her face with makeup and hats, taking on different personas such as a clown in *Untitled A* (figure 1) and a little girl in *Untitled D* (figure 4). Her fascination with self-transformation extended to her frequent trips to thrift stores, where she purchased vintage clothes and accessories, which suggested particular characters to her: "So it just grew and grew until I was buying and collecting more and more of these things, and suddenly the characters came together just because I had so much of the detritus from them."[3] Sherman began wearing these different costumes to gallery openings and events in Buffalo. For example, to attend one gallery opening, she dressed up as a pregnant woman. While there was an obvious performative element to this practice, Sherman never considered these outings "performances" in an artistic sense because she was "not maintaining a character" but simply "getting dressed up to go out."[4]

Untitled Film Stills, 1977–80

Upon graduation in 1977, Sherman and Longo moved to New York. She continued her role-playing in different guises and began photographing the results in their apartment, as in *Untitled Film Still #10* (plate 10); in outdoor locations in New York City, as in *Untitled Film Still #21* (plate 22); in Long Island in *Untitled Film Still #9* (plate 9); and in the Southwest in *Untitled Film Still #43* (plate 48). Sherman took most of the photographs, but some were shot by friends and family. The complete series was first exhibited at the Hirshhorn Museum in Washington, DC in 1995, and in the brochure for that show, Phyllis Rosenzweig discusses the relationships between the works. Similar characters appear in several photographs, resulting in mini series within the larger group. For example, the first six images feature the same blonde actress at different points in her career.[5] In each picture, Sherman depicts herself alone, as a familiar but unidentifiable film heroine in an appropriate setting. The characters include a floozy in a slip with a martini glass in *Untitled Film Still #7* (plate 7); a perky B-movie librarian in *Untitled Film Still #13* (plate 14); a young secretary in the city in *Untitled Film Still #21* (plate 22); a voluptuous, lower-class woman from an Italian neo-realist film in *Untitled Film Still #35* (plate 39); an innocent runaway in *Untitled Film Still #48* (plate 47); and a film noir victim in *Untitled Film Still #54* (plate 58). In works such as *Untitled Film Still #15* (plate 17) and *Untitled Film Still #34* (plate 35), Sherman appears as a seductress. Speaking of one such image, she has said, "to pick a character like that was about my own ambivalence about sexuality—growing up with the women role models that I had, and a lot of them in films, that were like that character, and yet you were supposed to be a good girl."[6]

The power of media images to influence identity, particularly in the young, is not a recent phenomenon. Stuart and Elizabeth Ewen address the impact of silent films on second-generation immigrant women. They refer to those

early movies as "manuals of desire, wishes, and dreams"[7] that wedged a gap between the mothers who had been raised according to traditions from their homelands and their daughters who wanted to assimilate into American culture. The Ewens credit Hollywood and the films of Cecil B. DeMille in particular with displaying the lives of the wealthy as glamorous and desirable. According to them, "DeMille gave voice to a crucial myth of modern culture: metamorphosis through consumption."[8]

Susan J. Douglas updates this view and refers to the media's mixed messages by tracing their impact during and immediately after World War II. According to Douglas, since women were needed in the factories en masse to substitute for the men who were fighting abroad, the media promoted the view that manufacturing work was glamorous as well as necessary with such productions as the "Glamour Girls of 1943," a newsreel about female factory workers, and ads in magazines with images of women workers, including one of a beaming riveter who was identified as "Miss America, 1943." As soon as the war was over, however, books and movies began portraying women who wanted to work outside of the home as bad mothers or mentally unhealthy. Douglas links this trend with the emergence of film noir. "Resonating with this message were the women of film noir, the black widow spiders, seductresses, and gun crazy bitches whose appetites for money and sex drove men to ruin in *The Postman Always Rings Twice* (1946)," among other films.[9]

Since Sherman's characters in the *Untitled Film Stills* are not specified, we are free to construct our own narratives for these women. Sherman encourages our participation by suggesting, through the deliberate nature of her poses, that she is the object of someone's gaze. The voyeuristic nature of these images and their filmic associations encourage a psychoanalytical reading of these works as illustrations of Laura Mulvey's renowned 1975 essay "Visual Pleasure and Narrative Cinema," which describes the image of woman onscreen as the subject of the controlling male gaze and the object of masculine desire. Sherman's *Untitled Film Stills* not only imply our own and the camera's gazes but at times hint at the presence of another person in the room with her, as in *Untitled Film Still #10* (plate 10), *Untitled Film Still #14* (plate 15), and *Untitled Film Still #65* (plate 64).

Numbering 69 in total, the *Untitled Film Stills* present an array of types, which, according to Judith Williamson in *Consuming Passions*, "force upon the viewer that elision of image and identity which women experience all the time: as if a sexy black dress made you *be* a femme fatale, whereas 'femme fatale' is precisely an image, it needs a viewer to function at all."[10] Williamson goes on to say that Sherman's work implicates the viewer in the construction of these identities while gazing at the images but, by offering so many characters, Sherman undermines this attempt to fix her image according to our desires.[11]

Desire mixed with nostalgia fuels the allure of the *Untitled Film Stills*—desire for the woman depicted as well as desire to be that woman, during that time. Considering the sources for the series, this potent mix is inevitable. In his study of the series, Arthur Danto points out that film stills are not isolated frames from movies but rather reenactments that are used to advertise a film and, as advertisements, they are meant to stimulate enough interest to sell tickets. "The still must tease with the promise of a story the viewer of it itches to be told."[12] As with any film still, performance is at the core of Sherman's images, and Danto attributes their success as being "simultaneously and inseparably photographs and performances."[13]

As photographic records of self-performances, the *Untitled Film Stills* are related to the feminist performance work of the 1970s by artists such as Eleanor Antin and Adrian Piper, who Sherman has identified as early influences.[14] In the early 1970s, Antin used costumes to transform herself into a series of characters: a king, a ballerina, a nurse, and a black movie star, in public pieces, which are also presented as photographs (figure 7). In a series of public performances begun in 1970 entitled *Catalysis* (figure 6), Adrian Piper performed in public in New York by, for example in *Catalysis I*, riding the subway and browsing through books while wearing clothes that had been soaked in foul-smelling fluids. These early performances by women (and those of men at the time) are known primarily through photographic documentation. Sherman's *Untitled Film Stills* are not only photographic records of performances but, inversely, performative accounts of filmic images. Sherman ended the series in 1980, when she realized that she was beginning to duplicate some of the stereotypes.[15]

4

figure 6
Adrian Piper
Catalysis III, 1970
Courtesy of the artist

figure 7
Eleanor Antin
The King of Solona Beach, 1975
Courtesy Ronald Feldman Fine Arts, New York

figure 7

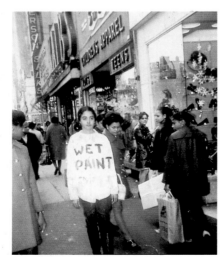

figure 6

Not

Rear Screen Projections,[16] 1980–81

Images are made palpable, ironed flat by technology and, in turn, dictate the seemingly real through the representative. And it is this representative, through its appearance and cultural circulation, that detonates issues and raises questions. Is it possible to construct a way of looking which welcomes the presence of pleasure and escapes the deceptions of desire?

—Barbara Kruger [17]

a bit of technique

Sherman's next series was her first work in color, which she continued to use to increasing effect. If the black-and-white *Untitled Film Stills* contain the nostalgia of an old movie, the Rear Screen Projections exude the artifice of a television show. Dictated by a desire to work at home rather than on location,[18] Sherman photographed herself in front of a screen on which she projected slides of outdoor and indoor scenes. The backgrounds in these photographs are obviously fake. The very realistic and sometimes quite closely cropped images of Sherman contrast with the blurry and insubstantial settings, heightening the artifice of the entire scene.

5

The resulting images are more contemporary than the previous series, reminiscent of the late 1960s and 1970s rather than the 1950s. Sherman is still role-playing, but these characters are decidedly more up-to-date in their demeanor. Rather than victims or femme fatales, the women in the Rear Screen Projections appear more confident and independent. In *Untitled #76* (plate 72), a young urbanite drinks a beer outside, and a mysterious woman in a straw hat gives a knowing look in *Untitled #72* (plate 71).

The majority of these works depict youthful, middle-class women out in the real world. These characters have their counterparts in the media images of women during the 1970s, exemplified by the Mary Richards character of *The Mary Tyler Moore Show* television series. According to Douglas, when it premiered in 1970 *The Mary Tyler Moore Show* was the only major television program featuring a single woman as the star. She was at times assertive and at others submissive, reflecting both the struggles of working women at the time and the ambivalence of the media about how to depict them.[19]

Sherman's appropriation of the media's forms in order to critique it has its parallel in the work of Barbara Kruger. Having worked in advertising, Kruger expertly mimics the look and imagery of ads and inserts disjunctive texts to expose their manipulations. She has similarly created works that deal with the media's representation of women but with none of the nostalgic allure of Sherman's early series; Kruger's approach is much more confrontational.

Centerfolds or Horizontals, 1981
While Sherman may pose as a pin-up, she still cannot be pinned down.
—Craig Owens[20]

In 1981, Sherman was asked to create a portfolio of images for an issue of *Artforum*. Inspired by the magazine's horizontal format and the request for a two-page layout, she produced a series of works that refer to the photo spreads in pornographic magazines. Large enough to be life-size, each image is in color, with Sherman as a different young woman or teenage girl looking off to the side with a vacant or pensive look. The figure fills the frame, cropped and in close-up, in a technique that she has continued to use often. She keeps background details to a minimum. The lighting is theatrical in works such as *Untitled #88* (plate 73), highlighting certain areas of the figures and throwing the rest into darkness. Some figures are lying down, as in *Untitled #90* (plate 74), *Untitled #93* (plate 76), and *Untitled #96* (plate 78), and others are crouched down on the floor, such as in *Untitled #92* (plate 75). The vantage point of the viewer, who looks down on these women, reinforces their vulnerability, as does their mostly disheveled look.

When the series was shown, Sherman was criticized by some as having created images that reaffirm sexist stereotypes, and *Artforum* eventually rejected the pictures. The most potentially suggestive of the works, *Untitled #93* (plate 76), depicts a woman with messy hair and smudged makeup in bed covering herself with black sheets. She looks toward a light that shines in her eyes. Although some critics read this as a scene after a rape, Sherman has stated that she was imagining someone who had just come home in the early morning from being out partying all night, and the sun wakes her shortly after she has gone to bed.[21] The controversy underscores the power of the frameworks created by the media and the risks of appropriating those strategies for purposes of critique. A curiously parallel situation occurred in 1974, also within the pages of *Artforum*. In a hilarious illustration (and send-up) of penis envy, Lynda Benglis inserted an ad into the pages of the magazine with a nude photograph of herself holding a large dildo. Some of the editors of the magazine responded in the following issue with a statement about the "extreme vulgarity" of the photograph and termed it "a shabby mockery of the aims of . . . [the women's] movement."[22]

As with the *Untitled Film Stills* and Rear Screen Projections, in the Centerfolds Sherman mimics and repeats mass media modes, thereby diffusing their potency. Liz Kootz discusses artists (specifically Lutz Bacher and Abigail Child) who "investigate the *instabilities* and *ambivalences* elicited when female artists invite female spectators to identify with conventionally male subject positions. . . ."[23] She suggests that by highlighting these ambivalences, the permanence of these gendered

positions is unsettled rather than strengthened, and the Centerfolds perform in a similar manner. By slipping so comfortably into these culturally ingrained representational structures, Sherman forces us to question their validity.

Pink Robes, 1982

Truth wants to give herself naked. . . . That hopeless striptease is the very striptease of reality, which disrobes in the literal sense, offering up to the eyes of gullible voyeurs the appearance of nudity. But the fact is that this nudity wraps it in a second skin, which no longer has even the erotic charm of a dress.

—Jean Baudrillard [24]

In the following series, Sherman responded to her critics by switching to a vertical format in an attempt to do away with the vulnerability of the character implied through the use of the horizontal format. Yet she continues to imitate the stance of porno models, posing only in a pink chenille bathrobe. Sherman thinks of these images as depictions of the porno models during breaks between posing for nude shots[25] and as such they are a continuation of the Centerfolds series. Devoid of the wigs and makeup she wore in the earlier works, Sherman sits unadorned and decidedly unsexy, staring directly out toward the viewer.

Peter Schjeldahl has interpreted this series as being the most revealing of "the real Cindy"[26] (his quotation marks) betraying a desire to find her true identity within the myriad guises she has assumed. Because we have seen her as so many persons, we are curious to know which version is authentic. This assumes, however, that Sherman's works are self-explorations. Rather, they are disparate views of Everywoman as she has appeared in the media. Speaking of what sounds like a particularly postmodern sense of fractured identity, she has said: "I divide myself into many different parts. My self in the country . . . is one part. . . . My professional self is another, and my work self in the studio is another."[27]

Concurrent with the Pink Robes is a group of works that depict an array of characters that look contemporary and are striking because of their normal appearance. Tough-looking chicks appear in *Untitled #102* (plate 81) and *Untitled #113* (plate 85), and adolescent girls show up in *Untitled #116* (plate 87) and *Untitled #112* (plate 84). As is Sherman's custom by now, the figures fill most of the frame, with almost no background particulars. Most of the works are vertical with the exception of *Untitled #108* (not in the exhibition) and *Untitled #109* (plate 83), which are androgynous-looking headshots. The chiaroscuro lighting she initiated in the Centerfolds returns in *Untitled #105* (plate 82) and *Untitled #113* (plate 85). Although the characters appear more ordinary, the lighting is more theatrical. For Sherman, these images functioned as "color tests" that allowed her to experiment with colored lights and gels. She gradually eliminated the amount of light throughout the series so that the photographs gradually appear darker.[28]

Fashion, 1983, 1984, 1993, 1994

The major accomplishment of the mass-fashion industry was its ability to plumb the wells
of popular desire.[29]

—Stuart and Elizabeth Ewen

Sherman has produced four groups of works that quote from fashion
photography. The first series was commissioned by shop owner Diane
Benson in 1983 for a spread in *Interview* magazine. Provided with clothes
by such high-end designers as Jean-Paul Gaultier and Comme des
Garçons, Sherman created, not surprisingly, the antithesis of glamour ads.
In works such as *Untitled #119* (plate 88) and *Untitled #131* (plate 91),
the models look silly but utterly delighted in their high-fashion frocks.
However other images are more sinister, like the slightly deranged *Untitled
#122* (plate 90). The second commission came from Dorothée Bis, a
French fashion company, which asked Sherman to produce
photographs featuring its designs for French *Vogue*. These images are even
more bizarre than the previous works, with the models looking
dejected in *Untitled #137* (plate 94), exaggeratedly wrinkled in *Untitled
#132* (plate 92), and even possibly homicidal in *Untitled #138* (plate 95).
In 1993, Sherman created works for an issue of *Harper's Bazaar*.
Less dark than the works for *Vogue*, these images are fantastical and make
full use of the clothes as costumes to completely transform Sherman
and turn backgrounds into theatrical settings. She produced the most
recent fashion shots for the Japanese fashion house Comme des
Garçons in 1994.

It seems inevitable that Sherman be drawn to create her own versions of
fashion spreads. Fashion is yet another means of masquerade for
women, and ads for clothes promise to convert the buyer into a more per-
fect version of herself. According to Joanne Finkelstein, "Fashion is a
means by which images of the self can be created and displayed . . .
a greater diversity in styles of appearance has evolved so that we can now
act in the public domain as if we each possessed a multiplicity of
identities."[30] Like all advertisements, fashion photographs manufacture a
desire that can never be fulfilled. We clamor for the latest style, which will
only be supplanted next year. Underlying the promise of originality
in high-fashion ads is, paradoxically, conformity to a prescribed look.
Sherman's Fashion photographs undermine the desirability of such images
by emphasizing their contrived nature.

Fairy Tales, 1985

In horror stories or in fairy tales, the fascination with the morbid is also, at least for me,
a way to prepare for the unthinkable. . . . That's why it's very important for me to show the
artificiality of it all, because the real horrors of the world are unmatchable, and they're
too profound. It's much easier to absorb—to be entertained by it, but also to let it affect you
psychologically—if it's done in a fake, humorous, artificial way.

—Cindy Sherman[31]

Sherman took the disturbing aspects of the Fashion works to a higher level in the Fairy Tales. It is at this point in her career that her images become truly strange and surreal, as if liberated from the confines of reality she can now transform into any manner of being. Invited by *Vanity Fair* to contribute photographs based on fairy tales, Sherman responded with a series of pictures that have nothing in common with the sweet bedtime stories that we associate with the genre. Instead she presents all the horrific creatures we encounter in the more gruesome tales, and the backgrounds become important elements to suggest narratives. They are unusual not only because of their element of horror, but also because we are unaccustomed to seeing such stories represented in photographs. Using all the tools of theater—dramatic lighting, vivid color, costumes, prostheses, wigs, and props—she creates obviously phony, but no less disturbing images that are also humorous. They are entirely fantastic constructions with the artifice so extreme that in some works Sherman appears more doll-like than human, as in *Untitled #147* (plate 98); in *Untitled #155* (plate 102), she resembles a mannequin. A particularly bizarre scene appears in *Untitled #150* (plate 99), in which an androgyn with a huge, extended tongue fills the foreground, and tiny figures stand in a landscape behind it, making it seem like a giant among Lilliputians.

As in her other works, Sherman's Fairy Tales do not depict specific examples but evoke a narrative form. The exceptions are the works illustrating one of Grimm's fairy tales, which she produced for a children's book entitled *Fitcher's Bird* (1992). Her croppings are especially severe in these photographs, with much of the images cut out, presumably so that children cannot see the very frightening whole picture.

The importance of these stories for children, Disney aside, goes beyond entertainment. In an anthology of feminist fairy tales, Jack Zipes discusses the impact of this genre on children and its importance, "as a key agent of socialisation, . . . [that] enables the child to discover his or her place in the world and to test hypotheses about the world."[32] The sexist slant of most of the traditional tales can be summed up with the cliché of a girl waiting for her "prince." In reaction to this attitude, Zipes points to Victorian women writers such as Mary De Morgan and Evelyn Sharp, who wrote fairy tales with assertive, self-determining heroines.[33] In the same Victorian era, women authors such as Christina Rossetti, Anne Thackeray Ritchie, and E. Nesbit composed particularly angry stories that were full of violence and satire.[34] Sherman, it would seem, belongs to this female tradition of concocting violent fairy tales.

Disasters, 1986–89

Since the Middle Ages, Western culture has represented the body, with increasing frequency, as an architectural metaphor of the society at large.

—Joanne Finkelstein [35]

In its emphatic yet beautiful display of the disgusting, Sherman's Disasters series is indistinguishable from the Fairy Tales. She employs the same theatrical devices and hallucinatory imagery to construct equally outlandish scenes. In these works, the body is besieged. The beasts from the Fairy Tales reappear as hybrid human-doll creatures in *Untitled #186* (plate 111) and *Untitled #187* (plate 112) and as deformed humans in *Untitled #160* (plate 104). In other works, the body is rearranged and/or hidden amidst detritus, as in *Untitled #190* (plate 114). It appears as a reflection in *Untitled #175* (plate 107) and as a series of obviously fake surrogates in *Untitled #188* (plate 113), *Untitled #177* (plate 108), and *Untitled #180* (plate 109). Finally, it disappears altogether in *Untitled #168* (plate 106).

An analogy can be drawn between these pictures of excess and revolt and our contemporary condition of violence and apparent chaos. While the body politic is under attack, we are obsessed with our individual physique and its fitness. In her analysis of the body as a metaphor for society, Finkelstein asserts that in Western culture, bodily control is a sign of status. She discusses the many mutants that appear in nineteenth-century literature such as Mary Shelley's Frankenstein, Victor Hugo's Hunchback of Notre Dame, and Robert Louis Stevenson's Dr. Jekyll and Mr. Hyde. These creatures are violent as a result of their mistreatment by society, and they are all very close to being human.[36] That, perhaps, is why they so fascinate us, for "it is as if we harbored a secret self, an immersed, repressed side . . . of which we live in fear because it could, at any time, burst from us accountably and, . . . instantly propel us beyond the boundaries of the acceptable."[37] Sherman's images of the assaulted body reveal this underside and resist the far more common pictures of the cultivated and socialized body that we encounter daily in the media.

History Portraits, 1989–90

There is something liberating in the way in which Sherman takes aim at the sheer weirdness of Old Master art.

—Amelia Arenas [38]

In her next series, Sherman created thirty-five works that are her own unique renditions of historical portraits. She returns as a sitter in this series, using props and wearing lush costumes, wigs, and fake appendages to assume the character of the various nobles, mythological heroes, and madonnas that have been depicted by court painters.

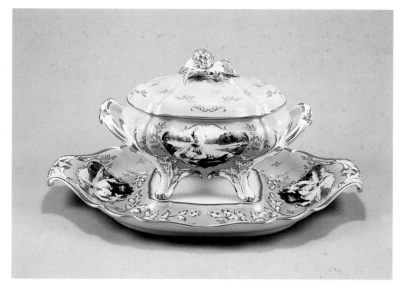

figure 8
Cindy Sherman
*Madame de Pompadour
Tureen,* 1990
Courtesy Artes Magnus,
New York

figure 8

The idea for these works originated in a commission Sherman received in 1988 from Artes Magnus to create works in porcelain for the French firm Limoges. Sherman used the original eighteenth-century molds for Madame de Pompadour's designs to produce new works, such as a soup tureen, with decals on them that contained images of Sherman dressed in period costume (figure 8). Sherman enlarged one of the images to include them in a group exhibition at Metro Pictures in 1988. A year later, she produced a series of works with characters from the French Revolution for an exhibition in Paris at Chantal Crousel Gallery during the French bicentennial. After a two-month stay in Rome during 1989, Sherman returned to her New York studio and produced another group of historical portraits, including *Untitled #224* (plate 121).[39]

Just as the *Untitled Film Stills* are not pictures of any specific movies, the History Portraits (for the most part) do not reproduce any particular paintings. Like the *Untitled Film Stills,* they depict types from the genre. Sachiko Osaki has identified possible sources for some works in the series,[40] but Sherman has singled out only three images that relate directly to actual paintings. They are *Untitled #224* (plate 121), which is modeled after Caravaggio's *Sick Bacchus* (1593–94), *Untitled #216* (not in the exhibition) after Jean Fouquet's *Madonna of Melun* (ca. 1450), and *Untitled #205* (not in the exhibition), based upon Raphael's *La Fornarina* (ca. 1518–19).[41]

Sherman masquerades as a man in works such as *Untitled #213* (plate 118) and *Untitled #227* (plate 123), and in this gender reversal she relates to Marcel Duchamp and the famous image of himself in drag as his alter-ego Rrose Sélavy. Sherman creates the most memorable and humorous

images, however, in her portrayals of women. Spoofing the often awkward depictions of the female anatomy in Old Master paintings, she uses fake breasts of astounding configurations to great effects in *Untitled #222* (plate 119) and particularly in *Untitled #225* (plate 122), in which the bosom of an aristocrat squirts a trajectory of fluid. The sheer ridiculousness of these works suggests that Sherman is mocking the Western canon and its seemingly endless depictions of extravagantly dressed royalty, clergy, mistresses, and religious figures. Although this series may at first seem like an anomaly in a career that has simulated the methods of the mass media, the History Portraits likewise deal with a representational system that reinforces a particular ideology, albeit a more dated one.

Sex Pictures, 1992

But what can porn do in a world pornographed in advance? . . . Except bring an added ironic value to appearances? Except trip a last paradoxical wink—of sex laughing at itself in its most exact and hence most monstrous form, laughing at its own disappearance beneath its most artificial form?
—Jean Baudrillard[42]

From the civilized milieu of the History Portraits, Sherman next turned to the raunch of the pornographic. Using anatomically detailed mannequins and body parts from medical catalogues, she constructed hybrid dolls. Rather than having sex, these figures proudly *show* their sex. Sherman arranges the dolls in poses that imitate those of pornography in *Untitled #258* (plate 128) and *Untitled #264* (plate 131), and she combines parts from various mannequins in the grotesque *Untitled #250* (plate 126), *Untitled #263* (plate 130), and *Untitled #264* (plate 131).

Sherman created these works in response to several issues. She had been considering how to incorporate total nudity into her work for a long time. She also wanted to respond to the series of photographic works by Jeff Koons that depict the artist and his then wife, Cicciolina, in sexual poses. The controversy over the National Endowment for the Arts (NEA) and the debates over what constitutes obscenity in art, which were occuring at the time, were a further inducement to produce the series.[43] Sherman's rebuttal to the threat of censorship are images that, though contrived, are genuinely pornographic; they objectify sex. The complexity of the issue of pornography is such that, as Ellen Willis points out, it unites feminists and extreme conservatives in an unlikely alliance against the exploitation of women and immoral behavior.[44] During the NEA debates, the radical right aimed their wrath particularly at photography and the works of Robert Mapplethorpe and Andres Serrano. Evidently the assumed veracity of the photograph is what gives these images power. Yet Sherman's Sex Pictures are manifestly artificial. As in all her works after the *Untitled Film Stills*, the tricks are apparent, disclosing all the manipulations of image-making. Typically, pornography portrays sex as anonymous, and in this series, Sherman depicts pornography as ridiculous. The clinical aspect of the mannequins and the shocking violations of their plastic parts result in gruesomely hilarious pictures to which we cannot help but relate because they appear so familiar.

figure 9
Hans Bellmer
La Poupée, 1936
Editions Filipacchi,
Paris, France

figure 10
Pierre Molinier
Autofellation Yoke, 1972
Courtesy Wooster
Gardens

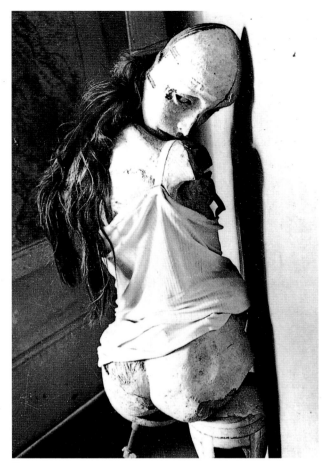

figure 9

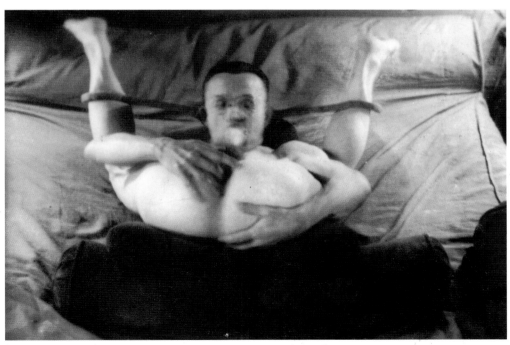

figure 10

The Sex Pictures have been compared with the *Poupée* series of photographs by Hans Bellmer (figure 9). During the 1930s, Bellmer produced photographs of monstrous images of bulbous bodies he constructed from doll parts. As strange depictions of the fragmented body they also relate to the work of the French artist Pierre Molinier. From the mid-1960s until his suicide in 1976, Molinier photographed himself in garters, stockings, and other fetishistic accoutrements (figure 10). At times he used the resulting images as collage elements combined in photographs of autoeroticism by his duplicated selves or in compositions that present a contorted body with multiple legs. The correlations between Sherman and Molinier extend to their working method. Both artists photograph themselves in the privacy of their own studios, transformed by clothing into other personas, which then become public. The impetus for their role-playing, however, is vastly different. Sherman is motivated by the external influence of the media, and Molinier was moved by his own desire.

Horror and Surrealist Pictures, 1994–96

The mask which concealed the visage was made so nearly to resemble the countenance of a stiffened corpse that the closest scrutiny must have had difficulty in detecting the cheat. And yet all this might have been endured, if not approved, by the mad revellers around. But the mummer had gone so far as to assume the type of the Red Death. His vesture was dappled in *blood*—and his broad brow, with all the features of the face, was besprinkled with the scarlet horror.

—Edgar Allan Poe[45]

In the subsequent group of works, Sherman returned to images of horror, which she had begun with the Fairy Tales series. In *Untitled #312* (plate 145) she continues to use the artificial body parts of the Sex Pictures to create a monstrous family, and in *Untitled #302* (plate 138) and *Untitled #308* (plate 141), she combines various parts to create a monster and an exquisite corpse, respectively. She eventually changes her focus from the full body to the face, retaining only the masks from the barrage of artificial body parts she had used in the Sex Pictures. Shot up close, these images present an array of manipulated masks. *Untitled #305* (plate 140) depicts a pair of masks that appear to be kissing. In the six-work series *Untitled #314 A–F* (plates 143, 144), she slices and reconfigures masks into gruesome, red visages that seem to include exterior and interior views of faces. This layering of surfaces appears in several of these works, as in *Untitled #316* (plate 147), in which a scarred doll's face is partially covered by smoother sections. At times the layering suggests that there is an actual human underneath the disguise, as in *Untitled #317* (plate 148). Sherman in fact appears in some of the works but also combines various masks in others. For the first time, in works such as *Untitled #303* (plate 139) and *Untitled #311* (plate 142), she employs photographic techniques such as double exposure that were favored by

the surrealists. Rather than customarily manipulating the objects she photographs, in these works she uses the technology of the camera to manipulate the image.

Works such as *Untitled #326* (plate 151) resemble frames from a film. In these photographs, disturbed looking characters bathed in vivid, deep tones gaze at the viewer in a menacing or maniacal way. Sherman has stated that these recent works are related to the horror film she directed, *Office Killer*, which is scheduled for release in late 1997. The film is about a magazine editor, Dorine, who accidentally kills an office worker. As more murder ensues, Dorine begins to bring home the bodies. In a scenario familiar to Sherman, she "sets up this tableau with them, sort of creating her ideal office. She rearranges some of the people."[46] Dorine can thus be seen as a stand-in for Sherman and another of her self-transformations.

From the *Untitled Film Stills* to an actual film and works that inspired it, Sherman's career has come full circle. The myriad masks and guises she dons allow her to undergo transformations that explore the workings of representation. That Sherman uses herself or surrogates in all of her work is significant, as we track her pursuit for a unified self-image, only to discover the futility of such a search. From her earliest pictures, Sherman has played to our desire. The allure of the *Untitled Film Stills* continues to her more recent images of disgust and horror, which she presents in full-color richness, attracting and repulsing our gaze.

Notes

16

1 Susan J. Douglas, *Where the Girls Are: Growing up Female with the Mass Media* (New York: Times Books, 1994), 13.

2 Cindy Sherman, interview by Noriko Fuku in "Interview with Cindy Sherman," *Cindy Sherman*, exhibition catalogue (Shiga, Japan: Museum of Modern Art, 1996), 161.

3 Sherman, interview by George Howell, "Anatomy of an Artist," *Art Papers* 19, no. 4 (July/August 1995): 7.

4 Cindy Sherman, in a May 6, 1997 conversation with the author.

5 Phyllis Rosenzweig, *Directions—Cindy Sherman: Film Stills* (Washington, DC: Hirshhorn Museum and Sculpture Garden, Smithsonian Institution, 1995), unpaginated brochure.

6 Sherman, interview by George Howell, "Anatomy of an Artist," *Art Papers* 19, no. 4 (July/August 1995): 7.

7 Stuart and Elizabeth Ewen, *Channels of Desire: Mass Images and the Shaping of American Consciousness* (Minneapolis: University of Minnesota Press, 1992), 70.

8 Ibid.

9 Susan J. Douglas, *Where the Girls Are: Growing up Female with the Mass Media* (New York: Times Books, 1994), 46–48.

10 Judith Williamson, *Consuming Passions* (London and New York: Marion Boyars Publishers, 1986), 91.

11 Ibid., 92.

12 Arthur Danto, *Cindy Sherman: Untitled Film Stills* (New York: Rizzoli, 1990), 9.

13 Ibid., 11.

14 Sherman, interview by George Howell, "Anatomy of an Artist," *Art Papers* 19, no. 4 (July/August 1995): 6.

15 Cindy Sherman, in *Cindy Sherman*, exhibition catalogue (Shiga, Japan: Museum of Modern Art, 1996), 163.

16 The series titles so commonly associated with Cindy Sherman's work were not assigned by the artist herself; rather, they originated with art critics and others following individual exhibitions. The only series title assigned by Cindy Sherman to a group of her works is *Untitled Film Stills*.

17 Barbara Kruger, "Incorrect," in *Remote Control: Power, Culture, and the World of Appearances* (Cambridge and London: The MIT Press, 1993), 220.

18 Cindy Sherman, in *Cindy Sherman* (Shiga, Japan: Museum of Modern Art, 1996), 163.

19 Susan J. Douglas, *Where the Girls Are: Growing up Female with the Mass Media* (New York: Times Books, 1994), 204–206.

20 Craig Owens, "The Discourse of Others: Feminists and Postmodernism," in *The Anti Aesthetic: Essays of Postmodern Culture*, Hal Foster, ed. (Seattle: Bay Press, 1983), 75.

21 Cindy Sherman, in *Cindy Sherman*, exhibition catalogue (Shiga, Japan: Museum of Modern Art, 1996), 165.

22 Amelia Jones, "Postfeminism, Feminist Pleasures, and Embodied Theories of Art," in *New Feminist Criticism: Art, Identity, Action*, Joanna Frueh, Cassandra L. Langer, and Arlene Raven, eds. (New York: HarperCollins Publishers, Inc., 1994), 34.

23 Liz Kootz, "Complicity: Women Artists Investigating Masculinity," in *Dirty Looks: Women, Pornography, and Power,* Pamela Church Gibson and Roma Gibson, eds. (London: British Film Institute, 1993), 101.

24 Jean Baudrillard, *The Perfect Crime* (London and New York: Verso, 1996), 3.

25 Cindy Sherman, in a May 6, 1997 conversation with the author.

26 Peter Schjeldahl, "The Oracle of Images," in *Cindy Sherman* (New York: Whitney Museum of American Art, 1987), 10.

27 Cindy Sherman, in *Cindy Sherman*, exhibition catalogue (Shiga, Japan: Museum of Modern Art, 1996), 162.

28 Cindy Sherman, in a May 6, 1997 conversation with the author.

29 Stuart and Elizabeth Ewen, *Channels of Desire: Mass Images and the Shaping of American Consciousness* (Minneapolis: University of Minnesota Press, 1992), 167.

30 Joanne Finkelstein, *The Fashioned Self* (Philadelphia: Temple University Press, 1991), 130.

31 Cindy Sherman, in *Cindy Sherman*, exhibition catalogue (Shiga, Japan: Museum of Modern Art, 1996), 164.

32 Jack Zipes, ed., *Don't Bet on the Prince: Contemporary Feminist Fairy Tales in North America and England* (New York: Routledge, 1986), xii.

33 Ibid., 13.

34 Nina Auerbach and U. C. Knoepflmacher, eds., *Forbidden Journeys: Fairy Tales and Fantasies by Victorian Women Writers* (Chicago and London: University of Chicago Press, 1992), 3.

35 Joanne Finkelstein, *The Fashioned Self* (Philadelphia: Temple University Press, 1991), 51.

36 Ibid., 51–64.

37 Ibid., 65.

38 Amelia Arenas, "Afraid of the Dark: Cindy Sherman and the Grotesque Imagination," in *Cindy Sherman* (Shiga, Japan: Museum of Modern Art, 1996), 46.

39 Cindy Sherman, in a May 6, 1997 conversation with the author.

40 See Sachiko Osaki, "Cindy Sherman's History Portraits," in *Cindy Sherman* (Shiga, Japan: Museum of Modern Art, 1996), 38–44.

41 Sherman, in *Cindy Sherman*, exhibition catalogue (Shiga: Museum of Modern Art, 1996), 162–63. Sherman mentions the three works in this interview. Osaki provides the titles of the earlier sources in the essay cited in the note above.

42 Jean Baudrillard, *The Perfect Crime* (London and New York: Verso, 1996), 129.

43 Cindy Sherman, in a May 6, 1997 conversation with the author.

44 Ellen Willis, *No More Nice Girls* (Hanover: Wesleyan University Press and University Press of New England, 1992), 15.

45 Edgar Allan Poe, "The Masque of the Red Death," in *The Complete Poems and Stories of Edgar Allan Poe,* Arthur Hobson Quinn and Edward H. O'Neill, eds. (New York: Alfred A. Knopf, 1982), 387.

46 Cindy Sherman in Phoebe Hoban, "Sherman's March," *Vogue* 187, no. 2 (February 1997), 242.

17

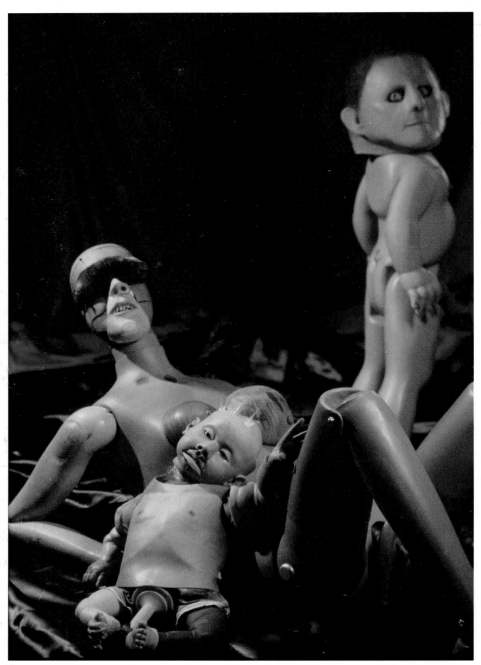

figure 1

The Sleep of Reason
Produces Monsters

ELIZABETH A. T. SMITH

Cindy Sherman's images are simultaneously horrific and comic, abject and insidiously seductive. In the work that she has produced since the early 1980s, horror, humor, and the grotesque pervade her treatment of the human figure or its surrogate, colliding and intertwining in provocatively complex and contradictory ways. Her use of these forms of expression, while intensely of our own time, also offers a number of intriguing parallels to the ways in which earlier artists have invoked the grotesque and the monstrous. Once we have examined some of these affinities we can attempt to locate this sensibility, which is evident in much of Sherman's work, within an art historical trajectory of parodic burlesque and of mordant social critique in which horror, humor, and the grotesque figure as significant devices.

figure 1
Cindy Sherman
Untitled #312, 1994
Collection of the artist
Courtesy Metro Pictures,
New York

The title of this essay derives from that of a well-known image by eighteenth-century artist Francisco Goya (1746–1828), *El sueño de la razón produce monstruos* (figure 2), an etching made in 1797 as the title plate of a suite of satirical graphic works called *Los Caprichos*.
It shows the artist himself having fallen asleep at his drawing table, while around him a horde of weird owl- and batlike apparitions hovers.
While this image has been interpreted by many later art historians as anticipating the concerns of surrealism by suggesting the play of the unconscious in a dream state, the author's intention was not to celebrate the liberation of the irrational mind but instead to place the *Caprichos* series within a realm of fantasy that would lend a partial veil of ambiguity and sense of the "capricious" to his biting critique of the society of the day.[1]

How does such an image relate to the work of Cindy Sherman, conceived almost two hundred years later in a medium unknown in Goya's time and under such entirely different historical circumstances as to be almost unrecognizable as part of the same overarching modern era? Despite the

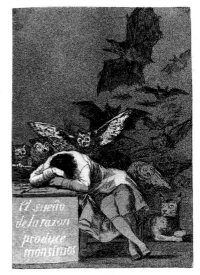

figure 2

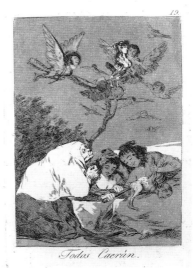

figure 3

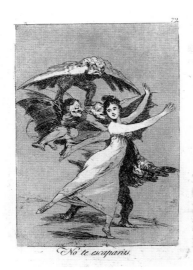

figure 4

vast and obvious differences, a kinship exists between both artists' use of the grotesque and of other devices of comedic horror in bodies of work with satiric intent. In addition, beyond this particular parallel with Goya, Sherman's work can be positioned within a lineage of other related manifestations of the grotesque—in particular, such earlier art historical examples as the medieval allegories of Hieronymus Bosch, bizarre mannerist portraits of excess by Arcimboldo, and, in the twentieth century, the eccentric and eerie manipulations of the figure in the photocollages and photographs of artists including Hannah Höch and Ralph Eugene Meatyard. Literary history offers additional examples of the grotesque, such as the fairy tale genre and the gothicisms of turn-of-the-century author Ambrose Bierce's horror stories.

In seeking to articulate a kinship between Sherman and Goya, I do not mean to suggest that a direct influence exists between them or that Sherman has sought to emulate Goya, but rather that upon close examination of their work a degree of resonance and affinity—a sense of correspondence—can be found in their imagery, their engagement with certain social themes, and their parodic sensibilities. Images of humans with exaggerated animalistic features or bizarre birdlike body parts, humorously scatological and violent scenes, gleefully gruesome manifestations of decrepitude and physical and social decay, and a

figure 2
Francisco Goya
El sueño de la razón produce monstruos
Los Caprichos, 1796–1799

figure 3
Francisco Goya
Todos cáeran
Los Caprichos, 1796–1799

figure 4
Francisco Goya
No te escaparás
Los Caprichos, 1796–1799

Photos courtesy
Norton Simon Art Foundation,
Pasadena, CA

preoccupation with the unmasking of artifice populate both Goya's *Caprichos* and the bulk of Sherman's series since the early 1980s. The metaphoric "sleep of reason" and its resultant monsters strongly permeate both oeuvres.

Each artist's casting of these "monsters" and the way in which socially and culturally inflected meanings emerge from the images, however, offer intriguing disparities as well as striking similarities. In Sherman's Centerfold series of the early 1980s, a palpable sense of foreboding and unknown terrors surrounds and exudes from the young female subjects, approximating the tone of Goya's recurrent treatment of the fate of a particular social class of young women in *Los Caprichos*. In images including *Untitled #86*, *Untitled #90* (plate 74), *Untitled #92* (plate 75), and *Untitled #93* (plate 76), Sherman employs harsh backlighting and fearful or ambiguously melancholic expressions, and she poses to convey a sense of terror, as in the melodrama of a horror film, or a vague, sullen sense of longing and frustration that could equally indicate mindless boredom or romantic reverie. Many of Goya's renditions of young women carry similar attributes. In contrast, however, he endows the phantasms, desires, temptations, foibles, vanities, malignancies (and a host of other real or imagined terrors that surround them) with physical form as grotesque personifications.

Freakish apparitions flank the central female figures in *No te escaparás* (figure 4) (*You will not escape*, number 72 of *Los Caprichos*), *No grites, tonta* (*Don't cry out, stupid*, number 74), *Ruega por ella* (*Pray for her*, number 31), and *Bellos consejos* (*Good advice*, number 15). These monsters, in varying degrees of animalesque states, signify carnality, irrationality, and social parasitism, and although they ensnare the woman pictured, she appears paradoxically complicit. Goya's harshly caricatural treatment of these forces and of the attraction they offer to the unenlightened but basically guileless young female is sternly moralizing, whereas the far greater ambiguity of Sherman's (self-)portraits allows no such clear readings. However both Goya and Sherman allude to and critique a social nexus of conventions and behavior codes surrounding women in the artists' respective cultures. Sherman accomplishes this not only by insidiously inverting the types of voluptuous, seductive female figures that consistently populate the magazine centerfold format but also by parodying a stock range of emotions embodied in a series of ordinary, seemingly empty-headed young women characters drawn from the conventions of media and popular culture.

Goya's frequent treatment of witches and sorcery in *Los Caprichos*, as well as in other examples of his graphic work and painting, suggest another thematic and imagistic parallel with Sherman's work, specifically her exploration of fairy tales and other related gothicisms during the mid-

1980s and again in the mid-1990s. Many of Goya's images present exaggerated, grotesque scenes of death, decay, and hideous transmogrifications of humans into terrifying, otherworldly creatures or into an amalgamation of body parts. These works satirize popular superstitions concerning witches, vampires, and other monsters, as well as point a finger at the clergy for fomenting such superstitions among an ignorant public. Sherman's grotesqueries, ranging from the half-pig/half-human of *Untitled #140* (plate 96), to the doll-like yet hideously fluid-secreting death mask of *Untitled #180* (plate 109), the repulsive close-up of pimpled buttocks in *Untitled #177* (plate 108), and assorted dismembered body parts amid decaying fields of oozing organic matter in *Untitled #167* and *Untitled #190* (plate 114) evoke similar phantasms from the world of popular myth and superstition.

In this respect Sherman's work also evokes the graphically demonic visions of sixteenth-century artist Hieronymus Bosch (1450–1516), whose monstrous hybrids of human anatomy, animals, insects, reptiles, and inanimate objects engaged in a plethora of violent, scatological, and otherwise gruesome activities are iconographic experiments in the representation of evil. In such well-known works as *The Garden of Earthly Delights* (figure 5), *The Last Judgment*, and *The Tower of Babel*, as well as in his numerous drawings of subjects such as monsters, witches, and bizarre amalgamations of human and landscape forms in *The Hearing Forest and the Seeing Field* and *The Tree Man*, Bosch developed a vivid pictorial language that appears fantastical but that was deeply rooted in the late medieval spiritual fabric in which witchcraft, alchemy, and magic were feared and moral abstractions were concretized as animals, demons, or monsters.

figure 5

figure 5
Hieronymus Bosch
The Garden of Earthly Delights
(detail of the right wing),
ca. 1500
Collection of
Museo del Prado,
Madrid, Spain

When we consider themes of spirituality and morality, however, Sherman parts company with Goya and Bosch. Her work is far from the spiritual attributes of Bosch's highly detailed treatment of the misfortunes of the ungodly and the dilemmas and confusion confronting humankind, and also departs from the moralizing genre of satire so readily apparent in Goya's work about such topical issues as the deplorable ignorance of the populace, the stupidity and fatuousness of the monied classes, or the irrational savageries of the Spanish Inquisition. Sherman prefers to play with the clichés of the grotesque, evincing an obvious delight in her penchant for the morbid and the fantastical. Here a new affinity presents itself, an additional art historical parallel with that of the mannerist painter Arcimboldo (1527–1593), whose arch allegorical fantasies of human forms composed of still-life elements—*Earth, Fire, Air, Water,* for

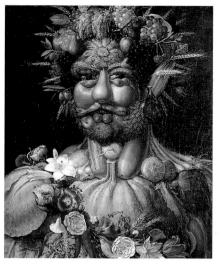

figure 6

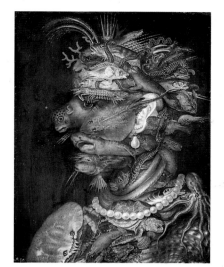

figure 7

figure 6
Giuseppe Arcimboldo
Vertumnus-Rudolf II, 1591
Slott, Skokloster, Stockholm,
Sweden

figure 7
Giuseppe Arcimboldo
The Water, 1566
Kunsthistorisches Museum,
Vienna, Austria

instance, as well as his paintings of the four seasons—are exemplars of
artifice and of a piquant fascination with the grotesque (figures 6–7).
Arcimboldo's bizarre composite images share with Sherman's not only
their deep verisimilitude but also the wit of their juxtapositions and their
keen exploitation of the artificial as a mode of caprice and invention,
although clearly the symbolism intended in Arcimboldo's allegories must
be understood in the intellectual and cultural context of the late
Renaissance.[2]

Taking her cues from the twentieth century and the late Romantic period,
Sherman mines the comedic potential of the grotesque in a way that
is never really terrifying but that succeeds in mirroring and mocking a col-
lective set of artistic, literary, and theatrical conventions about the
dark side of human nature. Using the fairy tale and the horror film as
sources to be parodied, her ebulliently stagey renditions of such scenes and
her reprisal of them in later images, including *Untitled #302* (plate 138)
and *Untitled #304*, both of 1994, and *Untitled #315* (plate 146) of
1995 manifest a tongue-in-cheek sensibility that comingles pleasure and
disgust. In light of this vein of Sherman's work, Marina Warner's
analysis of the tropes of the fairy tale genre seems apt: "Shape-shifting is
one of fairy tale's dominant and characteristic wonders: hands are cut off,
found and reattached, babies' throats are slit, but they are later
restored to life . . . the beggar changes into the powerful enchantress and
the slattern in the filthy donkeyskin into a golden-haired princess."[3]
Sherman exploits this manner of fantastical physical metamorphosis in her
Disasters and Fairy Tales series of the mid- to late 1980s and again in

more recent works of the mid-1990s inspired by surrealist photography. While they suggest a narrative dimension, however, her images deliberately avoid the kind of stock resolution in which dismembered parts are made whole or the slattern becomes the princess. Instead, she revels in the mock horror—the perversely intertwined repulsion and seductiveness—of the shape-shifting moment itself.[4]

While Sherman's practice cannot be construed as a social critique of the mordant intensity or specificity of that of Bosch or of Goya, her undermining of established genres—whether from popular culture and media, art history, or literature—points to a satirical vein that underpins her work's late twentieth-century ironic sensibility. Through her exploitation of trenchantly absurd juxtapositions and transformations and her embrace of melodrama, she succeeds in parodying the construction and presentation of myth and archetype in all of these genres. Evincing delight in their unmasking, Sherman even uses the mask itself as the central image of her most recent body of work, offering it in a dazzling variety of horrific, yet highly aesthetic, guises.

The moral implications of Sherman's use of satire lies in its ability to reveal, and therefore to critique, the artifice of constructions of identity, myth, and archetype and the social and psychological character that they manifest. At the same time, any moral reverberations in the horrific and grotesque aspects of her work are complicated and made ambiguous by the irreverent humor and sense of perverse pleasure that so clearly permeate her imagery. In her analysis of Sherman's engagement with the grotesque, writer Gen Doy suggests a parallel with sixteenth-century author François Rabelais's comic use of the grotesque body, but points to a significant difference between the affirmative worldview of Rabelais that placed human physicality at the center of the cosmos and the significantly more equivocal tenor apparent in Sherman's handling of similar imagery.[5]

The single series of Sherman's that can be described as stridently moralistic—in which outrage overpowers the comedic—is the Sex Pictures. These works were produced in the politically charged climate of the early 1990s, during which the religious right's presence increased, and issues of censorship and freedom of expression took on new prominence. Taking her cues from the conventions of hard-core pornography, Sherman's use of genital prostheses and fragmented mannequin parts to portray the body as monstrously sexualized—violated and violating—is more frankly disturbing and debased than the most lurid of her gory phantasms presented in other bodies of work. Other writers have discussed these images' visual parallels to the surrealist photographs Hans Bellmer (1902–1975) took of the violently distorted body parts of

mannequins. The foremost difference between them lies in the fact
that the debased sexuality of Sherman's obviously gendered male and
female mannequins is foregrounded, and that, as a female author
of such subjects, the artist's identity deeply inflects the tone of the series in
a way that is considerably more powerful and charged than the male
Bellmer's engagement with dismembered female fetishes.

Perhaps for Sherman, as for so many other artists and intellectuals of our
own time, the body is the central locus of significant ideas, issues,
and images, yet the meanings we attach to its representation as fragment-
ed, decayed, imperfect, and artificial are drastically different from those
of earlier times. In general terms, this change can be attributed not
only to the larger cultural implications of the gradual undermining of the
positivistic, rational worldview that began during the Enlightenment,
but also to the specific topical inflections of the events and outlook of the
late twentieth century.[6] The art of earlier figures such as Goya,
Rabelais, and even Bosch suggests that humanity could rise above its
foibles by adopting a preferred belief system and according to its
own will—either by exercising a vigilant rationalism, or in the case of
Bosch and his contemporaries, a religious faith. Sherman's art
demonstrates no such confidence.

In the large corpus of literature that exists on Sherman's work, most
writers who have devoted attention to theorizing the meaning of her
recent use of horrific and monstrous imagery have construed it as a mani-
festation of the "monstrous feminine" and "female grotesque."
A recent essay by Simon Taylor summarizes arguments by Barbara Creed,
Julia Kristeva, Laura Mulvey, Mary Russo, and others that specifically
ground Sherman's use of such imagery in relationship to a gendered
female subject and states that "Sherman's imagery enacts a sadomasochis-
tic dialectic, drawing upon, in order to thwart, pervasive desires and
fantasies of woman."[7] Based upon analyses of and reactions to Freudian
and Lacanian psychoanalytic theories, this feminist-inflected train of
argument indeed seems appropriate to much of Sherman's work made
from the mid-1980s to the early nineties, extending the central place her
work has occupied in feminist and poststructuralist theory since the
Untitled Film Stills of the late 1970s.

Some recent developments in Sherman's work, however, thwart considera-
tion of her renditions of the monstrous solely as female grotesques.
In series of 1994–95 and 1996, the issue of sexual identity is neutralized
in many of the masks, puppets, doll heads, and other fragmented,
weirdly amalgamated body parts that populate the images. Even when
configured as gender-specific family groupings, for instance, they seem to
function as sexually amorphous chimera—pathetically depraved

25

surrogates confounding the distinction between real flesh and artificial renditions and manipulations of it. Projecting apocalyptic, medieval overtones and indications of *memento mori* as well as surreal mixtures of rapture, nightmare, and vertigo, the dense emotive range of these pieces problematizes an interpretation grounded in issues of gender, which may be, in part, a consciously counterindicative response by Sherman to the proliferation of feminist theory that has revolved around her work.

Sherman's invocation of the grotesque approximates writer Mary Russo's discussion of the carnivalesque as defined by "issues of bodily exposure and containment, disguise and gender masquerade, abjection and marginality, parody and excess."[8] Russo continues,

> It is as if the carnivalesque body politic had ingested the entire corpus of high culture and, in its bloated and irrepressible state, released it in fits and starts in all manner of recombination, inversion, mockery, and degradation. The political implications of this heterogeneity are obvious; it sets carnival apart from the merely oppositional and reactive; carnival and the carnivalesque suggest a redeployment or counterproduction of culture, knowledge, and pleasure.[9]

Such a sensibility, strongly evident throughout Sherman's entire corpus of work, also characterizes the work of early twentieth-century German artist Hannah Höch (1889–1978). Through startlingly recombinant photocollages drawn from a variety of sources in the mass media, Höch produced works that function as mordant political critique and social satire as well as more ambiguous, surrealist-inspired, and highly personal images that anticipate some of Sherman's concerns and imagery. Grafting body parts from disparate sources—often focusing on eyes, mouth, teeth, and truncated portions of the face—such works by Höch as *Froeliche Dame (Merry Woman)* of 1923, *Mutter* (figure 9) (*Mother*, from the *Ethnographic Museum* series), and *Angst (Anxiety)*, 1970, the latter deriving from a photograph of a scientific model of a mannequin juxtaposed with a human nervous system, Höch's savage but humorous manipulations of the body are echoed in Sherman's equally wide-ranging subversions of established types and images.

Another twentieth-century artist with whom Sherman's work resonates is Ralph Eugene Meatyard (1925–1972) (figure 10), whose medium was also photography. The disquieting tenor of many of Meatyard's hallucinatory, evocative photographs, many of which use grotesque masks, mannequin body parts, or dolls as props used by human figures within incongruously mundane settings, offers a degree of funereal surreality and a conspicuous reliance on the trappings of artifice approaching those found throughout Sherman's work. While Meatyard's eccentric, highly personal vision differs from Sherman's sense of flamboyance and of the burlesque, a darkly gothic presence pervades both artists' imagery.

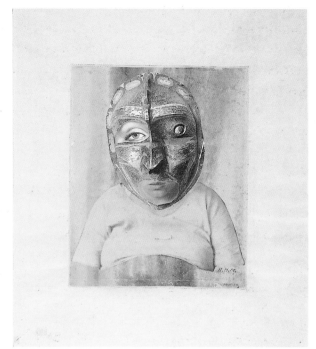

figure 9

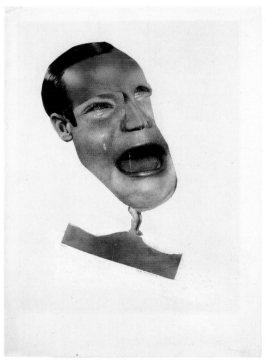

figure 8

figure 8
Hannah Höch
Der Kleine P (The Small P),
1931
Collection Staatsgalerie
Stuttgart

figure 9
Hannah Höch
Mutter (Mother), 1930 from the
series *Aus einem
ethnographischen Museum
(from an Ethnographic Museum)*
Collection Museé National
d'Art Moderne, Centre Georges
Pompidou, Paris (1967)

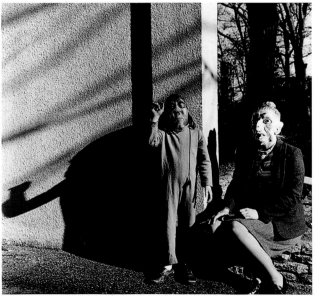

figure 10
Ralph Eugene Meatyard
*Lucybelle Crater and and
one of her good, good Meronian
friend's 7 children—Lucybelle
Crater*, 1969–72
© Ralph Eugene Meatyard
Estate, Courtesy of the Howard
Greenberg Gallery

figure 10

Beyond their common fascination with the use of masks as devices, Meatyard and Sherman have both used similar photographic techniques in terms of out-of-focus effects that impart dreamlike (or nightmarish) states to certain of their images—Sherman in several works of 1994 (*Untitled #310* and *#311*) (plate 142) and Meatyard in untitled images of the early 1960s.

While the filmic origins of Sherman's work have been extensively discussed by other writers, literary precedents have also played a role in the proliferation of horror and the grotesque in Sherman's work, not only the aforementioned Fairy Tales but also the late nineteenth- and early twentieth-century writings of such authors as Ambrose Bierce (1842–1914), whose grim tales of horror evince a clinical fascination with the unspeakable and the otherworldly. Bierce conjured terrifying situations arising in the midst of ordinary, unremarkable lives in a way that parallels Sherman's engagement with similar ideas and subjects in series including Centerfolds and Fairy Tales as well as in her direction of a recent horror film.[10]

The light was powerless to dispel the obscurity of the room, and it was some time before I discovered in the farthest angle the outlines of a bed, and approached it with a prescience of ill. I felt that here somehow the bad business of my adventure was to end with some horrible climax, yet could not resist the spell that urged me to the fulfilment. Upon the bed, partly clothed, lay the dead body of a human being. It lay upon its back, the arms straight along the sides. By bending over it, which I did with loathing but no fear, I could see that it was dreadfully decomposed. The ribs protruded from the leathern flesh; through the skin of the sunken belly could be seen the protuberances of the spine. The face was black and shriveled and the lips, drawn away from the yellow teeth, cursed it with a ghastly grin. A fulness under the closed lids seemed to indicate that the eyes had survived the general wreck; and this was true, for as I bent above them they slowly opened and gazed into mine with a tranquil, steady regard. Imagine my horror how you can—no words of mine can assist the conception; the eyes were my own!

—Ambrose Bierce[11]

In her examination of the meanings of horror and of the abject, Julia Kristeva writes that "far from being a minor, marginal activity in our culture, as a general consensus seems to have it, this kind of literature [horror] . . . represents the ultimate coding of our crises, of our most intimate and serious apocalypses. Hence its nocturnal power. . . . Hence its continual compromising. . . . Hence also its being seen as taking the place of the sacred. . . ."[12] Although Sherman's works succeed in vividly invoking a myriad of terrors, however, they are never really terrifying; their burlesque presence is too potent. Amelia Arenas writes, "More than the experience of watching a horror movie, Sherman's photographs recall the visions that come to haunt us later, reminding us that what keeps the child awake at night after a scary movie is not a story, but an *image*."[13]

While Sherman has consistently used specific artistic, cinematic, or popular media genres as frames of reference—the B movie, the magazine centerfold, the fashion spread, the fairy tale, old master paintings, pornography, surrealist photography, and horror film props—she has always recast them in insidious, transgressive ways with humorous, highly theatrical overtones. Constantly interweaving the real and the artificial, both in her imagery and her choice of genres, Sherman's enthusiastic engagement with the grotesque mocks the conventions of these genres by exaggerating their modes of artifice, offering a stunningly lurid portrayal of the artifacts of the monstrous.

29

Jan Avgikos has offered a provocative assessment of Sherman's work in terms of "the complex present in which we live and struggle to define. . . . We recognize ours as a time of such unparalleled transition and mayhem that science-fiction starts to look more and more like reality." Describing the tenor of Sherman's imagery of the mid-1980s, she continues,

We see a picture of the present that is over-articulated in relation to past and future. We see a picture of genetic engineering and biotechnologies and artificial intelligence and cyberspace and ironic faith, or worlds ambiguously natural and artificial, or creatures simultaneously human and animal and machine. We see a picture of post-gender. We see a picture of a post-apocalyptic ontology.[14]

Sherman's work enmeshes us in this complex and contradictory web of fantasy and reality and in so doing, collapses our comfortable references into a dizzying maelstrom of uncertainty.

Despite their wide temporal and historical differences, the simpering, the freakish, the fatuous, the vulnerable, the depraved, and the panoply of other types that appear in Sherman's comedic catalogue of human experience and fantasy approximate those that populate Goya's *Caprichos*, evincing a corresponding degree of satire and burlesque sensibility and referring to the frightening and disturbing aspects of the dream state. Like Goya, Sherman succeeds in parodying representations of the social—the roles, archetypes, and vainglorious and malignant desires that we create and perpetuate—brilliantly unleashing the monsters produced by the sleep of reason.

Notes

1 The inscription on the preparatory drawing for the image reads: "The author dreaming. His only intent is to uncover prejudicial vulgarities and to perpetuate with this capricious work the solid testimony of truth," in Alfonso E. Perez-Sanchez, *Goya: Caprichos, Desastres, Tauromaquia, Disparates* (Madrid: Fundacion Juan March, 1977), 56.

2 Thomas DaCosta Kaufmann, "The Allegories and their Meaning," in Pontus Hulten et. al., *The Arcimboldo Effect: Transformations of the Fact from the 16th to the 20th Century* (New York: Abbeville Publishers, 1987), 89–108, elaborates on the meanings of Arcimboldo's allegorical symbolic as indicative of a Renaissance idea of systems of accord between the parts of the universe—the macrocosm of the larger world, the microcosm of man, and the body politic—and with specific readings as imperial allegories.

3 Marina Warner, *From the Beast to the Blonde: On Fairy Tales and their Tellers* (New York: Farrar Straus Giroux, 1995), xix.

4 In a series of photographs used as illustrations for *Fitcher's Bird*, based on a fairy tale by the Brothers Grimm (New York: Rizzoli, 1992), Sherman maintains the focus of her imagery throughout the story on the nightmarish, the grotesque, and the portentiously symbolic, despite the book's "happily ever after" ending.

5 Gen Doy, "Cindy Sherman: Theory and Practice," in John Roberts, ed., *Art Has No History! The Making and Unmaking of Modern Art* (London and New York: Verso, 1994), 267.

6 Linda Nochlin argues in *The Body in Pieces: The Fragment as a Metaphor of Modernity* (New York: Thames and Hudson, 1994) that representations of the human body as fragmented, mutilated, and fetishistic bespeak an essentially modernist worldview of loss, crisis, and disintegration; she touches on the work of Sherman, Louise Bourgeois, and Robert Mapplethorpe as emblematic of postmodernist treatment of the fragment, implicating it "as the site of a triumphant reintroduction of the abject in the form of infantile desire and gender-bending metamorphosis" (54).

7 Simon Taylor, "The Phobic Object: Abjection in Contemporary Art," in *Abject Art: Repulsion and Desire in American Art*, exhibition catalogue (New York: Whitney Museum of American Art, 1993), 62.

8 Mary Russo, "Female Grotesques: Carnival and Theory," in Teresa de Lauretis, ed., *Feminist Studies/Critical Studies* (Indiana University Press, 1986), 214.

9 Ibid., 218.

10 *Office Killer*, 1997, marks Sherman's first directorial effort and relates closely to the concerns of her photographic work, as discussed in Phoebe Hoban, "Sherman's March," *Vogue* 187, no. 2 (February 1997): 240–43, 278.

11 Ambrose Bierce, *Ghost and Horror Stories of Ambrose Bierce* (New York: Dover Publications, Inc., 1964).

12 Julia Kristeva, *Powers of Horror: An Essay on Abjection* (New York: Columbia University Press, 1982), 208.

13 Amelia Arenas, "Afraid of
the Dark: Cindy Sherman and
the Grotesque Imagination," in
Cindy Sherman, exhibition
catalogue (Shiga, Japan:
Museum of Modern Art, 1996),
46.

14 Jan Avgikos, "Institutional
Critique, Identity Politics,
and Retro-Romanticism:
Finding the Face in Cindy
Sherman's Photographs," in
Jurgen Klauke, Cindy Sherman,
exhibition catalogue
(Munich: Sammlung Goetz,
1994), 51–53.

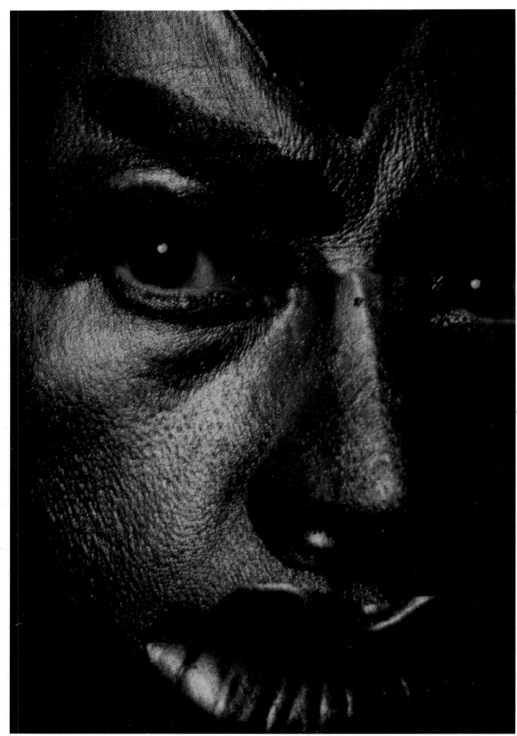

figure 1

Tracing the Subject
with Cindy Sherman

AMELIA JONES

figure 1
Cindy Sherman
Untitled #323, 1995
Collection of
Mr. and Mrs. W. Dexter
Paine III

Much ink has been spilled over Cindy Sherman. Art historians and critics have claimed her as an artist/genius who excavates the human consciousness or as a producer of work exemplifying a postmodern culture of simulation, a feminist negotiation of the male gaze, or the condition of the abject in artistic practice.[1] Instead of attempting to deliver yet another, final, definitive interpretation of Cindy Sherman's work, I prefer to offer here an engaged (rather than "objective") reading of particular Sherman images. I see no reason not to flaunt my partiality to feminism. I begin from the assumption that a body of work produced in and around a subject marked as feminine, within the context of the feminist-inflected postmodern scene, necessarily relates intimately to what I conceive as a feminist problematics of the subject.[2]

Drawing on feminism as well as phenomenology, I also suggest here that Sherman's work participates in a particular mode of performative artistic production typical of post-1960 body-oriented practices: a mode in which the subject of making is *enacted* through representation rather than *veiled* as in the modernist project. This mode proposes a new relation of artist/viewer engagement that might be linked to the phenomenological idea of the *chiasmus*: the way in which embodied subjects intertwine through the regime of a visibility that itself turns the world into flesh. That is, while one subject sees another, the subject in seeing is also seen and so made flesh. The "seeing that I am" becomes "really visible," and "I appear to myself completely turned inside out under my own eyes."[3] Read in this way (within the dual frameworks of feminism and phenomenology), Sherman's work can be seen to encourage an opening of the viewer/artist relation such that the viewer (or, more accurately, participant) "turns inside out," experiencing her investments and desires relative to the figures enacted in Sherman's work.

In this essay, I want to offer an historical framing of Sherman's work in relation to several other twentieth-century artistic practices that perform the particularized body (marked in relation to the very structures of representation as gendered, sexed, raced, classed, etc.) in the grasp of the photographic eye. Through these historicized vignettes, I attempt to stress something that has to my knowledge been overlooked in the voluminous writings about Sherman: the situatedness of her work—its embeddedness in a rich context of work (much of it feminist) addressing the ontology of the subject and the politics of its identifications through the enactment of the artist's body (the relationship of the self to the world and its others, and the role of representation and reproducibility in conditioning the particularized subject). This strategic comparison of images is offered as a way of using Sherman's work as itself a *lens* through which to view contemporary art and its ongoing concern with the profound issues of the structures of the self—with how we experience and conceive ourselves in the contemporary world.

The Projective Eye: The Constitution of the Body as Object
As theorized in the 1970s and 1980s, the projective eye is understood to be violent and penetrative. It gazes purposively and captures its victims in its vise grip; it is a simple but effective tool for the constitution of those without a penis as pathetic specks pinioned by its inexorable force-lines. As John Berger writes in his well-known 1972 book *Ways of Seeing*: "*men act* and *women appear*. Men look at women. Women watch themselves being looked at."[4]

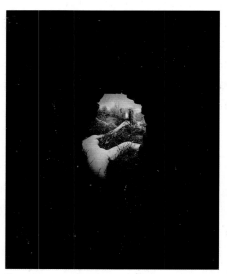

figure 2

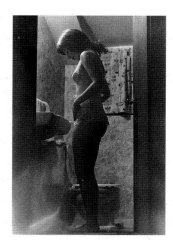

figure 3

figure 2
Marcel Duchamp
Interior view of *Étant donnés*, 1946–1966
Philadelphia Museum of Art: Gift of the Cassandra Foundation

figure 3
Cindy Sherman
Untitled Film Still #39, 1979
Collection of the artist
Courtesy Metro Pictures, New York

According to theories of the projective eye, there are three ways in which its victims take their place relative to it: they internalize this penislike eye, construing themselves as passive *effects* of its propulsive force; they aggressively enact themselves according to the very rules it has established; or they confuse its potentially disempowering effects by throwing the gaze back on the viewer. (None of these is "intentional" in its enactment—the "victim" may or may not recognize the effects of her particular relation to the projective gaze.) The third case turns the eye into something other than projective, and that will be the subject of the last part of this essay.

In the first case, we have the confirmation of feminism's model (per Berger or Laura Mulvey) of how femininity has conventionally been produced within the logic of the so-called *male gaze* through the dynamics of fetishism and scopophilia (in this scenario, Mulvey famously writes, "[w]oman . . . stands in patriarchal culture as a signifier for the male other, bound by a symbolic order in which man can live out his fantasies and obsessions . . . by imposing them on the silent image of woman still tied to her place as bearer, not maker, of meaning"[5]).

In the second case, we have the example of a *masquerade* (that is, the production of the self as the thing most expected—but marking this thing as *fake*). In the masquerade, the victim exaggerates the very modes of passivity and object-ness projected onto her via the male gaze; here, she might be able to open up the closed circuits of desire this eye has attempted to establish via its penetrative thrust through a kind of restaging of exactly what is expected of her. Mary Anne Doane reworked Joan Riviere's 1929 theory of feminine masquerade in an important 1982 essay "Film and the Masquerade," writing "[t]he masquerade, in flaunting femininity, holds it at a distance. Womanliness is a mask which can be worn or removed. The masquerade's resistance to patriarchal positioning would therefore lie in its denial of the production of femininity as closeness . . . as . . . imagistic."[6]

It is important to note that the projective eye is not a transcendent function waiting to be revealed in its true effects through these three models. The understanding of the world as congealed through a mastering gaze has its own history. This gaze was mechanized through the apparatus of the camera and its prototypes; the camera instrumentalizes the dualistic logic of Cartesian or Enlightenment conceptions of subjectivity. I'm here—you're there; I have a camera (an industrialized nation behind me)—you, without the tools of capitalism, are dominated by me. For the Enlightenment subject, "man is a machine" oriented toward the conquering of otherness through vision, and all must be arrayed before the projective (camera) eye in order to be made

visible: "[o]mnivoyance, Western Europe's totalitarian ambition, may here appear as the formation of a whole image by repressing the invisible."[7]

It is for this reason (the long history of the development of the photographic as a research and development arm of patriarchal, imperialist Western society) that the object of the projective camera eye at first knows only how to perform within the space allotted by this projective gaze. Within the logic of this model, the object—like Marcel Duchamp's dead and wounded female "Given"(figure 2)—folds herself into its rigid scopic armature (a double-edged erotic moment: she is both caressed and repudiated, thrown back into the two-dimensional surface of "picture" that is femininity, blackness, and/or otherwise other). Duchamp, like Sherman, exacerbates the structures of the gaze, encouraging the viewer to feel his participation in the oppressive erotics of voyeurism.

Masquerade: Playing into the Projective Gaze

The artistic masquerade has its own history. As the twentieth century advances—paralleling the increasing challenges to the colonizing, patriarchal gaze of the West—the strategic value of playing the game all too well (per the exaggerations of the masquerade) becomes increasingly clear. Artists of all kinds, especially, acknowledge how performance of the very codes by which the projective eye confirms its authority can deflate its overblown claims of conquest. Masquerade becomes increasingly common and then, toward the end of this century, a nearly dominant mode of self-production (since the 1960s, this explodes into popular culture as well). From the aesthete (Oscar Wilde at the turn

figure 4
Man Ray
Barbette, 1926
The J. Paul Getty Museum,
Los Angeles, California

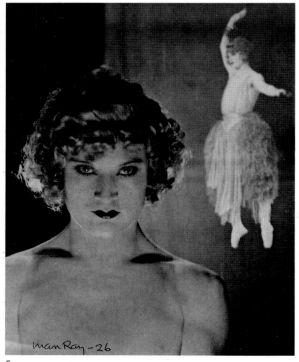

figure 4

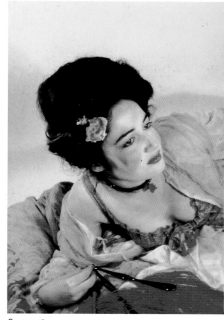

figure 6

figure 5

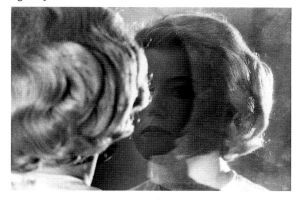

figure 5
Cindy Sherman
Unititled Film Still #56,
1980
Collection of the artist
Courtesy Metro Pictures,
New York

figure 6
Dori Atlantis
Victorian Whore, 1970
Model: Karen LeCoq
Photograph ©Dori
Atlantis

of the century),[8] to the cross-gendered characters of the surrealists'
extended drama (with "Barbette" (figure 4), a transvestite acrobat,[9] the
better known Duchampian Rrose Sélavy, and Claude Cahun as interesting
examples of how cabaret met the avant-garde through eroticized
and simulated feminine/masculine bodies), to—in the post 1960 period—
the explosion of flamboyant self-displays with Yayoi Kusama's obsessive
self-imaging as exotic (Japanese/female) pinup, Urs Lüthi's bizarre
self-performances as both self and other,[10] and Andy Warhol's perversely
swish self-performance as the antithesis of Jackson Pollock's virile but
veiled modernist body: the performance of the intersection of gender and
sexual orientation has played a major, if suppressed, role in transforming
modernism (with its fantasy of a coherent Cartesian subject) into
a postmodernism enacted by dissolved, nonnormative subjects marked
in their particularities.[11] Sherman, like Barbette, dissolves herself into
exaggerated and so apparently fake femininity.

Specifically, in the historical dimension (which is not to be understood
here as teleological, causally determined, or purposive but rather
as a web of looping eventualities) the time of Sherman's opening salvo into
the art world (the *Untitled Film Stills*) is the end of the 1970s, and the
context is an art world that has begun to spawn groups of disaffected,
mistreated "objects" who want to become subjects of art. The body,
through which we experience ourselves in the world, is at this time begin-
ning to be understood as an *historical idea*, with the ideas of
phenomenologist Maurice Merleau-Ponty and other French theorists
increasingly popular in the art world: "my body . . . is what opens

me out upon the world and places me in a situation there."[12] The performance of the body is thus seen to be a way to interrogate the social situation of the subject and is, correspondingly, adopted as a key strategy for feminists and other artists intent on addressing the particularities of their bodily codings (per 1970s identity politics, primarily gays and lesbians, blacks, Asian-Americans, and Chicanas/os). The performative and activist body merge.

38

With the specifically feminine masquerade, the "victim" takes on with a vengeance all of the myriad surfaces of femininity, which the gaze wants to corral into "woman." She reiterates femininity with a twist, opening the formerly sutured gap between its conventional codes and the bodies these codes are designed to fix as "female."[13] The early excursions into self-performance on the part of the formative Southern Californian feminist art movement were explicitly posed in written documents as attempts to explore stereotypical feminine identities so as to produce new, positive images and experiences of femininity (Arlene Raven proclaimed from her base in Los Angeles that feminist artists aimed to construct "[p]ositive role models, role-free images, and equalized Feminist social structures"[14] in their work). Yet, regardless of the stated "intention" (however it may now be interpreted), these exploratory performances—such as Karen LeCocq's overheated masquerade as a "Victorian Whore" (figure 6)—can be seen as enacting the collapse of femininity into image that Sherman's work would be soon to address, paradoxically pulling it apart through this exaggerated enactment in the masquerade.[15] Regardless of where Raven, LeCocq et. al. believed their identities to reside, these images handed down to us can only be grasped as failures to secure a transparent relation between appearance and essence (thus, LeCocq's whore is pressed into the two-dimensional surface of the print: performing and so taking apart the conflation of "woman" and "image," opening a gap for spectatorial engagement but definitively not promising positive interpretations).

Performing Gender

The adoption of femininity as a sign of the ways in which particular subjects are allowed to experience themselves produces the subject (whether anatomically male or female) as an object trapped within the inexorable purview of the projective gaze. But as the 1970s and 1980s progressed, artists began to explore femininity as not only the sign of oppression but as an indication of the performativity of sexuality and gender, specifically in relation to oppositional structures (male/female, hetero-/homosexual) staged conventionally via the projective eye (in Judith Butler's terms, gender and sexuality are "performative" processes designating the "very apparatus of production whereby the sexes themselves are established").[16] Thus, Sherman's *Untitled Film Stills*,

initially presented within the context of these theoretical paradigms of the male gaze and the masquerade, deploy technologies of envisioning the subject (photography and film) to explore the particular ways in which these function for bodies marked as female. Reading the masquerade in a slightly different way from Doane, Judith Williamson argues persuasively that, by *enacting* herself, Sherman proves femininity as it is conventionally construed to be nothing but a surface effect that gives an illusion of depth: "To present all those surfaces at once is such a superb way of flashing the images of 'Woman' back where they belong, in the recognition of the beholder. Sherman's pictures force upon the viewer that elision of image and identity which women experience all the time."[17]

As Williamson suggests, because femininity is produced as a surface effect (through visual codes), its enactment through representation is redundant. By enacting the feminine through representation (the visual structures of the projective eye), the artist doubles the effect of the feminine, perhaps making it seem somewhat strange and constructed, and also encourages the viewer to make note of "that elision of image and identity which women experience all the time."[18] Sherman's early pictures (especially the *Untitled Film Stills*) are notable precisely in that they interweave the 1970s feminist production of the subject as an effect of the gaze with the twentieth-century exploration of the subject (via masquerade) as a production of adopted and often exaggerated particularities (marked in terms of gender, sexuality, race, class, etc.).

In spite of the contortionist attempts by some writers to deny the relationship of Sherman's *Untitled Film Stills* to the particular feminist fixation on the projective eye in 1970s practice and theory, I cannot imagine how one can avoid considering the way in which many of the *Untitled Film Stills* seem explicitly to stage the positioning of the female subject as an effect of the projective eye. At the same time, this effect is never simple or consistent. While *Untitled Film Still #39* (figure 3) produces "femininity" as contained within the conventional structures of the gaze (trapped in the architectural spaces of the projective eye and either, depending on your point of view, confirming or dissecting "the phantasmagoric space conjured up by the female body"),[19] in *Untitled Film Still #56* (figure 5) Sherman is staged as "mirror" for the viewing subject and her image collapses into the surface of the print. In both images, the choreography of the gaze seems duly noted: one image (#39) engages the viewer, but through structures of voyeurism that are so familiar they might produce a relation of comfort as easily as one of estrangement; the other (#56) both engages and repels the projective eye. The face of the woman is so close, it becomes absorbed in the very surface of the image (exacerbating the ideological collapse

Williamson and Doane noted between "image" and "woman"). It is as if we are leaning in closer and closer to view (to master) a woman's face only to realize that, in immediate proximity, it becomes a blur (blocked, in fact, by the back of her head or by the sheen of the picture itself). Or, it is as if we are attempting to see *ourselves* in the mirror (of her face) but are blocked from so doing by *her* head and visage. The picture insistently renders Sherman (whoever that may be) in the indexical thickness of her body's apparent "presence" and simultaneously blocks both our identification and our projection through the recalcitrant surface of the print/her body.

The picture throws the gaze back onto itself in a gesture Duchamp explored as a "mirrorical return" (where the image in the mirror and the viewer bounce "gazes" back and forth, producing the flesh of one another).[20] In this way, I see Sherman's *Untitled Film Stills* and subsequent Rear Screen Projection series as setting the stage for her entire body of work's performance of the sexual subject *as an effect of the other* (the "fleshed" body/self whose identity is a projection of its embodied and desiring observers). Ultimately, as I experience it, Sherman's practice participates in what I have argued to be the opening of the subject to otherness (the baring of the circuits of desire connecting self and other in a dynamic of intersubjectivity) that gives what we might call postmodernism its most remarkable and particular antimodernist thrust.[21] In feminist and phenomenological terms, the body, which instantiates the self, is a "modality of reflexivity," posing the subject in relation to the other in a reciprocal relationship; through gendered/sexual performances of the body, the subject is situated and situates herself through the other.[22] The subject, then, is never complete within itself but is always contingent on others, and the glue of this intersubjectivity is the desire binding us together (the projective gaze is one mode of intersubjectivity but functions specifically to veil this contingency by projecting lack onto the other rather than admitting its own). It is the intersubjective dimension of Sherman's work that has largely been ignored (not surprisingly, since it exposes the investedness and contingency of every reading of her pictures—including this one).

Sherman's Rear Screen Projection series exemplifies this ambivalence (the fulfilling and refusal of projective/identificative desires) as well. In *Untitled #66* (figure 7), Sherman is propelled outward from the fake backdrop—staged in relation to the vanishing point marked by the perspectival force-lines of the receding street. Sherman is both thrown into and cast out of the projective eye: she is both "viewed" and "viewer" (staged "before" the scene like a spectator). But in *Untitled #76* (figure 8), raising a liquid-filled bottle to her mouth, she is both flattened against and ancillary to the artificial environment. Her head protrudes only slightly

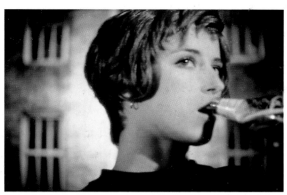

figure 8

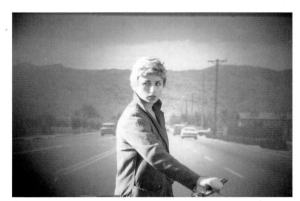

figure 7

41

figure 7
Cindy Sherman
Untitled #66, 1980
Collection of the Art Gallery
of Ontario, Canada

figure 8
Cindy Sherman
Untitled #76, 1980
The Carol and Arthur
Goldberg Collection

from the patently unreal, blurry building façade behind—a low relief gargoyle marking both the flatness and textured dimensionality of its surround (the photograph suggests that the female subject is beginning to be experienced and viewed as dimensional rather than simply a point of projected desire).

And finally, in the 1981 Centerfold series, Sherman—not quite ready to move out from under the grip of the projective gaze—mimics the format of magazine pornography in *Untitled #96* (figure 10) by smashing herself flat and phallic, to be "read" across the open spread (spread legs?) of the glossy porn-turned-art mag *Artforum*, a "pimp" prostituting art (here the female body) as commodity.[23] As if to emphasize this point, she performs herself as a flat-chested adolescent dressed in 1950s clothing (signifiers of nostalgia deployed in most of the *Untitled Film Stills*), clutching a crumpled piece of paper. The paper is a just blossoming sprout protruding from her groin, while her body is pinioned flat against the page as if under a rigid sheet of glass.

While Barbara Kruger, in this signature work *Untitled (Your gaze hits the side of my face)* (figure 9), attempts to stop the projective eye in its vicious path through the Brechtian strategy of using interruptive text against the seductive effect of the image, Sherman continues to negotiate: "Your gaze hits the (resistant) flat of my body." Sherman enacts the gaze's spaces of desire—but in so doing, slows it to a crawl.[24] The turgid, inexorable two-dimensionality of this body splayed across the "spread" doesn't just mimic the path of the gaze (reiterating, as Laura Mulvey has argued, "the

figure 9

figure 9
Barbara Kruger
*Untitled (Your gaze hits
the side of my face)*, 1981
Courtesy of Mary Boone
Gallery, New York

figure 10
Cindy Sherman
Untitled #96, 1981
Collection of Robert and
Jane Rosenblum,
New York

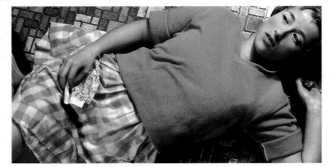

figure 10

'to-be-looked-at-ness' of femininity"), it slavishly subordinates itself to
"the texture of the photographic medium itself,"[25] and thus reiterates too
expertly the collapse of image into identity that is the feminine. Kruger's
image uses words to produce depth. Sherman's image *refuses* depth to pro-
duce femininity as all surface, but this surface merges with its context
(here marked explicitly as that of the pornographic centerfold).[26] The
beaver/pubis *is* the gutter (of the magazine); the female body *is* the slick
surface of the photographic image: unattainable and impenetrable.

Moving to the late 1970s into the 1980s: dominant art discourses
begin to theorize a structure of viewing that was thought to have informed
the previous long history of image-making since the Renaissance and,
for at least ten years, the art world is in thrall to the idea of the projective
eye, with its aggressively dualistic politics of self and other and
its reduction of the self/other relation to a two-dimensional dance of
eye/picture. But exploring the dichotomous effects of this projective eye
is, apparently, both a way of producing the very gaze it seeks to
explore and, ultimately, a very productive way of getting somewhere else.
After this, in the mid-1980s, Sherman thus suddenly explodes herself
beyond flatness and beyond the architectural spaces of the projective eye.
In so doing, she returns to the *exchange* of subjectivities that she
had first addressed in relation to the mirror, where sexuality, as "both
reflexive and corporeal, as signifying a relation between the embodied
subject and others," is enacted as "a mode of situating oneself in terms of
one's intersubjectivity."[27]

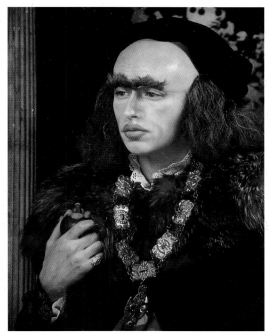

figure 11
Cindy Sherman
Untitled #213, 1989
Collection of The Birmingham
Museum of Art, Birmingham,
Alabama; Museum purchase
with funds provided by
the Acquisitions Fund and
Rena Hill Selfe

figure 11

The Hole Eye: The Dissolution and Particularization of the Body/ Self

The History Pictures seem to me to mark in interesting ways the transition
from a projective eye to a "hole eye," from a perspectival rendering
of (female) bodies in architecturally conceived spaces (two-dimensional
renderings of three-dimensional containers), to a free-fall explosion
of dissolved bodies in non-perspectival, metaphorically open space. The
History Pictures are still, in fact, "pictures" as this is generally
understood (two-dimensional, rectangular in shape, vertical in emphasis
like the standard portrait) but, even lodged within the frame with
their deployment of obviously fake body parts, they begin to suggest what
has been called a kind of formlessness: the pictures elaborate a
slippage of body parts downward, which has been said to suggest "the
field of a desublimatory, horizontal axis that erodes the façade of the verti-
cal, bearing witness to the fact that behind that façade there lies not the
transparency of Truth, of meaning, but the opacity of the body's matter,
which is to say the formless."[28] But this "formlessness" of the body
is not vague or abstract but always already experienced in its particularity,
as I interpret Sherman's exacerbatedly artificial personae (clearly
marked in terms of gender and class in the History Pictures) as suggesting.

Further, Sherman's practice seems to me to put the lie to the idea
that the body, its representations, or its orientation are façades hiding the
opacity or formlessness of the body (themselves offered as a kind of
"truth" in the above claim). Rather, while the *Untitled Film Stills* seem to
enact the (female) subject as an effect of a projective vision (a "subject"
paradoxically defined through objecthood via an external gaze), I under-

stand Sherman's History Picture project as suggesting that the "façade" here *is* the body (which in turn, phenomenologically speaking, *is* the self as we experience it from the outside as well as internally). Thus, Sherman's "Renaissance Man" in *Untitled #213* (figure 11) is not just a "dis-corroboration" of the vertical axis of the sublimated image of Renaissance through modern portraiture, but a "dis-corroboration" of the very idea of the subject as externally defined via a congealing, projective eye.[29] Correlatively, the picture is a "dis-corroboration" of the kind of reading that would stage its type as a critique of Truth even while confirming the Truth value of the interpretation itself.

As I read Sherman's image, it thus specifically engages again the trajectory of exploration stemming out of feminist art theory and practice in the 1970s and 1980s (perhaps most specifically not only gaze theory but the "images of women" discourse that attempted to look back into art history or into popular culture to judge images of women as either "positive" or "negative"[30]— clearly this man/woman is neither). The images are still, as noted, definitively pictorial, staging subjects within the vertical purview of the painterly portrait, and yet the body of the subject of the picture, in *Untitled #213* anointed with attributes that look simultaneously too "real" and too much like they came from a cheap costume shop (fur collar, metal necklace, gray hair/wig, hand clutching fruit), begins to propose a viewing relation that is *engaged* rather than antagonistic.

In the History Pictures, there is an ambivalence vis-à-vis the viewing eye. The eye is seduced by the exaggerated textures of the "subject" rather than simply mimicked in its projective effects. The body/self of the spectator is still posed as exterior gaze; but, through a kind of mirroring (itself proposed through the conventionality of the pictures' portrait format), the body/self of the spectator is also absorbed into the picture. Like the body/self of the depicted subject, the viewer becomes both fully embodied and fragmented, artificial. Far from being a "façade" with a "formless" interior, our embodied subjectivities become dissolved *in relation to each other* (the History Pictures' subjects are opened to the subjects of viewing: we constitute one another). That is, moving away from the structures that explore or confirm an external gaze that defines the (female) subject as object, here, the pictures, with their almost sculptural but artificial "deep space," propose subjects that point to the fact that we are never coherent in ourselves but always take meaning from the others whose significance we in turn project. (A dynamic, not incidentally, that could be said to describe the hidden mechanics of art history as a discipline.)[31]

Untitled #180 (figure 13): The human face is a pit of fossilized flesh that sucks in rather than beckons the gaze; it is, literally, guttered in the center, rendered as "spread"/hole rather than whole. *Untitled #175* (figure 12): The (female) body is illustrated as either totally interior (vomit) or totally exterior (reflec-

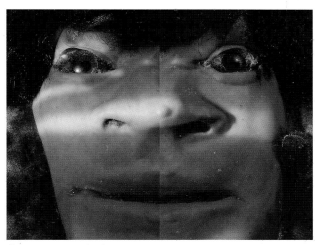

figure 13

45

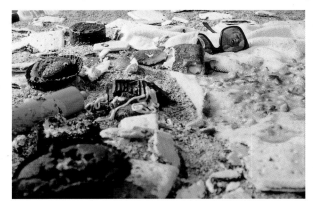

figure 12

figure 12
Cindy Sherman
Untitled #175, 1987
Collection of the artist
Courtesy Metro Pictures,
New York

figure 13
Cindy Sherman
Untitled #180, 1987
Collection of The Eli Broad
Family Foundation, Santa
Monica

tion), tracing the trajectory of "food" within the feminine (where food is the lever through which external body image is controlled as well as being the matter, "originally vested in the other [the mother]," marking the mingling of self and other).[32] The splattering of the body/self across the picture plane itself *consumes* the gaze of the viewer, opening up the dialectic of inside and out that establishes the difference between self and other. The horizontal register elaborates not just the "formless" but the space of traditional *history painting*, where subjects are rendered not as "individuals" (per the portrait) but splashed across imperial vistas dominated by the perspectivally symbolized force of the nation/gaze.

Suddenly (or it may *seem* suddenly if you haven't been watching and waiting all along), the projective eye becomes blinded. We start to feel we can laugh at it and even poke fun at our own obsessive fixation over its "power": enough of the fetish already. The eye itself begins to be "viewed" from the inside and out as a hole (like, in fact, the torn aperture through which Duchamp stages his "Given" female nude). It no longer projects lightning flashes of power (like a ray-gun in a B movie) but sucks in. It begins to *comprehend* (from *prehendere*: to grasp; meaning "to take in or embrace").[33] Open to its grasp (it sucks and pulls rather than penetrating or wounding), those who used to think of themselves as victims of the projective eye (pinioned like dead butterflies at the center of its sharp point [of view]) now fling themselves into the hole eye (they're not only "there," at the center of the gaze's trajectory; now they're here, there, and everywhere). They no longer "pose" or "perform" but, rather, spew outward jubilantly, dissolving in the juicy and succulent embrace of the hole (eye). They are both dispersed and insistently embodied as well as specific.

figure 14

figure 15

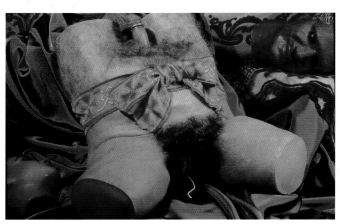

figure 16

46

Sherman's exploded selves—the vomit and sex dolls—in the work of the late 1980s and 1990s have a place within a trajectory of mutilated and grotesque bodies in twentieth-century art history. While Hans Bellmer has been invoked as a singular origin for Sherman's Sex Pictures,[34] one might just as easily stage them in relation to another—feminist— trajectory. Women and gay male artists have, for one reason or another, often resorted to bodily fragments as a way, perhaps, of exploding the congealing, external force of what might appear to be an inexorable (heterosexual male) gaze. Thus, while Bellmer mutilates doll bodies that most often appear to be female, and that still propose what Mulvey would call a fetishistic relation (whereby the female body is broken into sexualized bits or fetishes to allay anxieties about male subjectivity, wholeness, and power),[35] artists from Meret Oppenheim to Louise Bourgeois to Jasper Johns to Hannah Wilke, Lynda Benglis, Kiki Smith, Annette Messager, Mona Hatoum, Robert Gober, Faith Wilding, and Sutapa Biswas have produced fragmented bodies (of all types) that produce an effect of the eye as hole (dark continental abyss where the coherent subject dissolves in engagement with others who are highly marked in their gendered, sexed, raced, and class particularities).

While Lynda Benglis (figure 14) and Kiki Smith (figure 15)—paralleling
Marcel Duchamp's sexual objects of the 1950s[36]—draw on the three-
dimensionality of sculpture to merge concavity and convexity into a con-
fusion of sexual parts, Sherman (as always) makes use of the illusionary
space of the photograph to stage the merging of female and male
into a repulsive amputated erotic object (subject?). In *Untitled #263* (figure
16), Sherman extends the earlier feminist project of rendering the body in
fragmented parts to produce a mutant sex body that is dangled in the
abyss of a gaze that takes place everywhere at once.[37] While we look from
"outside" at the picture as a theater of perverted desire (the penis
ringed, the cunt stuffed with a tampon), it is looked at from within by two
mannequin heads—one of which hides its gaze from us, the other of
which (clearly male) confronts us at the same time as it soaks in the gross
rubber body/bodies of desire. The ultimate point of this picture for me is
the production of the male gaze itself *within the picture* and *as an object.*

Specifically viewed within the history of feminist and gay male uses
of fragmented bodies (which explode the projective space of the male
gaze into a hole), Sherman's latest work can be seen as producing a
subject that complicates the projective thrust of the gaze that was
theorized and no doubt experienced by nonnormative subjects well into
the 1980s. It seems to me that all of her series use the technology
of photography (which, again, was developed precisely out of the
compulsion to master the world through a monocular gaze) to stage
scenarios that engage or repulse this projective eye in one way or another,
ultimately turning it inside out (into the sucking hole eye). Most
important, I think, her work always poses itself (and "itself" is most often
Sherman, as she collapses the artist into the work) in relation to the
structures not only of "viewing," per se, but of the intersubjective engage-
ments that constitute us as bodies/selves in the social arena. Her
project I thus determine (through my own projective desires) to be fully
feminist—inasmuch as it insists upon the picture (the "woman" in
Williamson's terms) as constituted via a circuit of particular identities and
desires. (Even her ostensibly "male" characters, as in the "Renaissance
Man" History Picture noted above, wear a masculinity that appears as but
a thin gloss on their reference to the "female" subject Sherman.)

Finally, after a hiatus of a few years (where the body part reigned in
grotesque yet somehow erotically engaging scenarios of desire), Sherman
has returned insistently to the face. The face is either "real" and
made to look like a mask (*Untitled #323*) (figure 1) or it is a mask that
nonetheless (like Gilbert Stuart's *Washington* or the *Mona Lisa*) looks out
with an uncannily affective gaze (*Untitled #314F*) (figure 17). The face fills
the space of the picture, which itself more than fills the space of our vision
(these, like the last several series, are large, over-life-size images). Feeding

47

figure 17
Cindy Sherman
Untitled #314F, 1994
Collection of the artist
Courtesy Metro Pictures,
New York

figure 18
Cindy Sherman
Untitled #184, 1988
Robert Shiffler Collection
and Archive,
Greenville, Ohio

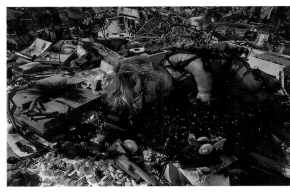

figure 18

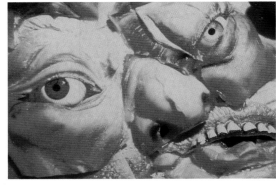

figure 17

the voracious hole of our gaze, they also incorporate us in their shiny (*Untitled #323*) or gooey and rubbery (*Untitled #314F*) surfaces, which are also depths. Thus, the black face—in its both particular ("black") and blandly neutral appearance—reverses into concavity, embracing our gazing visage rather than serving as its object (as the "black face" has long been forced to do, whomever has engaged it).

Never full within itself, never clear in its signifiers or their signifieds, the picture is one element in a dynamic and ongoing system of our production as social subjects. We are never just a gaze nor are we ever only objects; we cannot, in the post-1960 era, think ourselves outside of feminism, nor, for that matter, out of the awareness of black consciousness, the Chicana/o movement, gay/lesbian rights, etc. (one might well ask why we would want to). Rather, as the work of artists such as Sherman suggests, we constitute ourselves as embodied subjects through technologies of representation in relation to other embodied subjects (whom we nonetheless may *want* to see simply as "pictures" to make the world seem a less threatening place). The very "fact" of our embodied vision (which Sherman engages so explicitly in every one of the series) entails not our coherence and self-sufficiency but our reliance on the other, and points to the particularities of how the circuit of intersubjective identifications and repudiations take place. As Merleau-Ponty argued, "it is necessary that the vision . . . be doubled with a complementary vision or with another vision: myself seen from without, such as another would see me, installed in the midst of the visible, occupied in considering it from a certain spot . . . he who sees cannot possess the

visible unless he is possessed by it, unless he *is of it* . . . "[38] Fully technologized *through photography*, we must recognize our participation in the effects of such seeing.

This rumination offers itself as a provisional and suggestive formulation. It revels in its failure to cohere into a convincing new picture of Sherman, just as it reads her work as strategically failing to cohere the (female) subject and, in so doing, assisting in the production of a new eye: one that embraces rather than penetrates, one that sucks and gleams rather than projecting, one that offers the possibility of new subjects of vision who mold themselves into the intersubjective mask of blackness (for example) rather than attempting to master blackness as other.[39] At the same time, I take Sherman's work as a challenge to acknowledge the contingency of my readings on my very pointed (feminist) investments and desires.

49

Notes

1 As Abigail Solomon-Godeau points out in her essay "Suitable for Framing: The Critical Recasting of Cindy Sherman," *Parkett* 29 (1991): 112–115, critics such as Peter Schjeldahl, Lisa Phillips, and Arthur Danto have written about Sherman in universalizing terms; I made the same argument vis-à-vis Donald Kuspit's description of Sherman as an exemplar of "the new subjectivism" in my essay "Postfeminism, Feminist Pleasures, and Embodied Theories of Art," in *New Feminist Criticism: Art, Identity, Action,* ed. Joanna Frueh, Cassandra L. Langer, Arlene Raven (New York: HarperCollins, 1994), 24. Sherman's work was consistently defined as paradigmatic of the use of photography to explore postmodern simulation in essays from the late 1970s and 1980s such as Douglas Crimp's "Pictures," first published as an exhibition essay then expanded in *October* (1979) and reprinted in *Art after Modernism: Rethinking Representation,* ed. Brian Wallis (New York: New Museum of Contemporary Art and Boston: David R. Godine, 1984), see 180–181. This formulation of Sherman's work is extended in Rosalind Krauss's *Cindy Sherman: 1975–1993* (New York: Rizzoli, 1993), and Sachiko Osaki's "Cindy Sherman's *History Portraits,*" in *Cindy Sherman* (Shiga, Japan: Museum of Modern Art, Shiga, 1996), 38–44. Laura Mulvey's "Visual Pleasure and Narrative Cinema" (published in *Screen* in 1975), reprinted in *Visual and Other Pleasures* (Bloomington and Indianapolis: Indiana University Press, 1989), 14–26, set the stage for feminist theories of the male gaze. Her more recent essay on Sherman to a certain extent draws on this earlier theory of voyeurism. See Mulvey, "A Phantasmagoria of the Female Body: The Work of Cindy Sherman," *New Left Review* 188 (July/August 1991): 136–150. In the 1990s, Sherman's work has been discussed in relation to "formlessness" and abjection. See Mulvey, "A Phantasmagoria"; Krauss, *Cindy Sherman*; Amelia Arenas, "Afraid of the Dark: Cindy Sherman and the Grotesque Imagination," in *Cindy Sherman* (Shiga: 1996), 45–48; Rosemary Betterton, "Body Horror? Food (and Sex and Death) in Women's Art," in *An Intimate Distance: Women, Artists and the Body* (New York and London: Routledge, 1996), 130–160; and Simon Taylor, "The Phobic Object: Abjection in Contemporary Art," in *Abject Art: Repulsion and Desire in American Art,* Craig Houser, Leslie C. Jones, and Simon Taylor (New York: Whitney Museum of American Art, 1993), 59–83.

2 I will try to avoid the suggestion that the feminism of Sherman's work somehow *inheres* in its structures—I want to suggest its feminism is contextual and linked to the work's openness to and encouragement of spectatorial engagement.

3 Maurice Merleau-Ponty, "The Intertwining—The Chiasm," in *Visible and the Invisible,* ed. Claude Lefort, trans. Alphonso Lingis, (Evanston: Northwestern University Press, 1968), 143. Feminist phenomenological models have informed my reading of Sherman's work: see Luce Irigaray, 'The Invisible of the Flesh: A Reading of Merleau-Ponty,' *The Visible and the Invisible,* "The Intertwining—The Chiasm," in *An Ethics of Sexual Difference,* trans. Carolyn Burke and Gillian C. Gill (Ithaca: Cornell University Press, 1993), 151–184; Iris Marion Young, "Throwing Like a Girl: A

Phenomenology of Feminine Body Comportment, Motility, and Spatiality," and Judith Butler, "Sexual Ideology and Phenomenological Description: A Feminist Critique of Merleau-Ponty's *Phenomenology of Perception*," and *The Thinking Muse: Feminism and Modern French Philosophy*, ed. Jeffner Allen and Iris Marion Young (Bloomington: Indiana University Press, 1989), 51–70 and 85–100.

4 John Berger, *Ways of Seeing* (London: British Broadcasting Corporation and Harmondsworth: Penguin Books, 1972), 47. Berger's rather simple but crucial early formulation is expanded by Mulvey in her well-known "Visual Pleasure and Narrative Cinema."

5 Mulvey, "Visual Pleasure and Narrative Cinema," 15.

6 Mary Ann Doane, "Film and the Masquerade: Theorizing the Female Spectator," in *Femmes Fatales: Feminism, Film Theory, Psychoanalysis* (New York and London: Routledge, 1991), 25. Doane's essay, like Mulvey's, was originally published in *Screen*, one of the major sites for the development of feminist psychoanalytic theories of the gaze.

7 "Man is a machine," according to Julien Offray de la Mettrie in his fascinating Enlightenment treatise *L'Homme Machine* (Man a Machine) 1748 Leyden Edition [first edition], trans. Gertrude C. Bussey, M.W. Calkins (La Salle, IL: The Open Court Publishing Co., 1961). The latter quotation is from Paul Virilio, *The Vision Machine*, trans. Julie Rose (Indianapolis and Bloomington: Indiana University Press, 1994), 33.

8 I discuss Wilde, aestheticism, and dandyism in my essay "'Clothes Make the Man': The Male Artist as a Performative Function," *Oxford Art Journal* 18, no. 2 (1995), 21–22.

9 In his contemporaneous study *Men in Women's Guise*, O. P. Gilbert discusses Barbette as resembling "an American girl," and notes the popularity of such male to female cross-gendering in theatrical settings during the teens and 1920s. See O. P. Gilbert, *Men in Women's Guise*, trans. Robert B. Douglas (London: John the Bodley Head Ltd., 1926), 270.

10 Lüthi, a Swiss artist, performed himself in numerous guises ranging from the hyper-feminine to absurdly masculine (with masks, shaved head, and/or making faces) in photographs from the 1970s up to the 1990s; often these were done in elaborate architectural scenarios and with female collaborators playing equally strange roles. See *Urs Lüthi—Tableaux 1970–1984* (exhibition organized by le Fonds Régional d'Art Contemporain des Pays de la Loire, 1984), and Rainer Michael Mason, *Urs Lüthi: l'oeuvre multiplié: 1970–1991* (Genève: Musée d'art et d'histoire, Cabinet des Estampes, 1991).

11 I discuss this trajectory of self-performance in my book *Body Art/ Performing the Subject* (Minneapolis: University of Minnesota Press, forthcoming).

12 Merleau-Ponty, *Phenomenology of Perception*, trans. Colin Smith (New York and London: Routledge, 1962), 165.

13 Judith Butler theorizes the performativity of the subject in terms of "a reiteration of a norm or set of norms" through which "sex is both produced and destabilized" in *Bodies that Matter: On the Discursive Limits of 'Sex'* (New York and London: Routledge, 1993), 10, 13.

14 Arlene Raven, "Feminist Content in Current Female Art," *Sister* 6, no. 5 (October/November 1975): 10. Judy Chicago discusses the importance of such performative self-explorations in the pedagogy of the Feminist Art Program in her autobiography *Through the Flower: My Struggle as a Woman Artist* (Garden City, NY: Doubleday & Co., 1975), see 87, 125–132. The centrality of exaggerated self-performance to early feminist practice is well known. In New York in the early 1970s, Pat Oleszko also enacted herself in elaborate, often hyper-feminine costumes (in one case, she performed as a stripper covered with stuffed male hands); see Maud Lavin, "Dressing Up (& Down): Pat Oleszko's Transformations," *Art Express* 2, no. 2 (March–April 1982): 28–33.

15 Doane discusses masquerade, again, as precisely a strategic breaking apart of the union between "woman" and "image"—"Female specificity is . . . theorized in terms of spatial proximity" such that the female spectator of the image of a woman can only *become* it; the masquerade, as noted, "in flaunting femininity, holds it at a distance"; Doane, "Film and the Masquerade," 22, 23, 25.

16 Judith Butler, *Gender Trouble: Feminism and the Subversion of Identity* (New York and London: Routledge, 1990), 7.

17 Judith Williamson, "Images of 'Woman'—The Photographs of Cindy Sherman," *Screen* 24, n. 6 (November/December 1983): 102.

18 *Ibid.* At the same time such a doubling achieves only regressive ends in the readings of some viewers. Mira Schor sees Sherman's work as only reinforcing the stereotypes it engages: "a substantial number of the women enacted by Sherman are either squatting, crouching or prone, crazed or dead. . . . one has only to see certain Sherman photographs on a collector's wall to understand the rather traditional nature of their appeal: a wet T-shirt clinging to breasts is the same old thing, whether you call it *draperie mouillée* . . . or tits and ass." Schor, "Backlash and Appropriation," in *The Power of Feminist Art: The American Movement of the 1970s, History and Impact,* ed. Norma Broude and Mary D. Garrard (New York: Harry N. Abrams, 1994), 255. While I appreciate Schor's passion, I think such a reading is far too simplistic (as any examination of the broad reception her work has engendered would suggest).

19 Mulvey, "A Phantasmagoria," 138. Krauss reads this image specifically against Mulvey's model, arguing that the notion of the gaze is countered by the "voyeuristic remove" established by the "nimbus that washes around the frame of the image, repeating in the register of light the sense of barrier that the door frame constructs in the world of physical objects," in *Cindy Sherman: 1975–1993,* 56. While Krauss's attention to the wash of light flaring in at the bottom of the photograph is compelling (the nimbus does mark the photograph as "image" and makes evident circuits of identification or projection), her attempt to use this observation as "proof"

that the gaze is not an issue in this photograph is in my view unconvincing. Krauss leaps from an interesting observation to an untenable claim that completely ignores the history of soft-core pornography: the way in which the "nimbus" can just as easily suggest the welcoming of a gaze as it can a "voyeuristic remove." Further, the use of a light flare (like Sherman's use of graininess in *Untitled Film Still #2,* which Krauss discusses in similar terms) could also be viewed in feminist terms as making the (male) gaze *aware of itself,* just as exaggerating the texture of the photograph could be viewed as a way of splitting the conventionally sutured duo of "image" and "feminine." There is no point in dwelling on Krauss's antifeminism, but I do want to note, as it is relevant to my own argument, that she performs precisely the sin she accuses feminists (in particular Laura Mulvey) of committing vis-à-vis Sherman's work: fixating on an a priori model of explanation (in Mulvey's case that of the model of the gaze) such that, in the terms Krauss applies to Mulvey, the interpreter fails to "look under the hood" (that is, one assumes, to see the "true" meaning of Sherman's work—as specified by Krauss). Krauss's apparently consuming need to devalue feminism (to dismiss the last thirty years of feminist theorizing, while at the same time appropriating much of its language) compels her to overlook her own participation in rereading Sherman's work according to a formalist paradigm. In the oldest trick in the art historical book, Krauss uses the stick of objectivity to pose her readings as correct (according to Krauss, Mulvey *imposes* her model and consumes Sherman's images as myth, while Krauss, by attending to the formal structure, lighting effects, etc. of the photographs, simply shows us the truth of what is "under the hood" of

Sherman's images). If she had attended to *her own participation* in recasting Sherman's images as proposing a desublimated rather than coherent subject and explored why this might be an interesting thing to do at this moment, Krauss's insights (and they are many) would have been more convincing overall.

20 This is my expanded, phenomenological definition based on Duchamp's notes; see "The Green Box" (1934), *The Writings of Marcel Duchamp,* ed. Michel Sanouillet and Elmer Peterson (New York: Da Capo, 1973), 65. On "Flesh" as an indication of the embodiment of the self in relation to the world see Merleau-Ponty, "The Intertwining—The Chiasm," 130–155.

21 I make this argument vis-à-vis body art in my book *Body Art/Performing the Subject.*

22 Judith Butler, "Sexual Ideology and Phenomenological Description," 89. On intersubjectivity in the work of Jean-Paul Sartre and Merleau-Ponty, see also Martin Jay, *Downcast Eyes: The Denigration of Vision in Twentieth-Century Thought* (Berkeley and Los Angeles: University of California Press, 1993), 311.

23 Initially commissioned by *Artforum,* the images were not ultimately published there.

24 On feminist Brechtian strategies, which Sherman's works particularly avoid, see Griselda Pollock, "Screening the seventies; sexuality and representation in feminist practice— a Brechtian perspective," in *Vision and Difference: Femininity, Feminism and the Histories of Art* (New York and London: Routledge, 1988), 155–199.

25 Mulvey, "A Phantasmagoria," 143; here, Mulvey uses her own terminology from "Visual Pleasure and Narrative Cinema."

26 In her chapter on the Centerfolds (Cindy Sherman: 1975–1993, 89–97), Krauss again proposes her particular determination of meaning for the Centerfold images as inherent to the photographs. Arguing that the "signifier" at issue in these images is "point-of-view," or the shift from the vertical to horizontal axis, Krauss then proceeds to offer a narrow interpretation of what the significance of this shift entails. Critiquing Mulvey's feminist reading (as still "firmly fixed on the signified"), she eradicates the obvious link between "centerfold" and "pornography," failing to acknowledge that her own reading also supplies a fixed "signified" to the "signifier" of point-of-view. Krauss uses the language of semiotics to naturalize her particular assignment of a signified, posing her reading as simply obvious or natural (precisely the function of myth, as Roland Barthes describes it in a model Krauss employs here to debunk Mulvey's reading).

27 Butler, "Sexual Ideology and Phenomenological Description," 89.

28 Krauss, Cindy Sherman: 1975–1993, 174.

29 Ibid. In this sense, Sherman takes the Renaissance portrait, which John Welchman argues to offer "the self as a gorgeously specific object and not as an interior," and postmodernizes it ("The Renaissance figure becomes a ghost that haunts the forms and disguises of the postmodern self"). John Welchman, "Peeping Over the Wall," in Narcissism: Artists Reflect Themselves (Escondido: California Center for the Arts Museum, 1996), 16, 18.

30 Griselda Pollock summarizes these arguments in her essay "What's Wrong with Images of Women?," in Screen Education, no. 24 (Autumn 1977): 25–33.

31 See Donald Preziosi, Rethinking Art History: Meditations on a Coy Science (New Haven and London: Yale University Press, 1989).

32 Betterton in "Body Horror?," 144; she is citing Maud Elman.

33 Random House Dictionary of the English Language, second edition (New York: Random House, 1987), 420.

34 By Krauss (Cindy Sherman: 1975–1993, 208), who links Sherman's sex doll imagery to Hal Foster's discussion of Bellmer's dolls in his essay "Armor Fou," October no.56 (Spring 1991): 86.

35 See especially Mulvey's essay "Fears, Fantasies and the Male Unconscious or 'You Don't Know What is Happening, Do You Mr. Jones?'" (1973), in Visual and Other Pleasures, 6–13.

36 On Duchamp's sex objects see my Postmodernism and the En-Gendering of Marcel Duchamp (New York and Cambridge, England: Cambridge University Press, 1994), 90–93.

37 According to Jan Avgikos, these are made with medical dummies; see Jan Avgikos, "Cindy Sherman: Burning Down the House," Artforum 31, no. 5 (January 1993): 78. I have a hard time viewing the obviously lurid sex organ portions of these perverse dolls as medical in orientation—if they are, I can only imagine what bodily invasions they presuppose.

38 Merleau-Ponty, "The Intertwining—The Chiasm," 134–135.

39 To a certain extent I am obviously speaking to the normative (white) subjects of the art world here. Peggy Phelan elegantly explores Sherman's work in similar terms, arguing that it marks the failure of the subject to be rendered within the terms of the visible and in so doing gives us another way of understanding our link to the other within and without ourselves. Phelan, Unmarked: The Politics of Performance (New York and London: Routledge, 1993), 69.

Plates

This section also includes
excerpts from Sherman's notebooks,
selections from contact sheets,
and Polaroid studies for color
photographs.

56

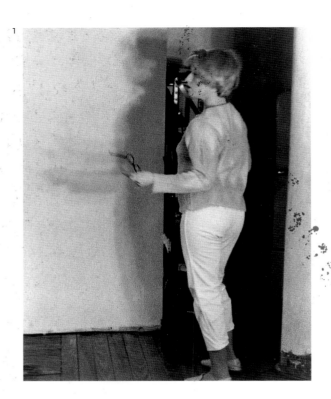

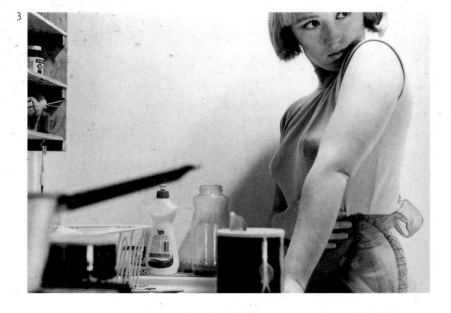

plate 1 *Untitled Film Still #1*
 1977
plate 2 *Untitled Film Still #2*
 1977
plate 3 *Untitled Film Still #3*
 1977

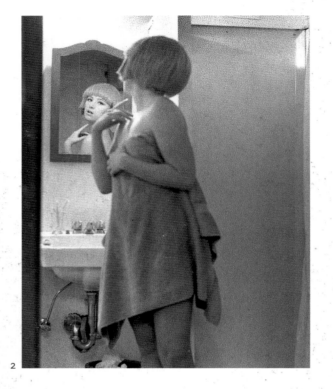

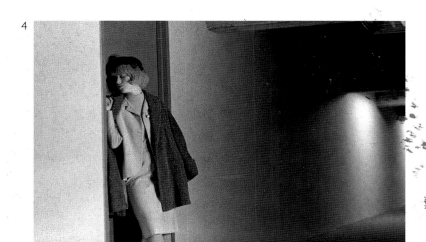

plate 4 *Untitled Film Still #4*
 1977
plate 5 *Untitled Film Still #5*
 1977
plate 6 *Untitled Film Still #6*
 1977

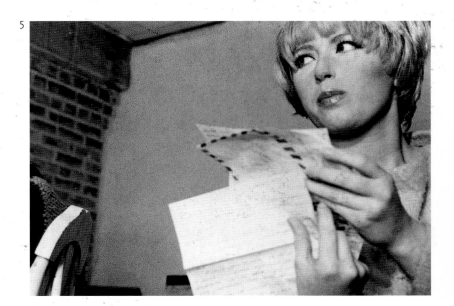

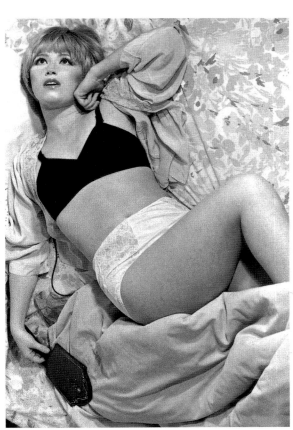

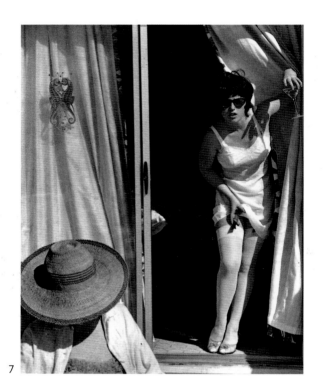

7

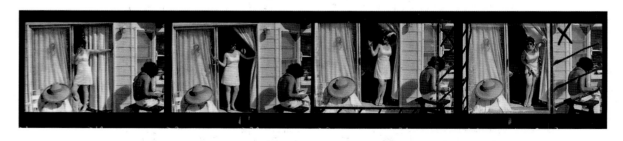

plate 7 *Untitled Film Still #7*
 1978
plate 8 *Untitled Film Still #8*
 1978
plate 9 *Untitled Film Still #9*
 1978

8

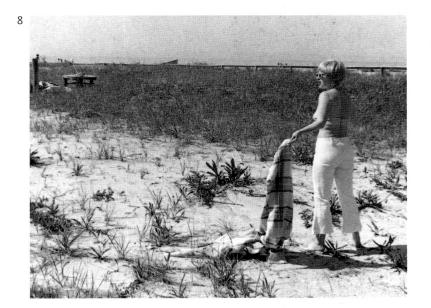

9

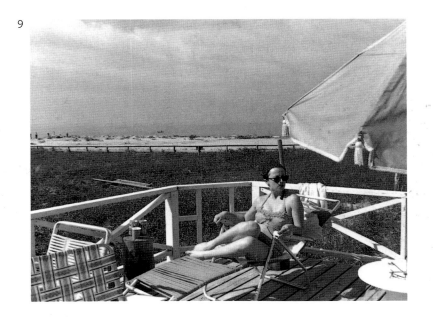

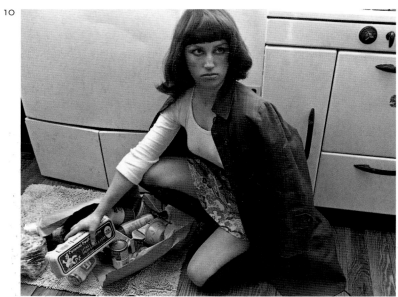

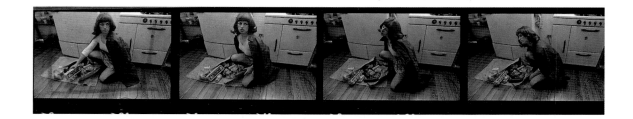

11

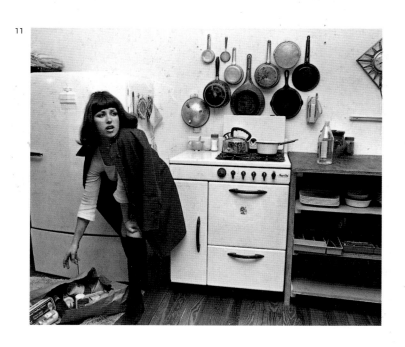

12

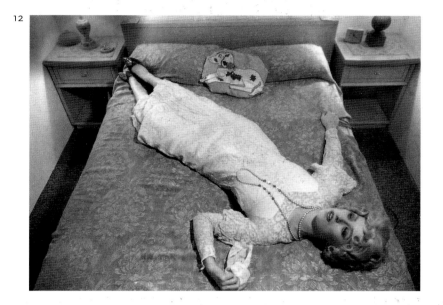

13

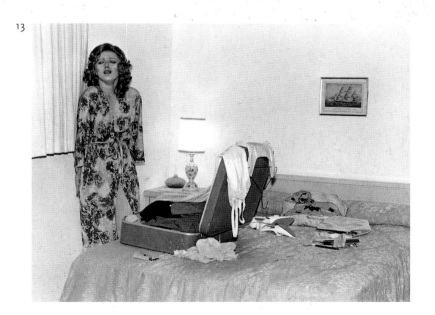

plate 10 *Untitled Film Still #10*
 1978
plate 11 *Untitled Film Still #84*
 1980
plate 12 *Untitled Film Still #11*
 1978
plate 13 *Untitled Film Still #12*
 1978

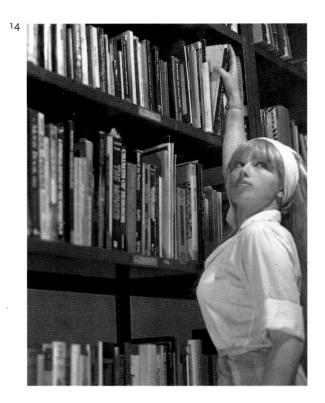

15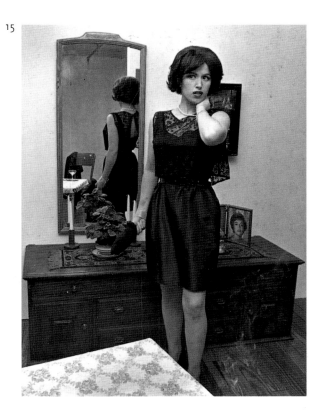

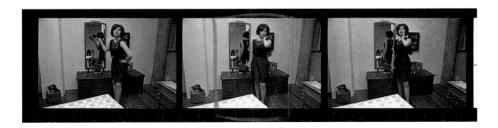

plate 14 *Untitled Film Still #13*
 1978
plate 15 *Untitled Film Still #14*
 1978

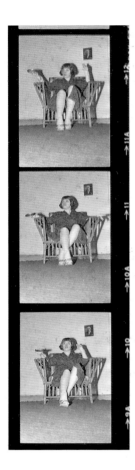

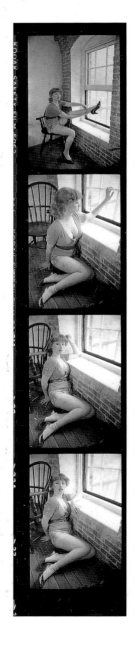

plate 16 *Untitled Film Still #16*
 1978
plate 17 *Untitled Film Still #15*
 1978

16

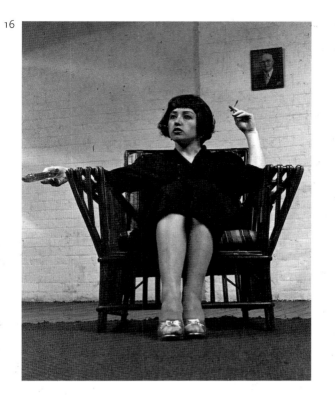

17

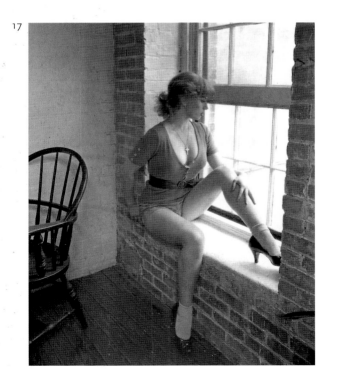

18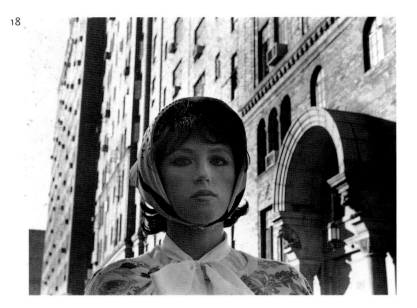

19

plate 18 *Untitled Film Still #17*
1978
plate 19 *Untitled Film Still #18*
1978

20

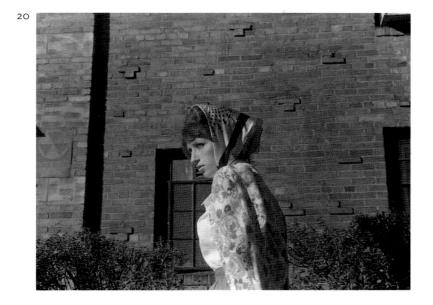

21

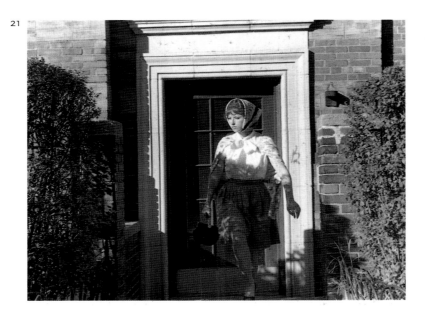

plate 20 *Untitled Film Still #19*
 1978
plate 21 *Untitled Film Still #20*
 1978

22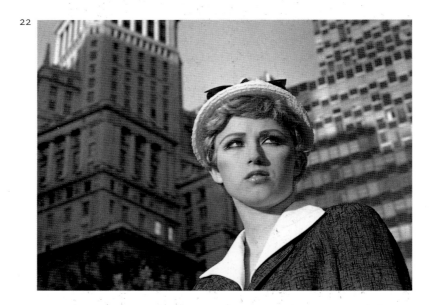

plate 22 *Untitled Film Still #21*
 1978
plate 23 *Untitled Film Still #22*
 1978
plate 24 *Untitled Film Still #23*
 1978

23

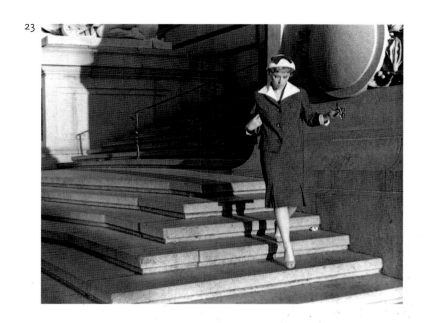

24

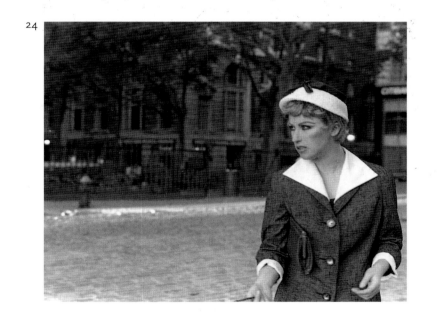

25

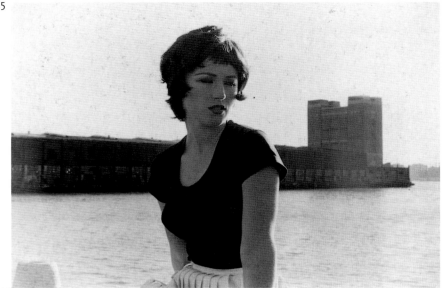

26

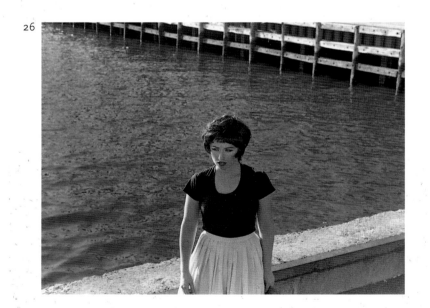

plate 25 *Untitled Film Still #24*
 1978
plate 26 *Untitled Film Still #25*
 1978
plate 27 *Untitled Film Still #27B*
 1979
plate 28 *Untitled Film Still #26*
 1979

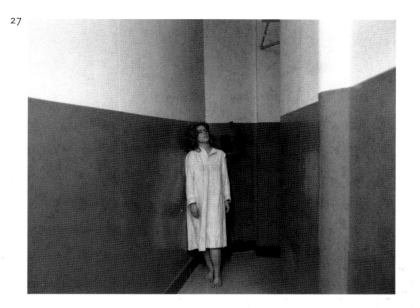

27

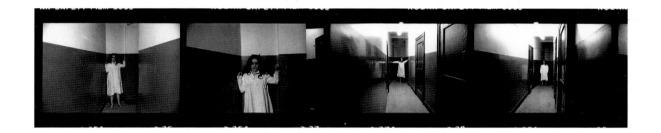

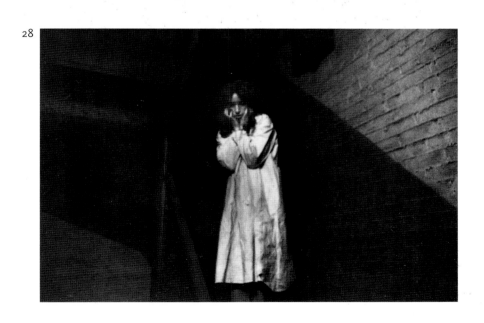

28

29

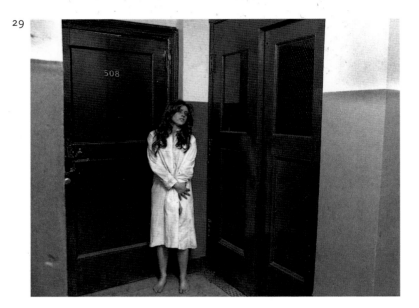

30

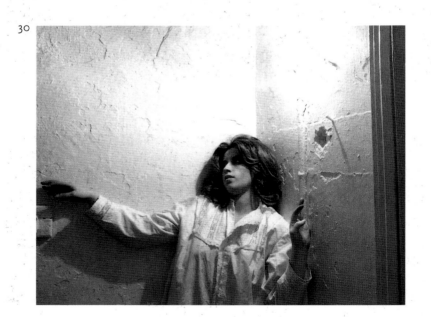

plate 29 *Untitled Film Still #28*
 1979
plate 30 *Untitled Film Still #29*
 1979
plate 31 *Untitled Film Still #27*
 1979
plate 32 *Untitled Film Still #50*
 1979

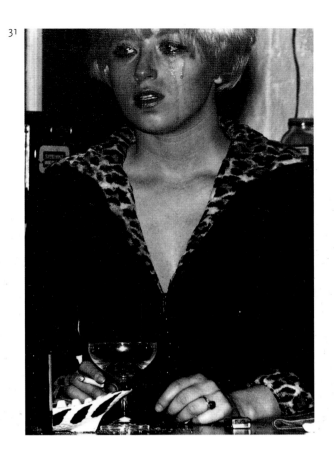

32

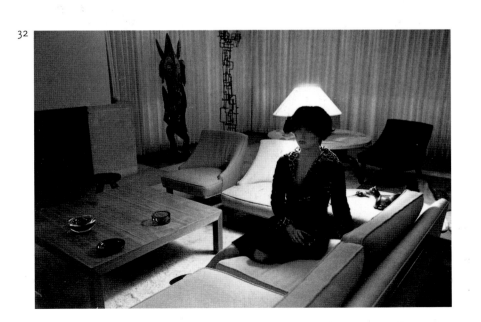

33

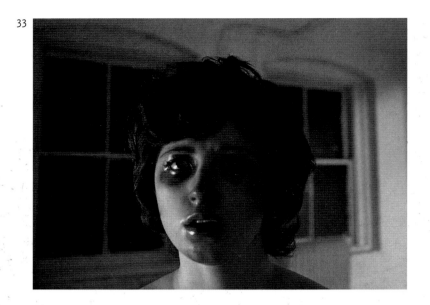

34

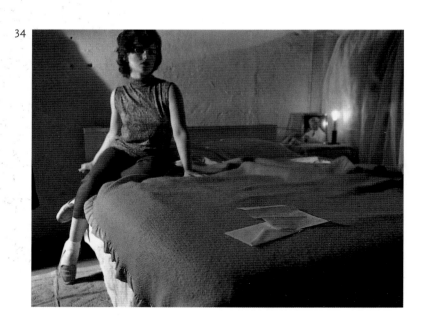

35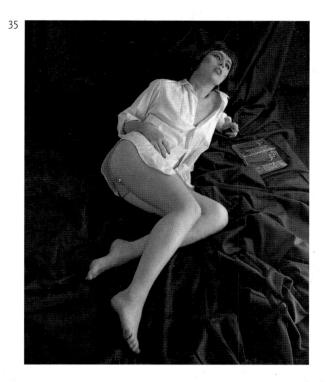

plate 33 *Untitled Film Still #30*
 1979
plate 34 *Untitled Film Still #33*
 1979
plate 35 *Untitled Film Still #34*
 1979

36

37

38

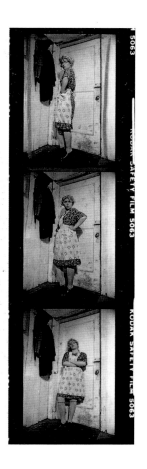

plate 36 *Untitled Film Still #31*
 1979
plate 37 *Untitled Film Still #32*
 1979
plate 38 *Untitled Film Still #36*
 1979
plate 39 *Untitled Film Still #35*
 1979

39

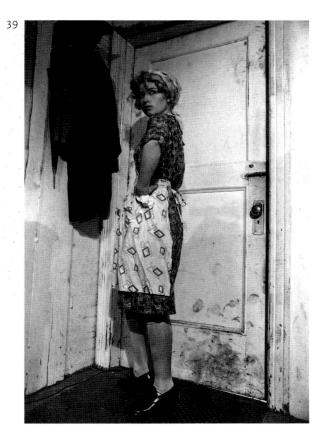

40

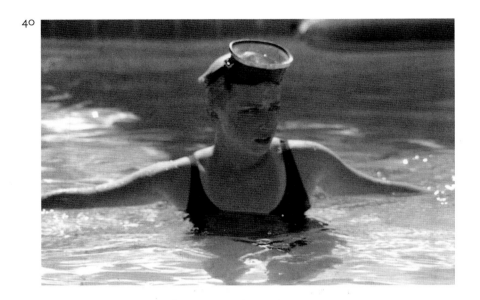

41

42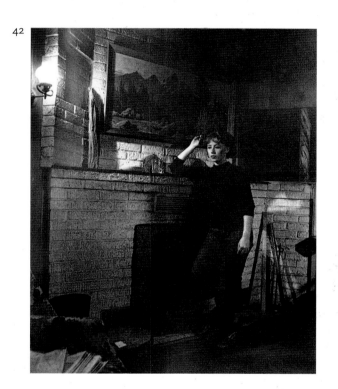

plate 40 *Untitled Film Still #45*
 1979
plate 41 *Untitled Film Still #46*
 1979
plate 42 *Untitled Film Still # 37*
 1979

43

plate 43 *Untitled Film Still #38*
 1979
plate 44 *Untitled Film Still #39*
 1979
plate 45 *Untitled Film Still #40*
 1979
plate 46 *Untitled Film Still #47*
 1979

44

45

46

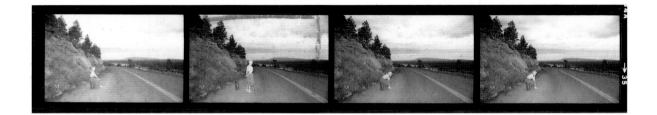

47

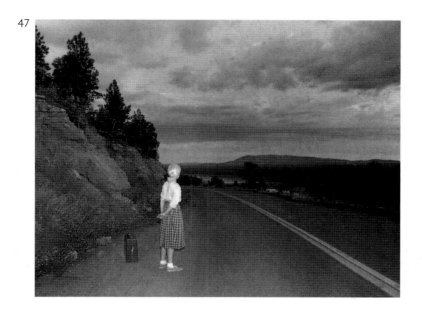

48

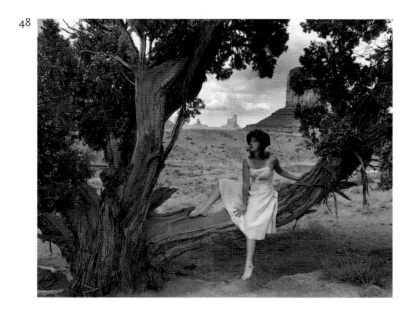

plate 47 *Untitled Film Still #48*
 1979
plate 48 *Untitled Film Still #43*
 1979

49

84

50

51

52

53

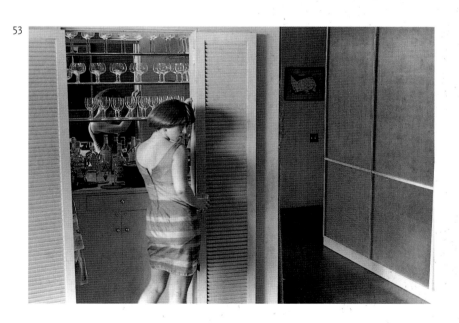

54

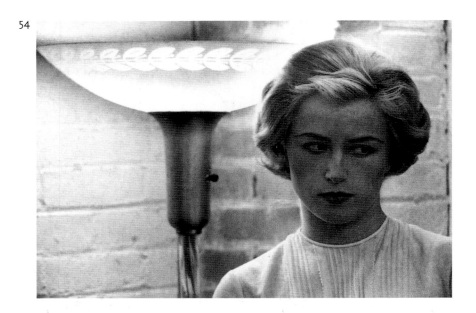

55

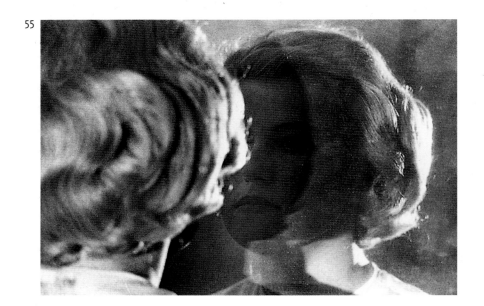

56

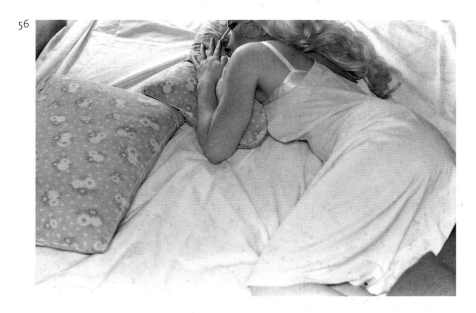

plate 54 *Untitled Film Still #53*
 1980
plate 55 *Untitled Film Still #56*
 1980
plate 56 *Untitled Film Still #52*
 1979

57

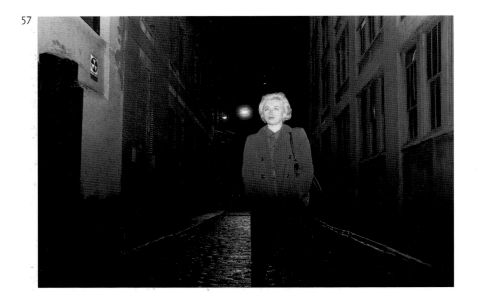

58

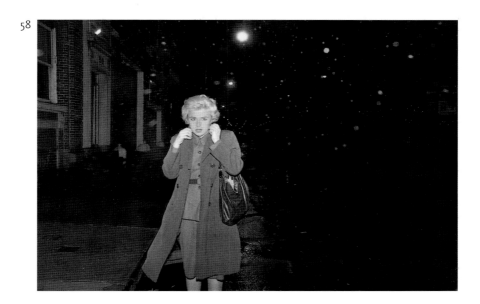

plate 57 *Untitled Film Still #55*
 1980
plate 58 *Untitled Film Still #54*
 1980

59

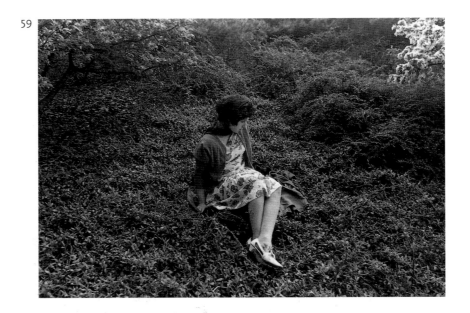

60

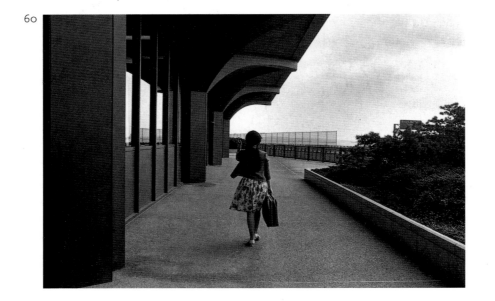

61

plate 59 *Untitled Film Still #57*
 1980
plate 60 *Untitled Film Still #59*
 1980
plate 61 *Untitled Film Still #58*
 1980

62

plate 62 *Untitled Film Still #60*
1980
plate 63 *Untitled Film Still #61*
1979
plate 64 *Untitled Film Still #65*
1980
plate 65 *Untitled Film Still #64*
1980

63

64

65

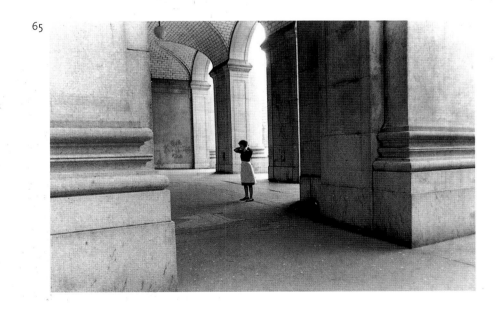

66

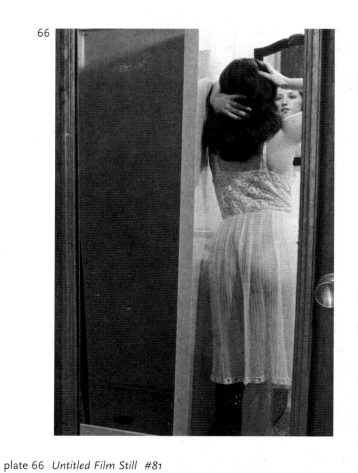

67

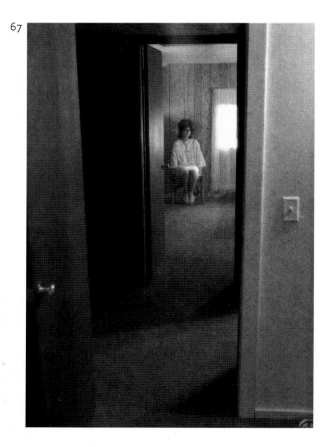

plate 66 *Untitled Film Still #81*
 1978
plate 67 *Untitled Film Still #82*
 1979
plate 68 *Untitled Film Still #83*
 1980
plate 69 *Untitled Film Still #63*
 1980

68

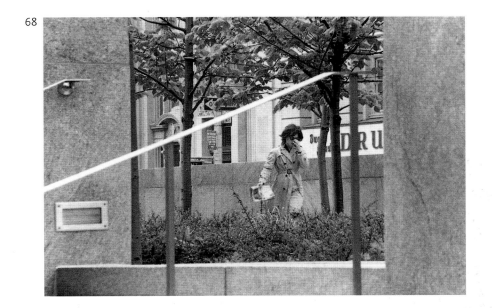

69

70

plate 70 *Untitled #66*
1980

71

plate 71 *Untitled #72*
 1980
plate 72 *Untitled #76*
 1980

72

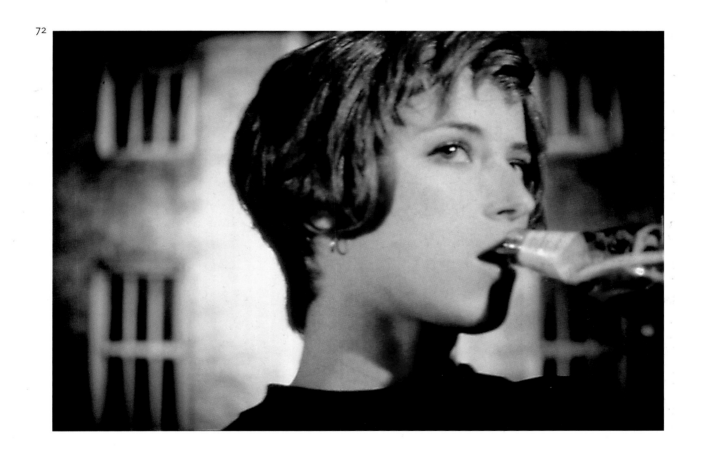

7/8/81

Artforum spread

centerfold

Lying down positions:
- sleeping
- fallen or thrown
- unable to walk
- lounging

to be able
to also work
when magazine
held thus:

characters:
- drunk
 · well dressed
 · bum

- "innocent" cripple

- beaten woman

- peasant

- weathered, out-doorsy

If these (centerfolds) are going
to be <u>big</u> they'd better
be <u>cluttered</u> with images, information.
That means no solid fields of
space, or color w/ nothing in it or going on.

~~~~~~~~~

Try some <u>movement</u> in the centerfolds.

~~~~~~~~~

This would be in 2 parts —
close-up + full view.
 or
close-up + view of room/location.

~~~~~~~~~

<u>superimposition</u>?
                                    separately shot.
of full figure over background.

73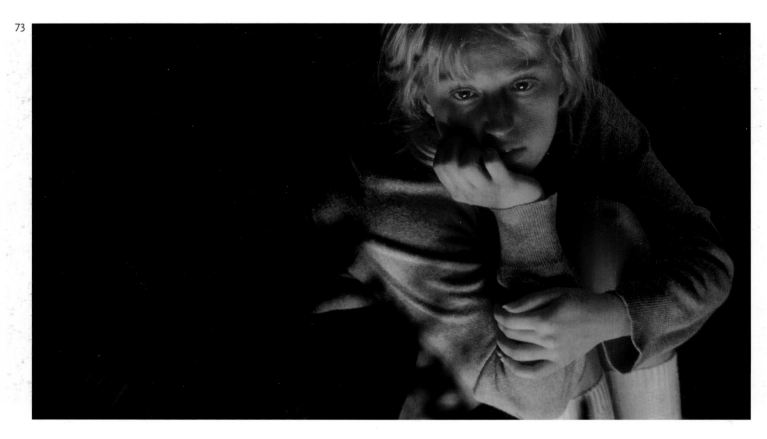

plate 73  *Untitled #88*
         1981
plate 74  *Untitled #90*
         1981

74

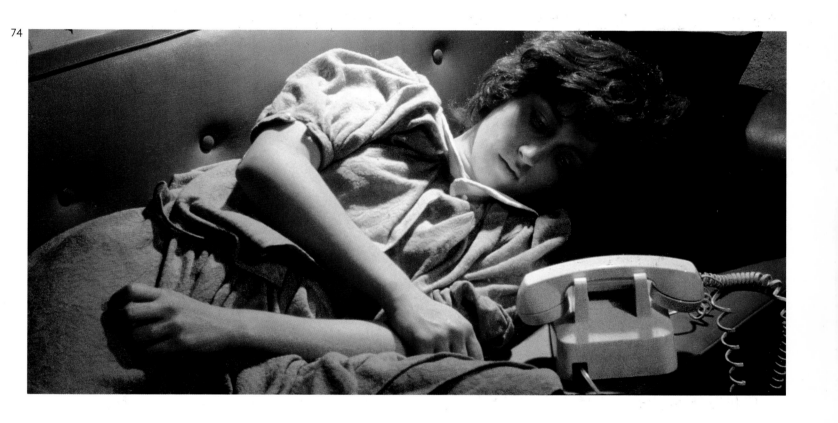

104

75

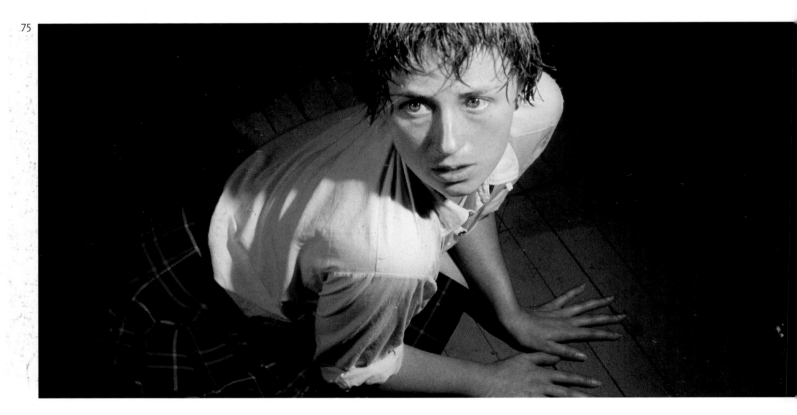

plate 75   *Untitled #92*
           1981
plate 76   *Untitled #93*
           1981

76

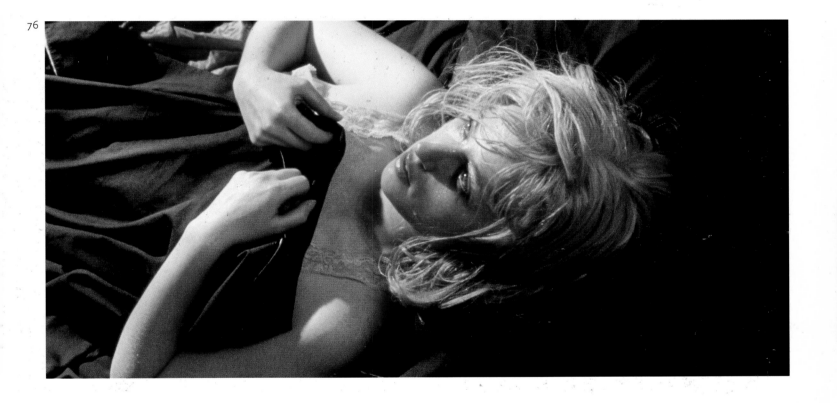

77

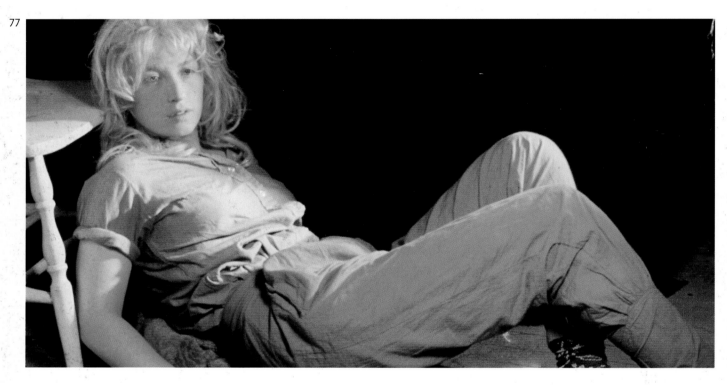

plate 77   *Untitled #94*
           1981
plate 78   *Untitled #96*
           1981

78

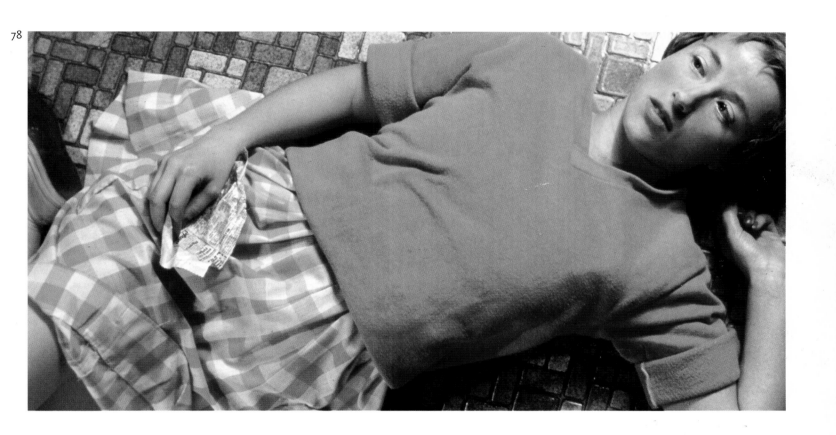

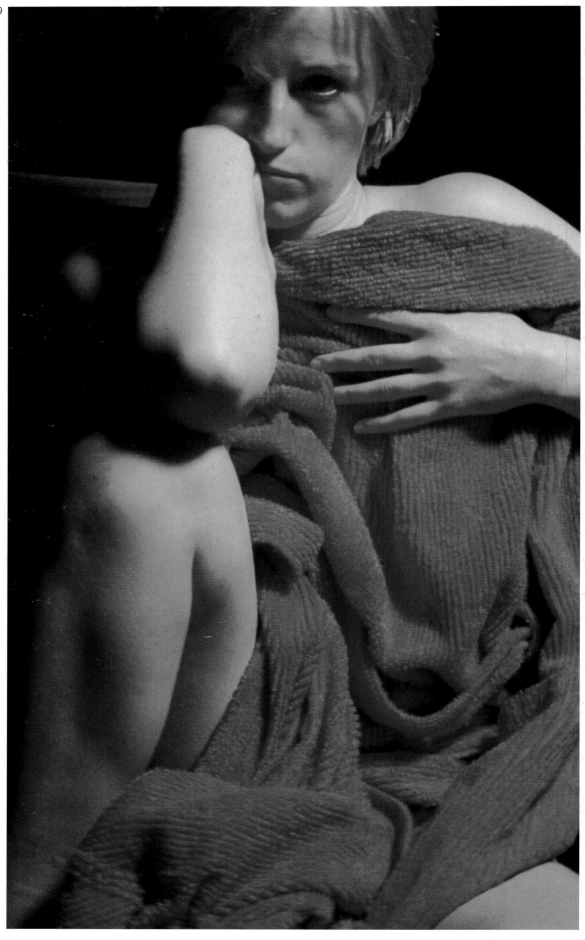

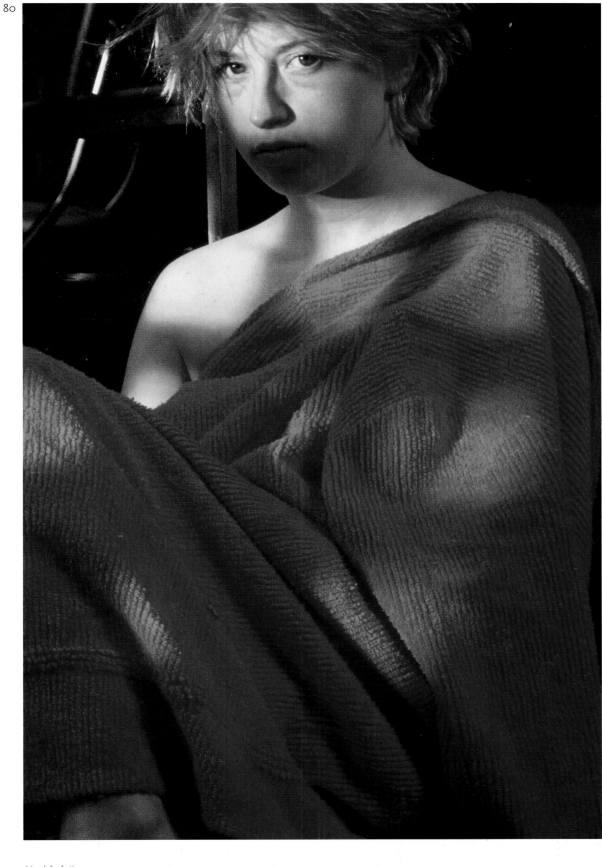

plate 79   *Untitled #97*
          1982
plate 80   *Untitled #98*
          1982

~~I would really like to know why~~

- Vertical shots (i.e. one for Artforum):

strong characters/pose

looking at camera/viewer

eye contact - confrontation.

No Make-up, wigs (?)

looking down?

liting changes

expression changes
(real)

Play on Narcissism/Self-portrait

Shocking/Provocative?/Punchy

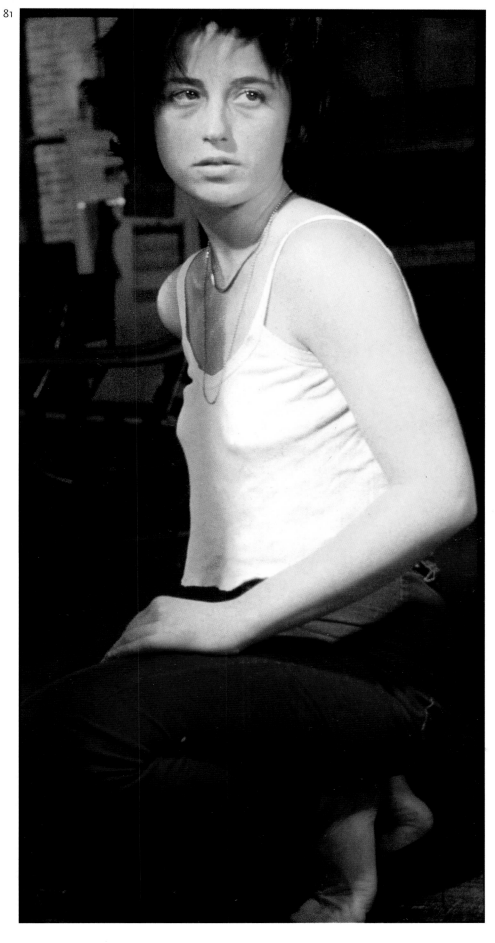

plate 81  *Untitled #102*
1981

83

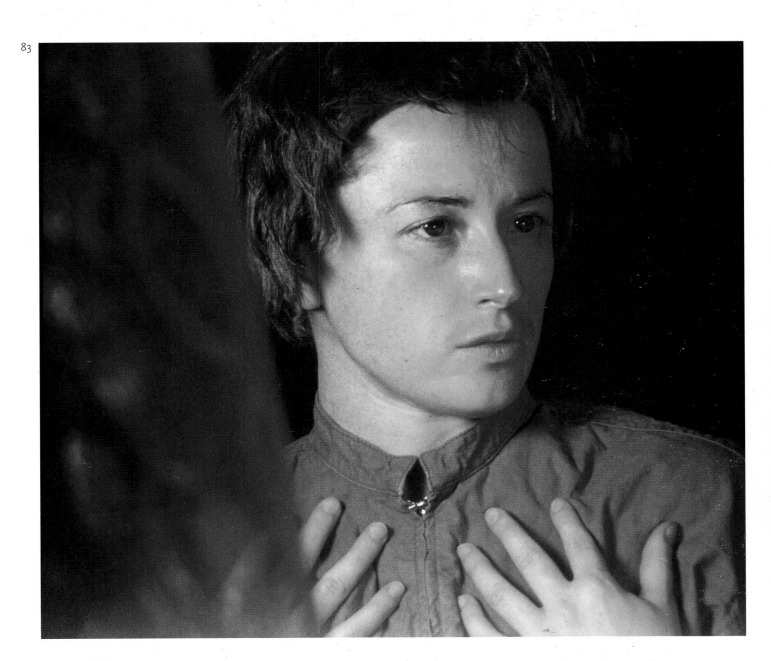

plate 82  *Untitled #105*
          1982
plate 83  *Untitled #109*
          1982

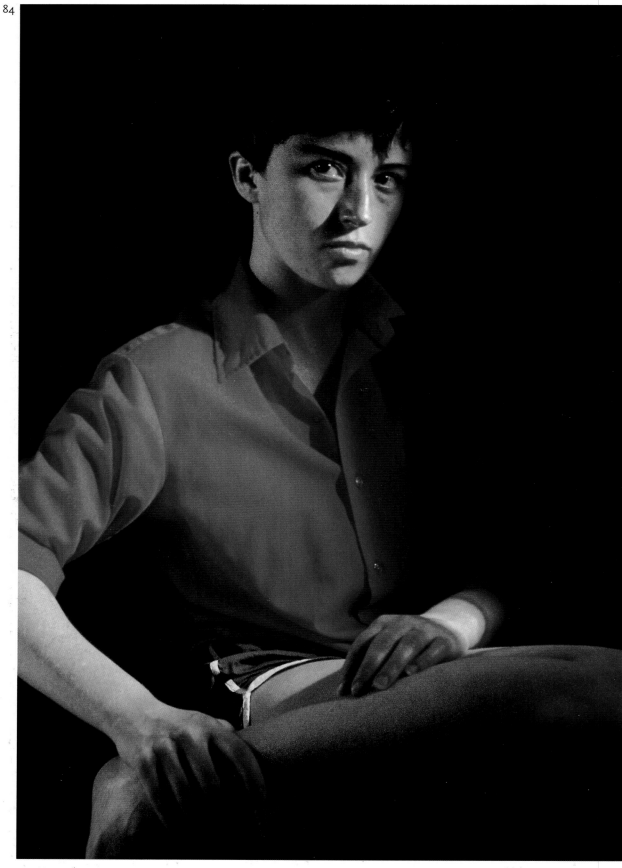

plate 84   *Untitled #112*
             1982
plate 85   *Untitled #113*
             1982

plate 86   *Untitled #114*
         1982
plate 87   *Untitled #116*
         1982

Jan. 3 '83

Diane B photos

Attack clothes

┌─────────────────────────────┐
│ ugly person (face/body)     │
│           vs.               │
│ fashionable clothes         │
└─────────────────────────────┘

Try OVEREXPOSING
            for pale picture series.

✳ Make-up dripping down face

┌─────────────────────────────────────┐
│ buy more hair rinse                  │
│ buy transparent netting w/ glitter   │
└─────────────────────────────────────┘

think [full page] and [double sq. size (Artforum)]
            interview

✳ Boys in clothes

✳ Ugly girls ( ~~make~~ awkward-gawky-adolescents)
        ↑
     playing dress-up w/ "Mom's" clothing

┌──────────────────────────────────────────────┐
│ MAKE SURE NEITHER NOSTALGIC OR NEW WAVE        │
└──────────────────────────────────────────────┘

*TO GET THIS PROJECT DONE ...*

1/6/97

fashionable take-offs
of my own work?

pseudo-
↑ fashion shots

- like what I did w/ the Vogue cover
takeoffs (75 or 76)

( I can't seem to make my "own" work
with these clothes at this time. )

I don't know what I want to do now.
I'm not ready to go ahead with my own
ideas. I'd be repeating my old formulas
if I tried to at this point

Stupid looking model-types
(but ethnic-dirty)

· ( I can't escape the fashionability of these
clothes )

Perhaps I shouldn't try to incorporate
any these clothes w/ my own work/style.
Maybe that's the mistake or problem.
I should think of this as only a
special project and use the
elements of the fashion medium (which
or self-
conscious aware of) for the final result of this
series.

88

plate 88   *Untitled #119*
             1983
plate 89   *Untitled #120*
             1983

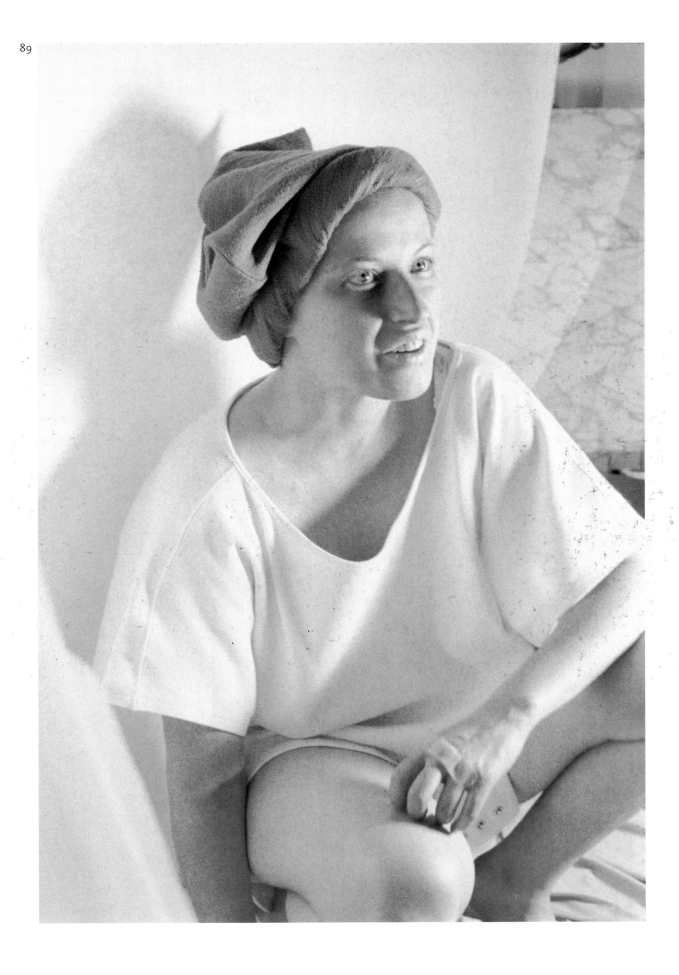

122

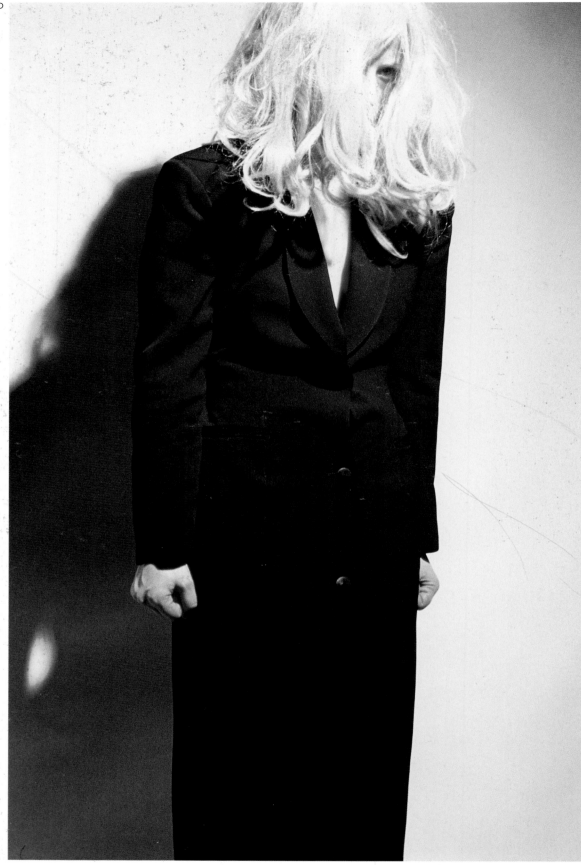

plate 90   *Untitled #122*
            1983
plate 91   *Untitled #131*
            1983

91

123

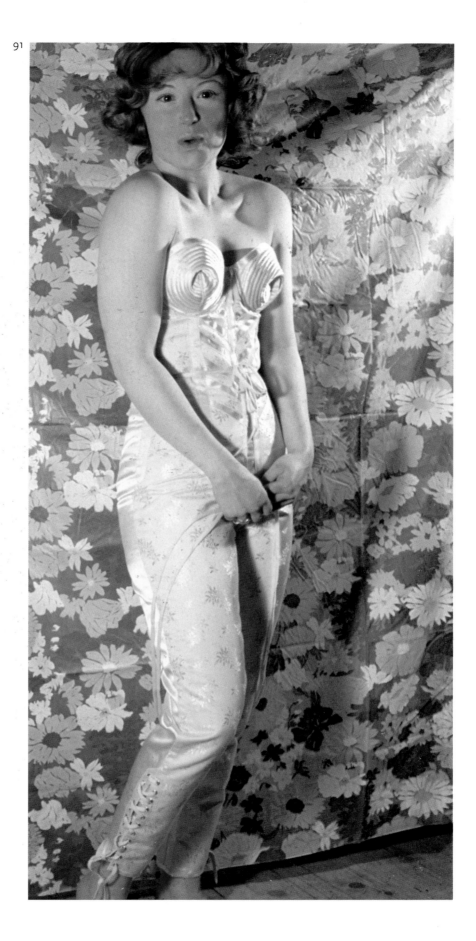

Dorothée Bis:   10/18/83

throwing-up, drooling, snot running down nose,
Bag-lady-like

End of bad night —                    ( But clothes
                                        perfect looking )
Fat person

shooting-up, snorting coke

(Double Exposures)

Contorted poses - as in excersizing.
    view through arms, legs, twisted

looking straight down?

Pin pointed lite-spots?

— Bleeding, dying, etc.

— Emerging out of something — water like,
                              (cellophane?)

Skins colors:  green, gold, silver, Black
                              Grey

hairy hands, Afro?
" chest, arms!

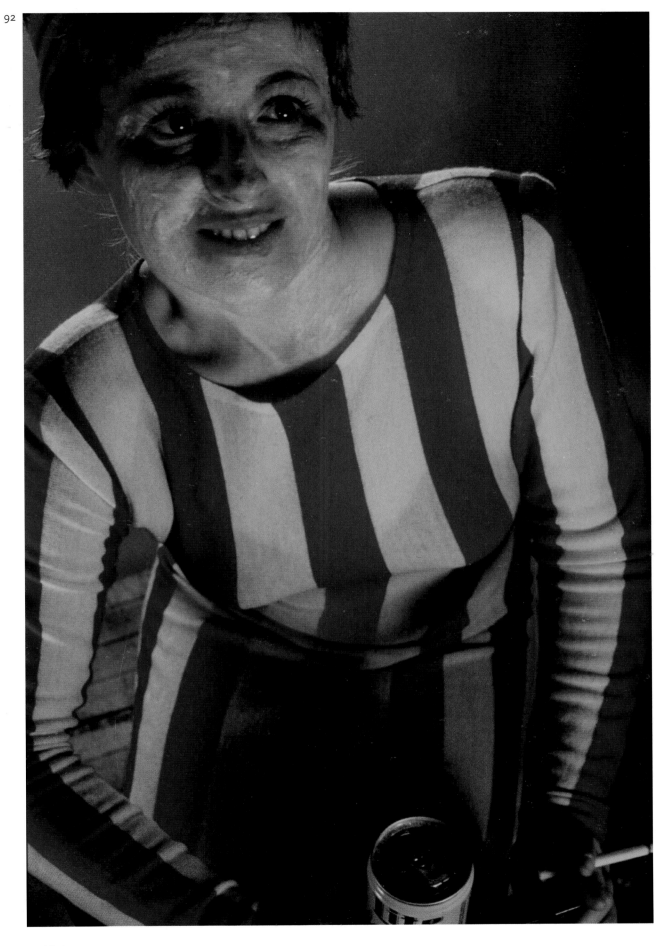

plate 92   *Untitled #132*
1984

93

126

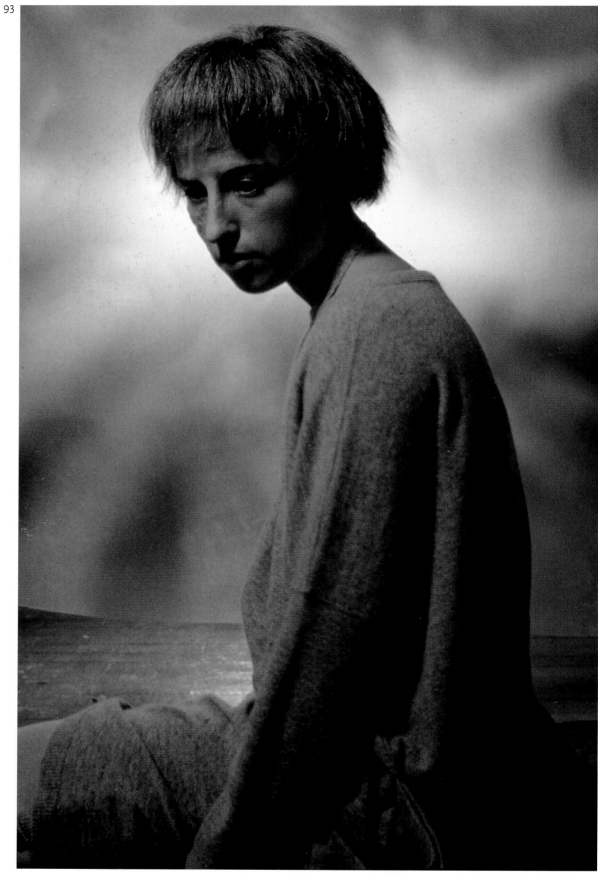

plate 93  *Untitled #133*
        1984
plate 94  *Untitled #137*
        1984

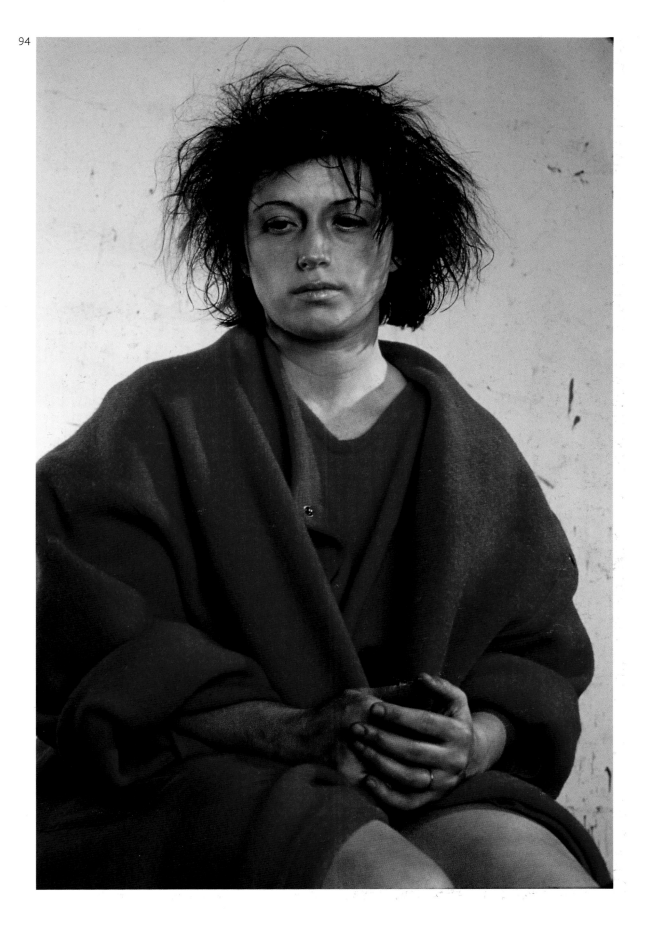

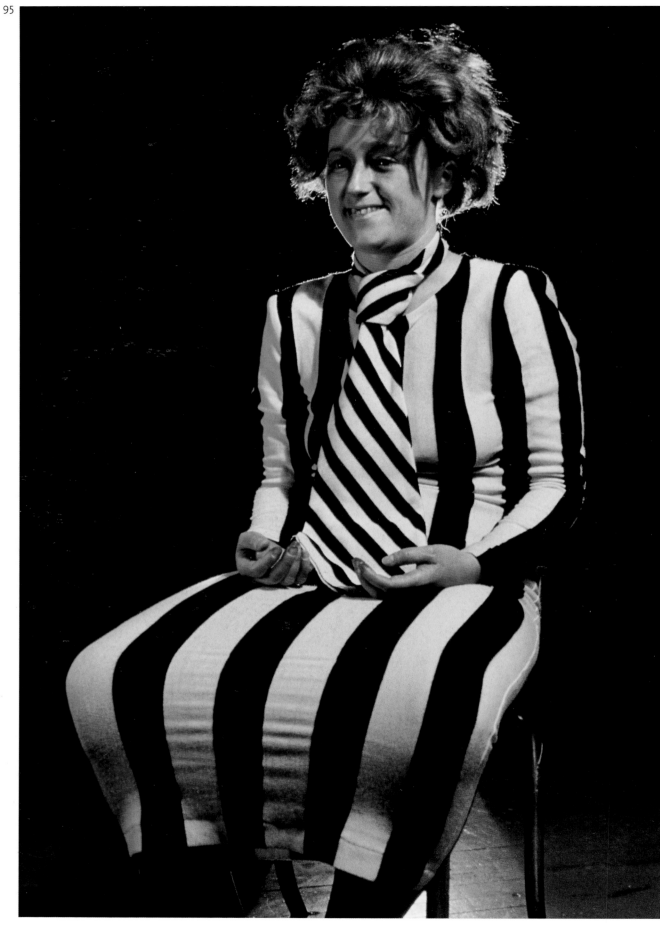

plate 95  *Untitled #138*
1984

3/6/85   Fairy Tales

"The Maiden w/wt Hands"

1. kneeling, (w/wt Hands) praying,

2. eating pear hanging from tree

3. Maid w/ silver hands        silver make-up.
                                        & paint

4. King's face covered.

5. White maiden carrying silver hands

"Birdie + Her Friend"

1) clothes caught in branches of tree,
    little girl hanging (or sitting).

2 Old woman who hated children
    (carrying 2 buckets).

3 Hag lying in pond.

130

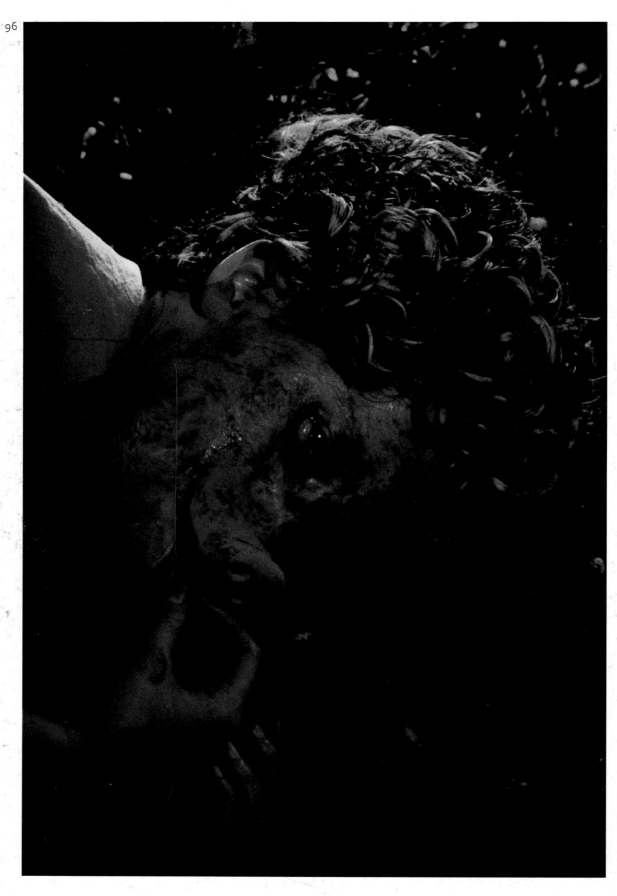

plate 96  *Untitled #140*
          1985
plate 97  *Untitled #146*
          1985

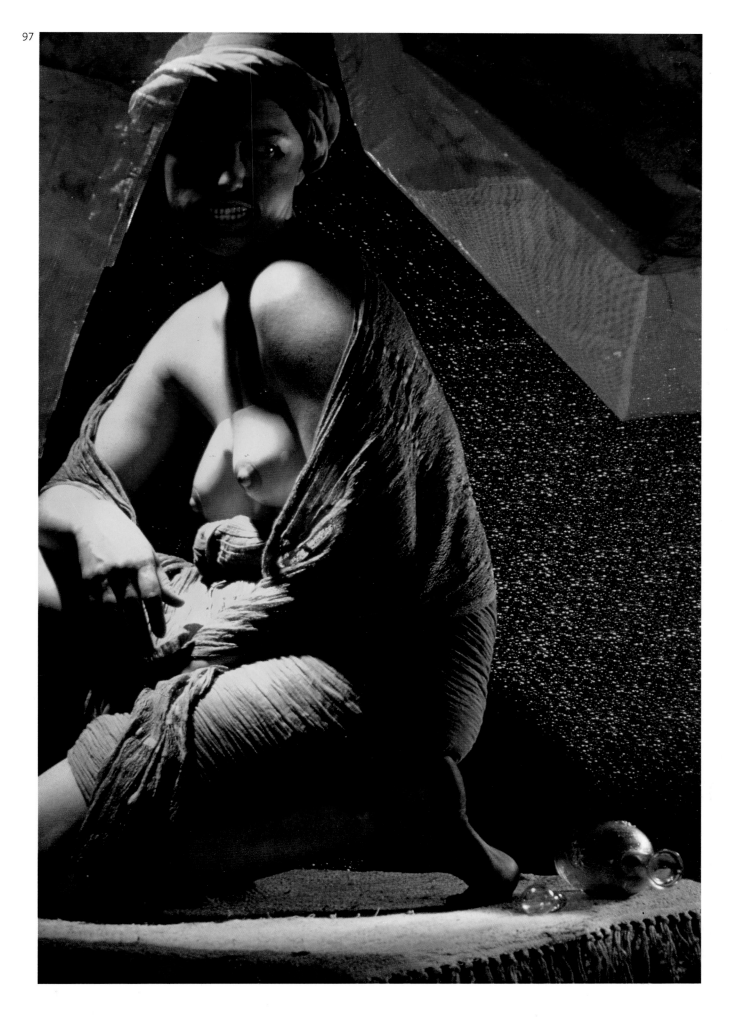

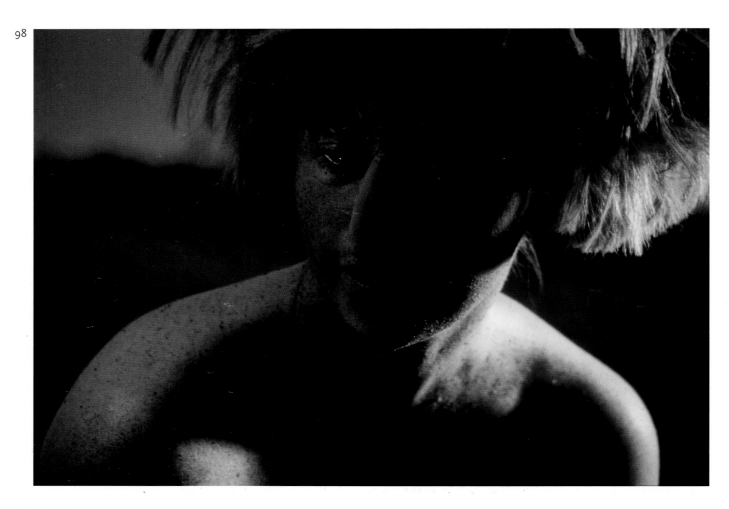

98

plate 98  *Untitled #147*
         1985
plate 99  *Untitled #150*
         1985

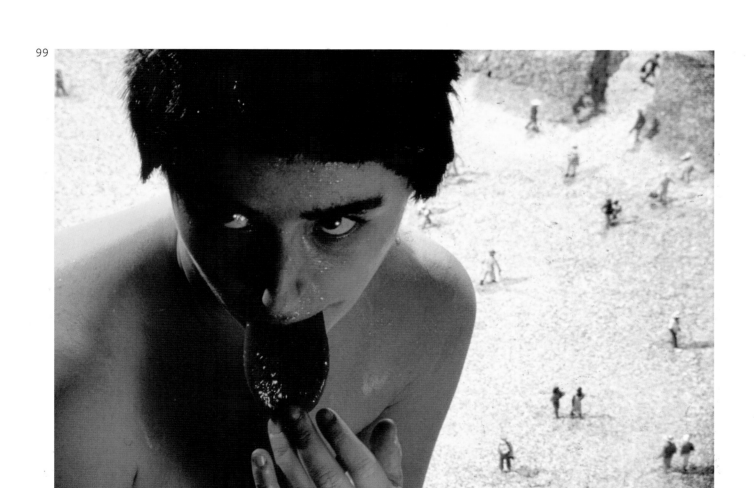

99

100

134

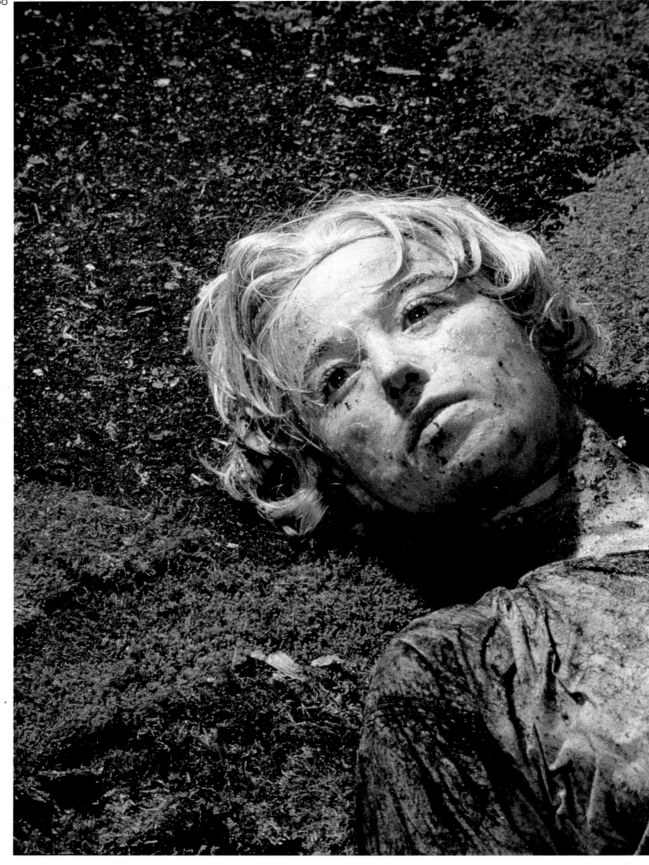

plate 100   *Untitled #153*
            1985
plate 101   *Untitled #154*
            1985

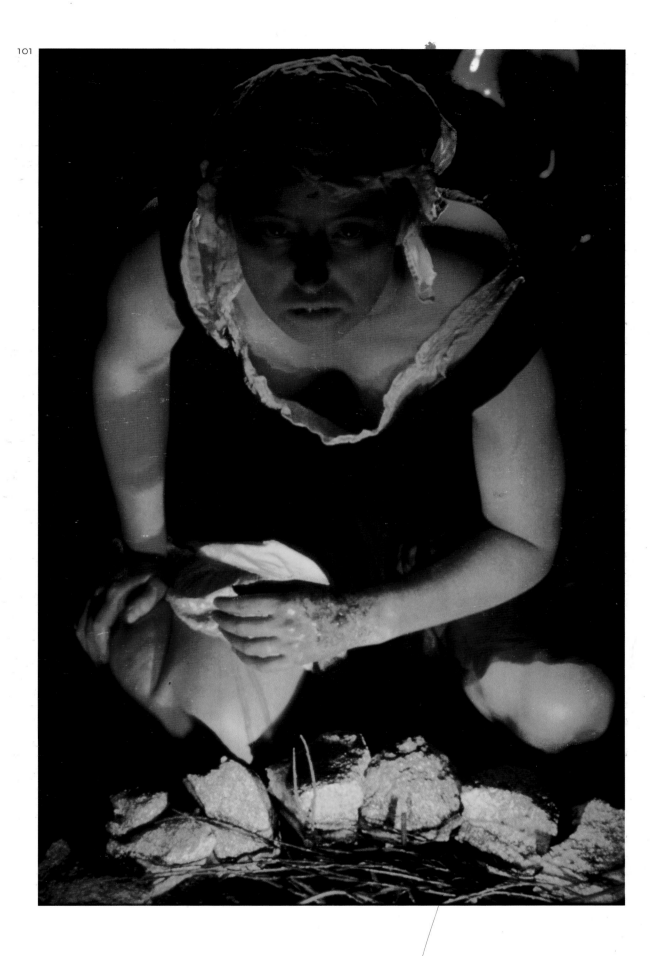

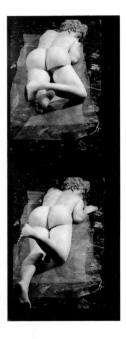

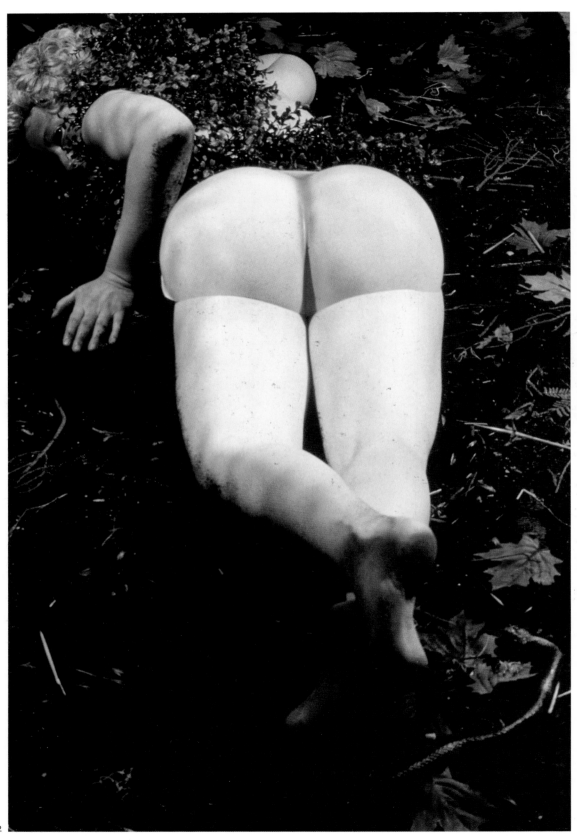

103

plate 102    *Untitled #155*
             1985
plate 103    *Untitled #156*
             1985

105

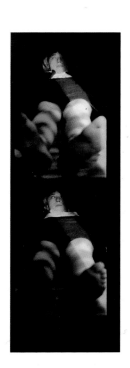

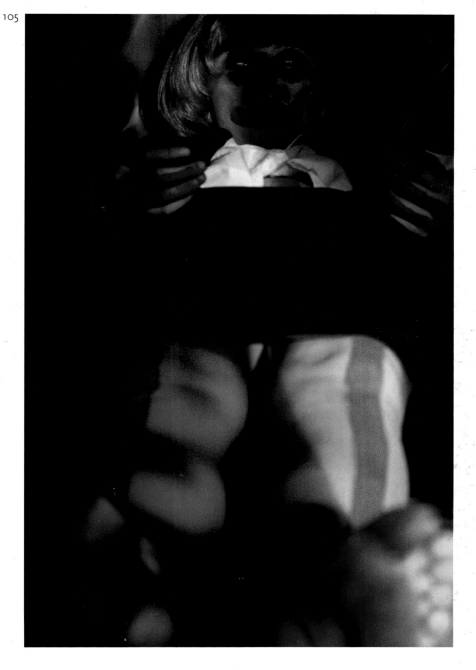

plate 104    *Untitled #160*
             1986
plate 105    *Untitled #166*
             1986

140

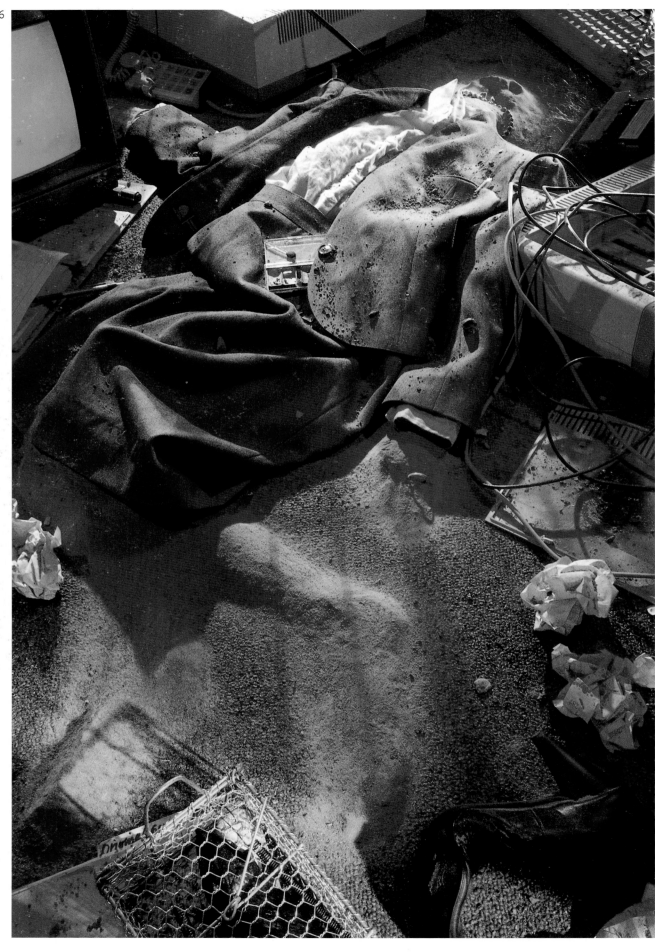

107

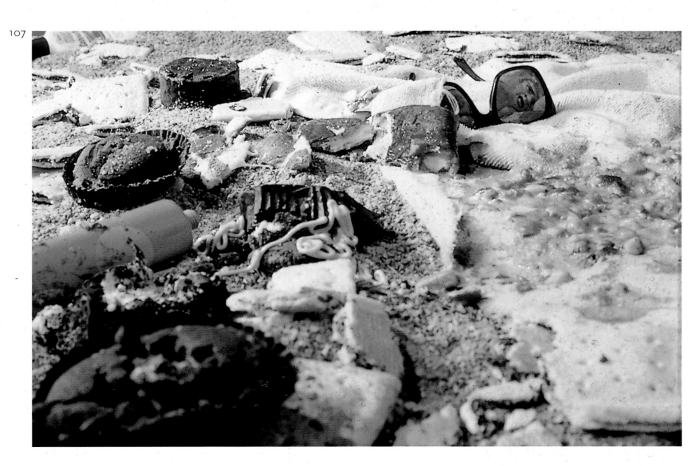

plate 106    *Untitled #168*
           1987
plate 107    *Untitled #175*
           1987

142

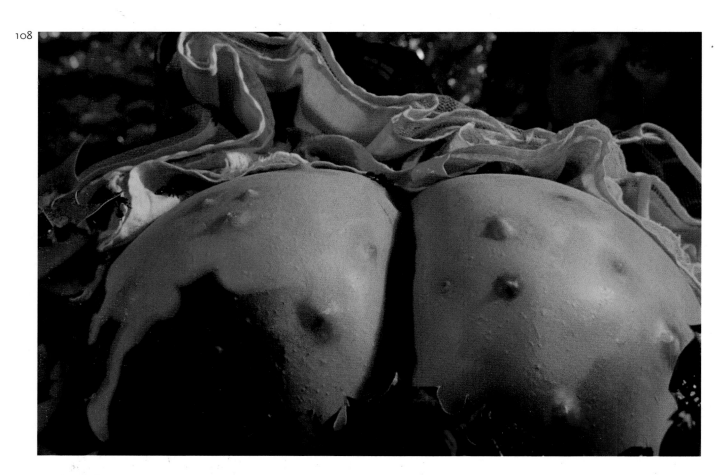

108

plate 108  *Untitled #177*
          1987
plate 109  *Untitled #180*
          1987

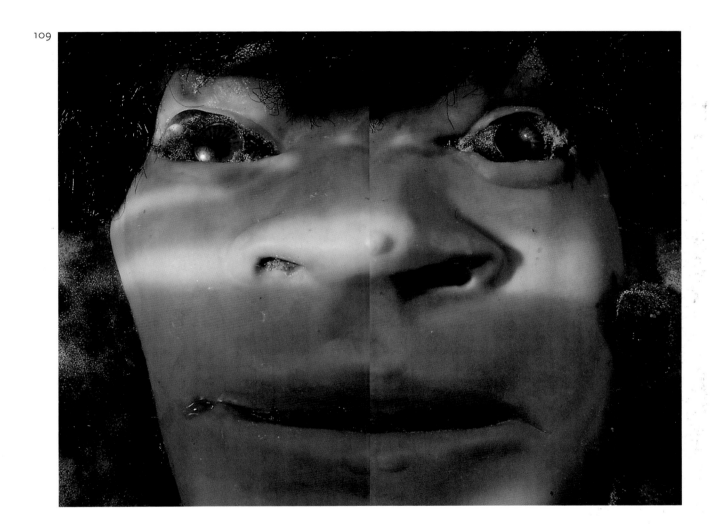

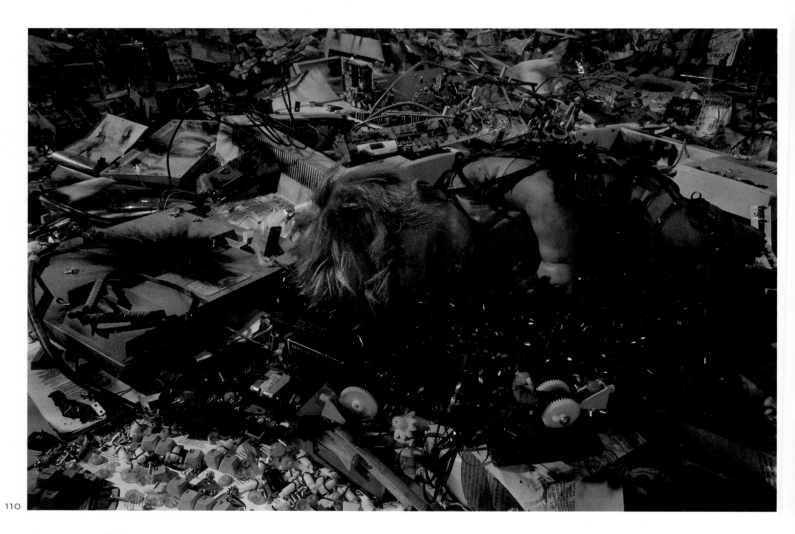

110

plate 110   *Untitled #184*
1988

skeleton - "age" teeth, etc w/ paint

ununu

11-11-88

combining destroyed computer
w/ doll/troll

Use "toys" w/ other elements so that i.e.,
the "Flex-factory" monster doesn't just look
like pieces of a doll or cartoon.

Use depth

Show that it is a toy by showing the
base of "factory"

Spielberg-esque — the toys coming to
life...
( But not cutesy ! )

Ideally the toys should not look
like toys at all

146

plate 111    *Untitled #186*
             1989
plate 112    *Untitled #187*
             1989

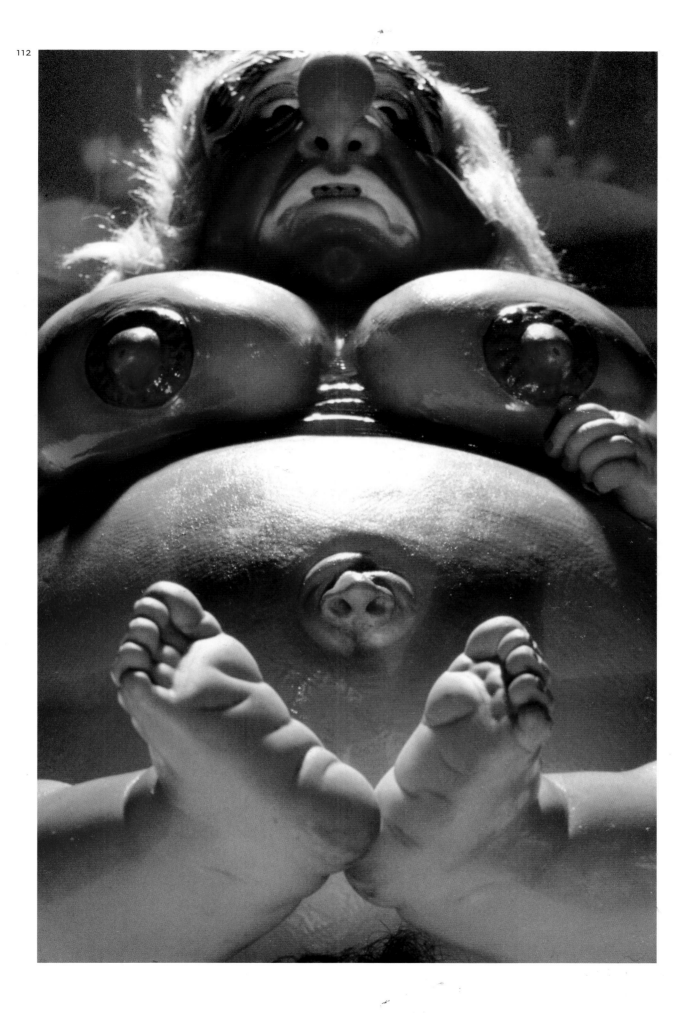

148

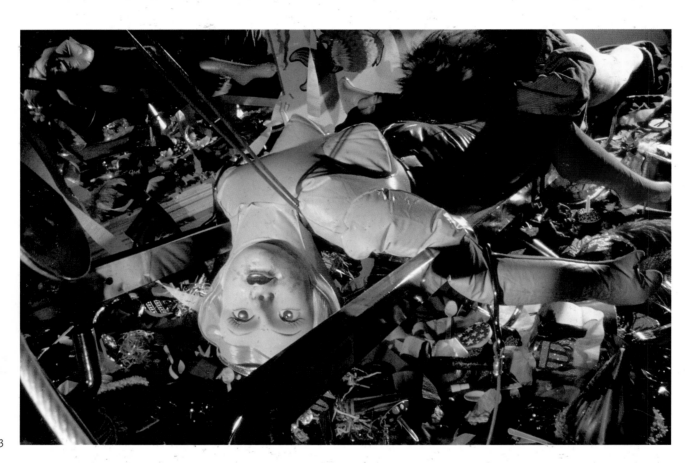

113

plate 113   *Untitled #188*
            1989
plate 114   *Untitled #190*
            1989

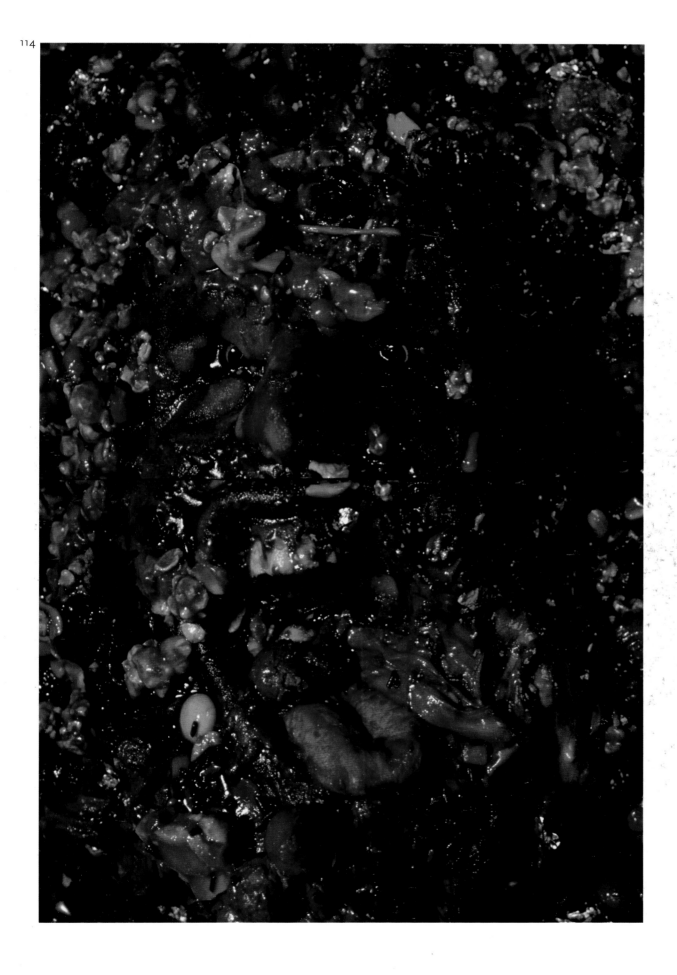

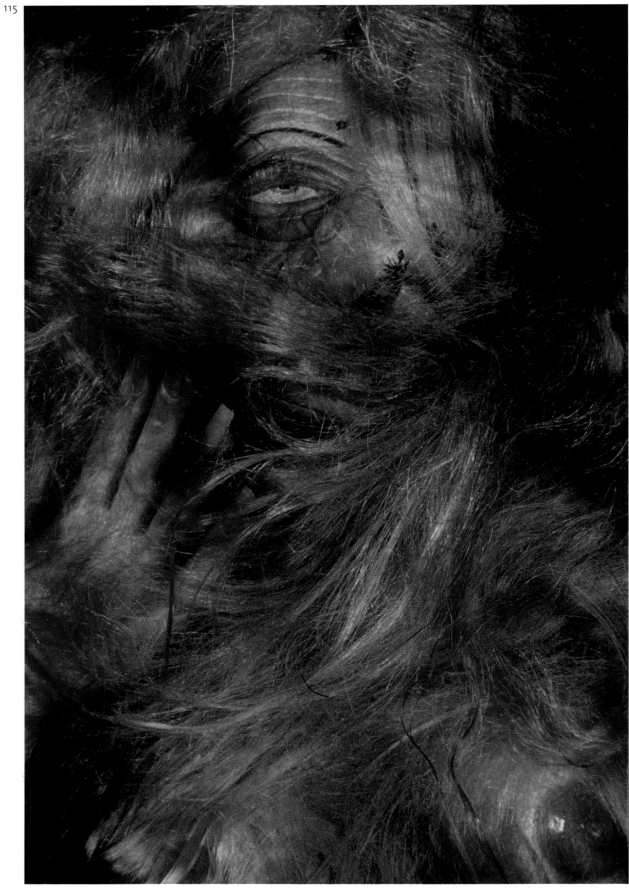

plate 115    *Untitled #191*
1989

4/12/~~89~~ 89

backgrounds:
    curtain / material draped
    solid color / white / black / grey
    projected clouds?
    ~~his~~ " window?
    beam of lite?
    close-up of tapestry
    pattern

*(boxed note: rent from Canal Plastics)*

    bust       fruit
    pillar     candleabra
    statue
    table / chair

props (hand held):
    book
    knife
    gloves
    feather pen
    rosary ?
    sword
    maps / scrolls
    pitcher / goblet
    flowers
  letter
    maps
    clock

152

chair

3-19-90

nude ① — full figure (w/ fur?)  } to look fat
    ② from behind (w/ mirror?)
         (big ass)

③ (tits squirting milk) — madonna?

④ dark simple profile

⑤ old topless woman ?

dark sleeper ?

Judith w/ head

Old ♂ w/ beard

moustached ♂

priest

bare-chested man — pot-bellied
                   muscle-chest

♂ w/ big scar

smiling w/ rotten teeth

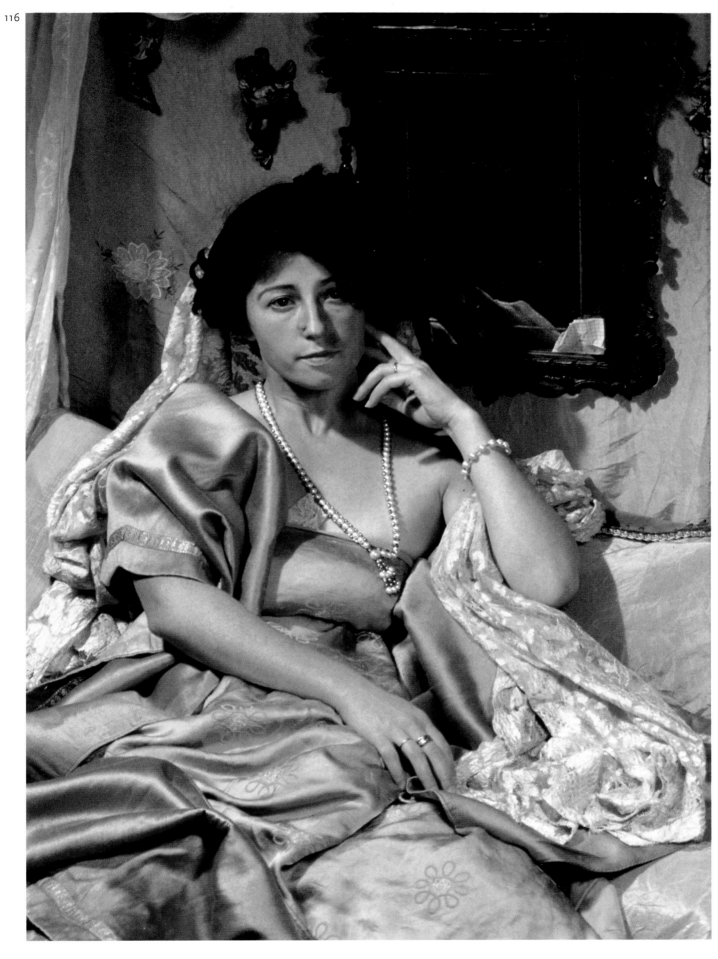

plate 116    *Untitled #204*
1989

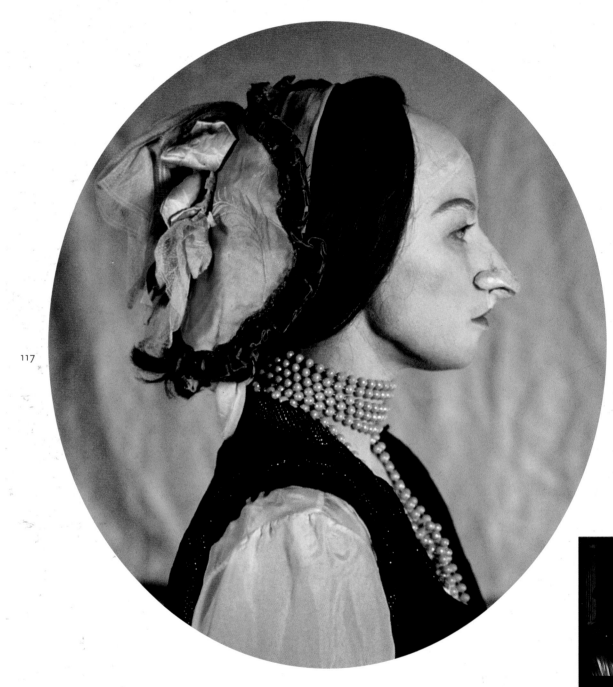

117

plate 117    *Untitled #211*
             1989
plate 118    *Untitled #213*
             1989

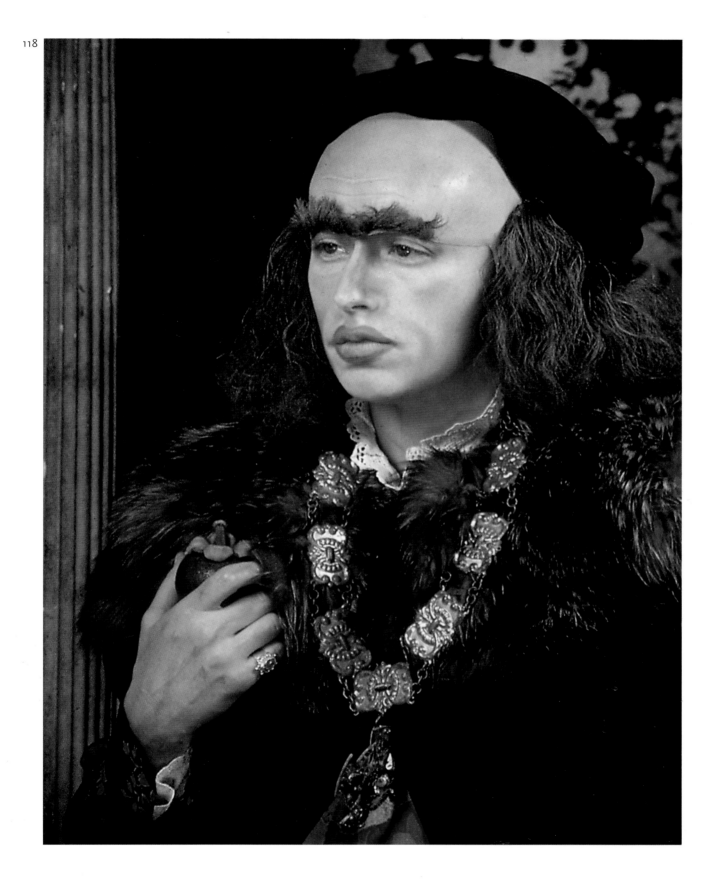

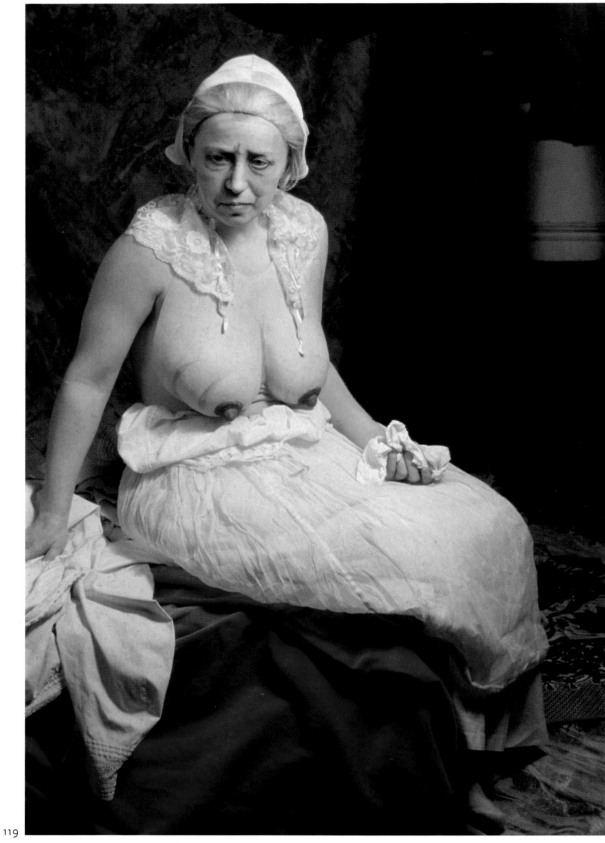

plate 119    *Untitled #222*
              1990
plate 120    *Untitled #223*
              1990

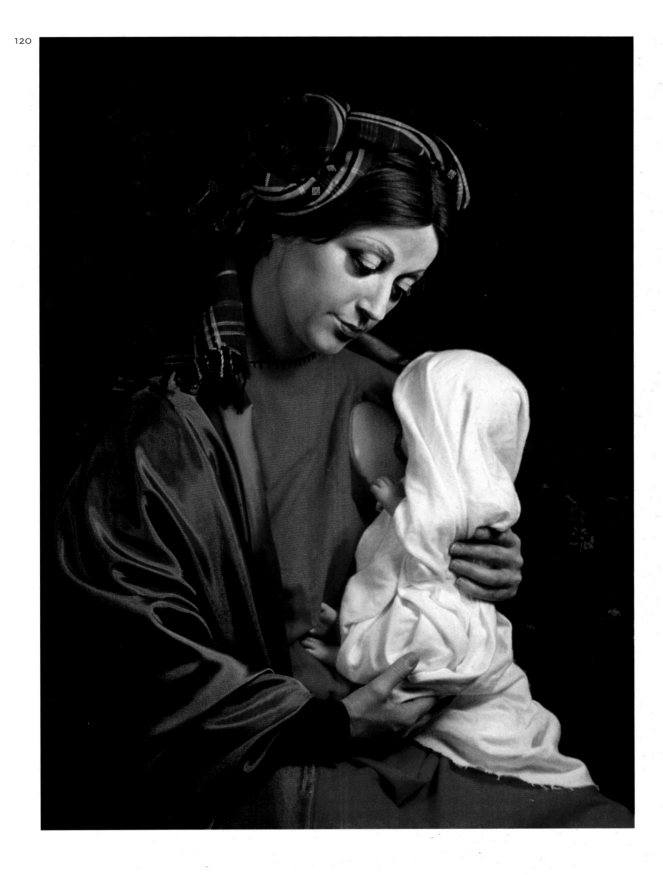

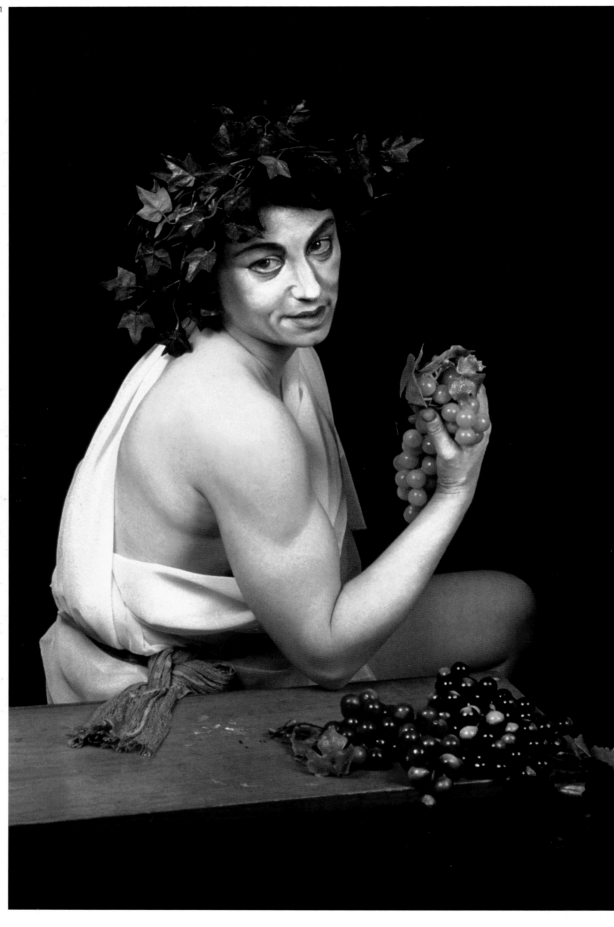

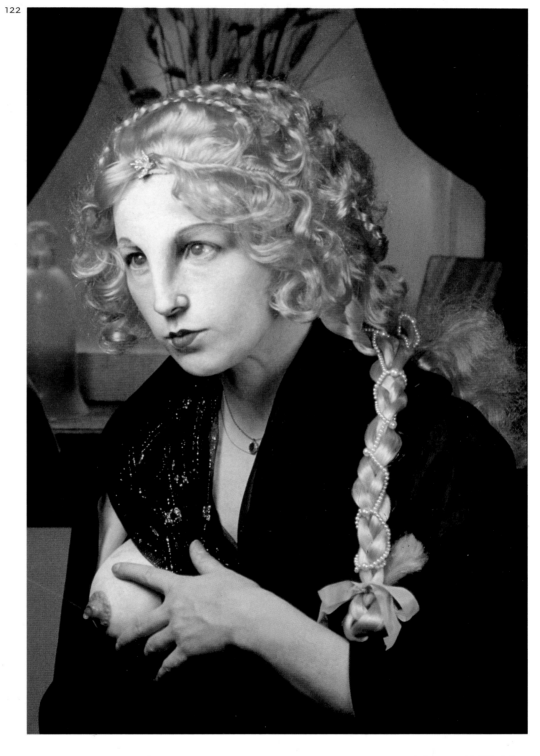

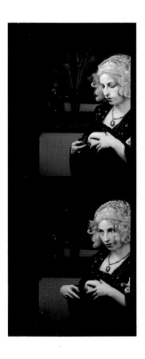

plate 121  *Untitled #224*
1990
plate 122  *Untitled #225*
1990

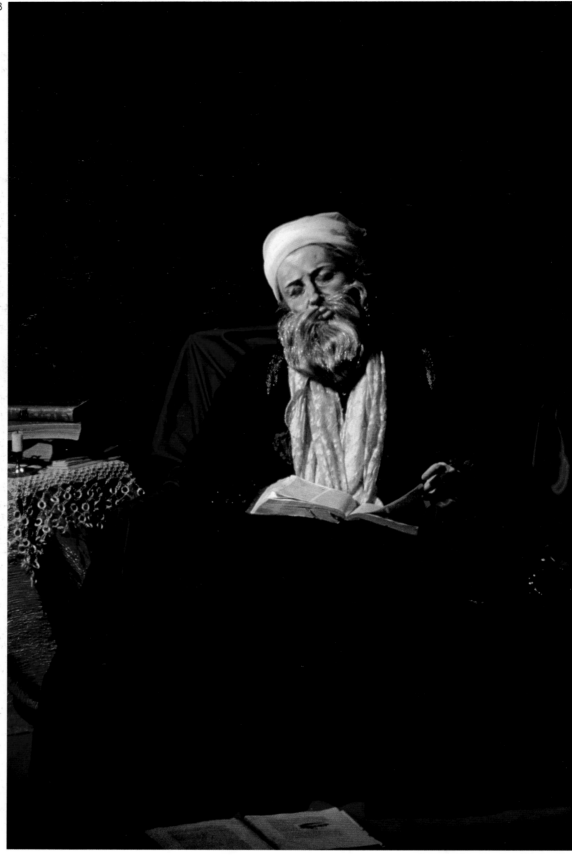

plate 123   *Untitled #227*
            1990
plate 124   *Untitled #236*
            1987/1990

125

plate 125　*Untitled #244*
　　　　　　1991

What could I possibly do when I
want to stop using myself and ~~the~~
~~I~~ don't want "other people" in the
photos?    Dummys
          Photos of other people in the photo
          parts of the body (no face)
          shadows
          "empty" (no people at all) scenes
          wear masks
          blur the face

2/2/92

<u>Sex pix</u>

funny becomes cute & doesn't work

⌐should move more towards terror

Shouldn't be merely about sex perse as
    shock element.
The shock (or terror) should come from
what the sexual elements are really
standing for — death, power, aggression,
beauty, sadness, etc.

It's too easy to make a funny or shocking
picture based solely on the ~~sex organs~~ <sup>appearances</sup>
or revelations of the sex organs (especially
these organs). The difficulty is making
<u>poignant</u> yet <u>explicit</u> imagery.

But I also want to explore the abstract (art-
use of the body parts — a more formal <sup>(tradional)</sup> ~~way~~)
approach.

| | |
|---|---|
| pissing/humiliation | condoms?? |
| S&M | (but perhaps this |
| masturbation | would ~~be~~ almost "date" |
| exhibitimism | the work — although |
| anal sex | if I refer to any |
| oral sex | strait forward "penetrating" |
| castration | sex it would have to be |
| | safe)    ⟶ |

126

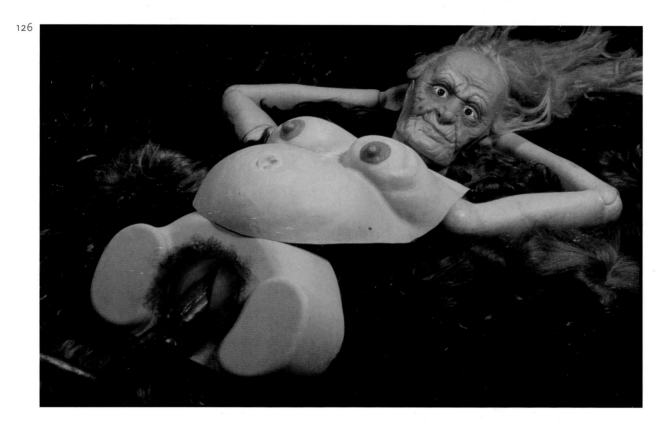

plate 126   *Untitled #250*
          1992

127

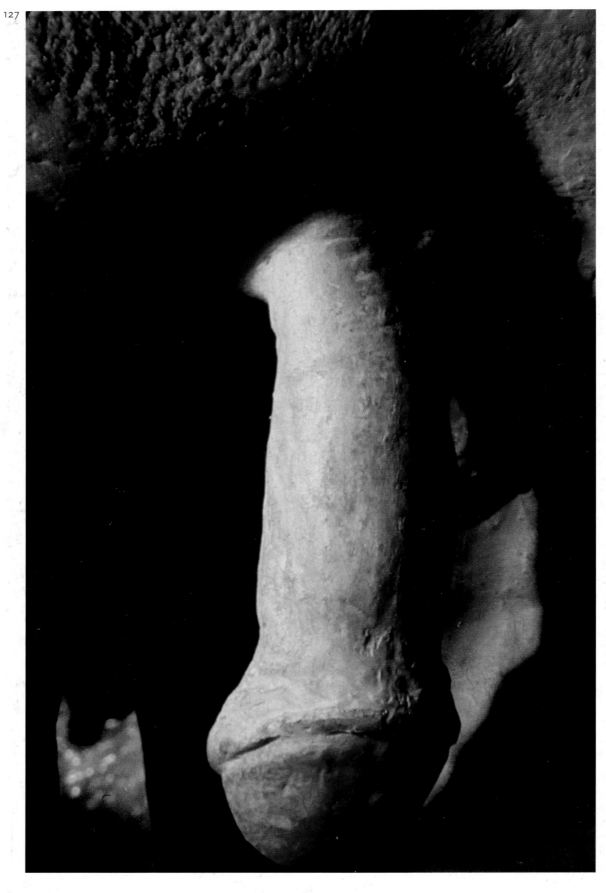

plate 127 *Untitled #252*
1992
plate 128 *Untitled #258*
1992

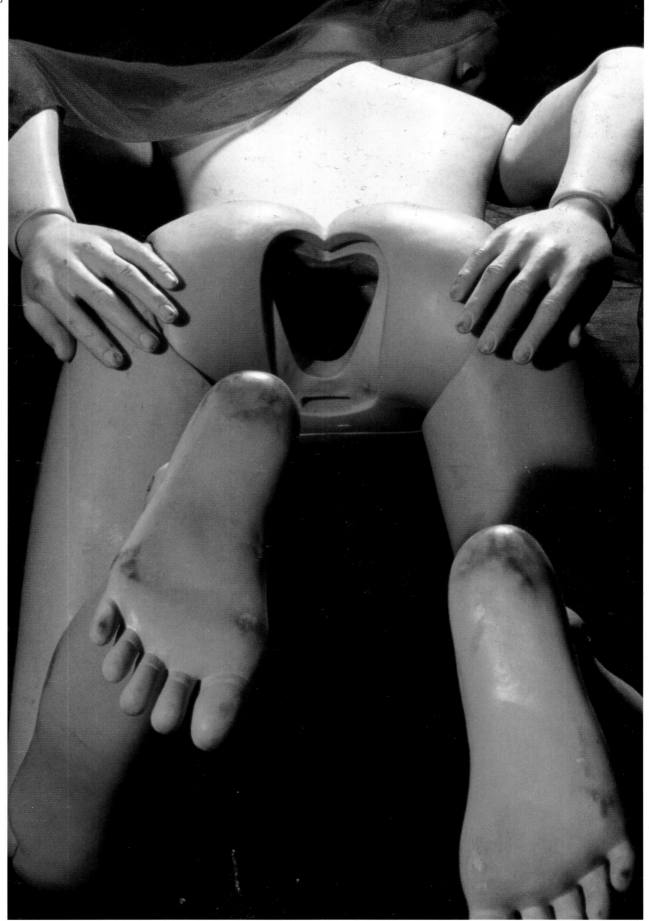

168

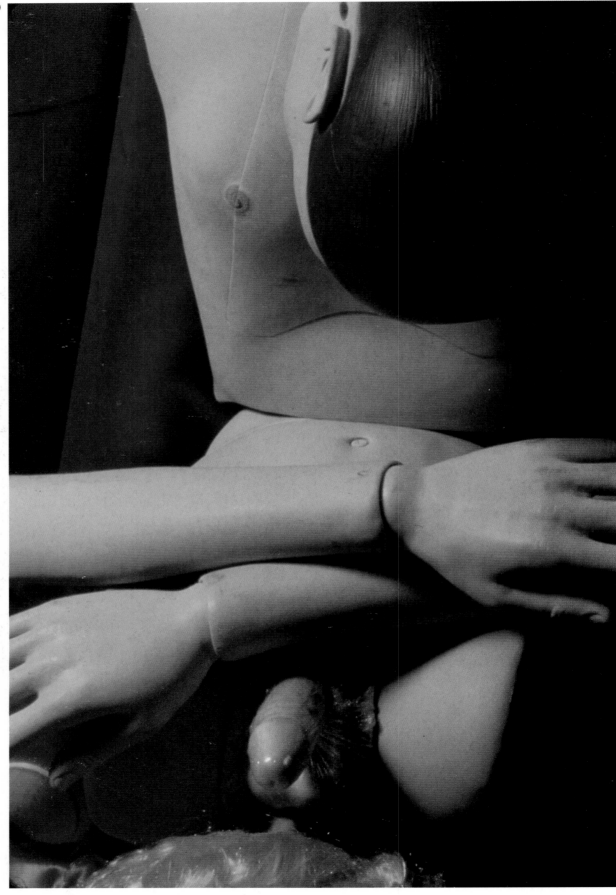

130

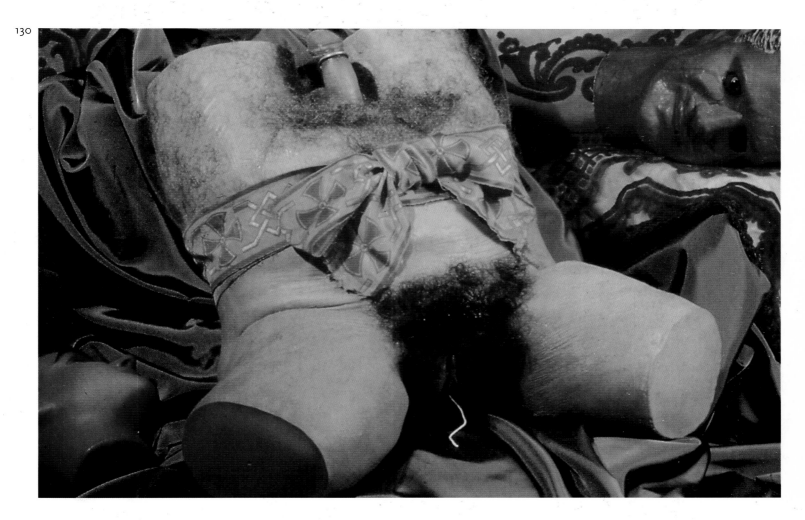

plate 129 *Untitled #259*
1992
plate 130 *Untitled #263*
1992

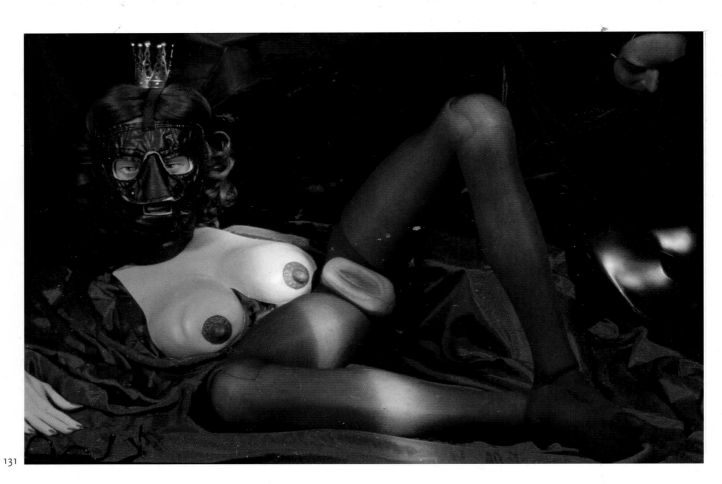

131

plate 131  *Untitled #264*
1992

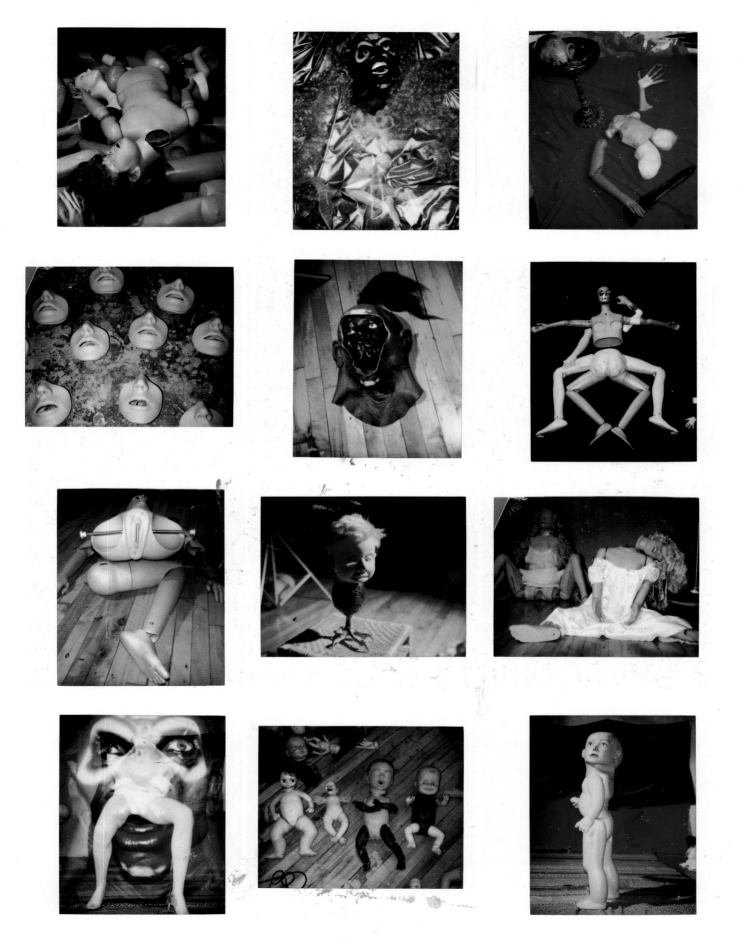

132

plate 132 *Untitled #268*
1992
plate 133 *Untitled #270*
1992

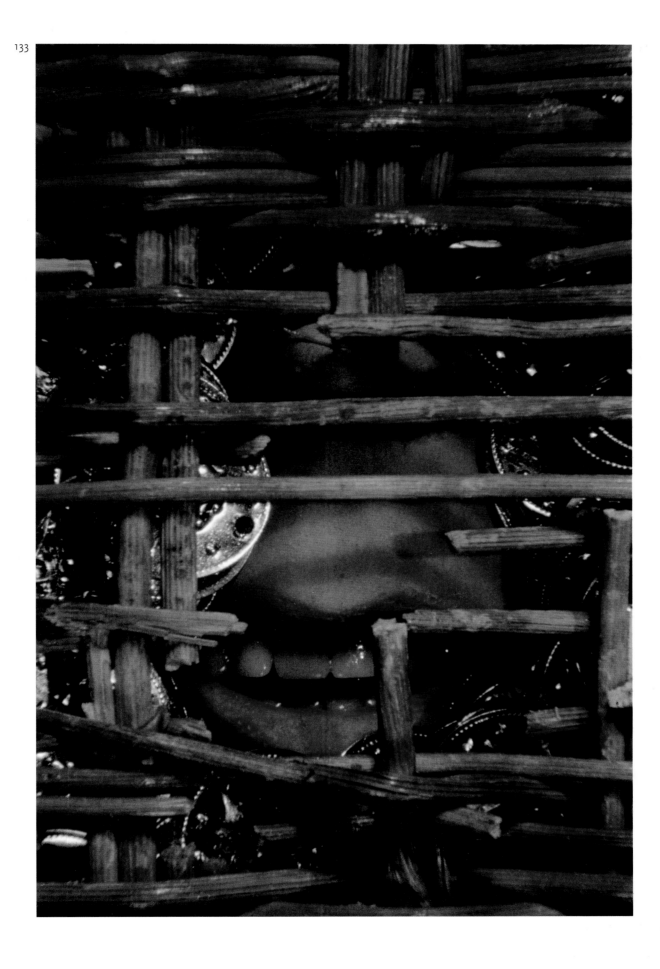

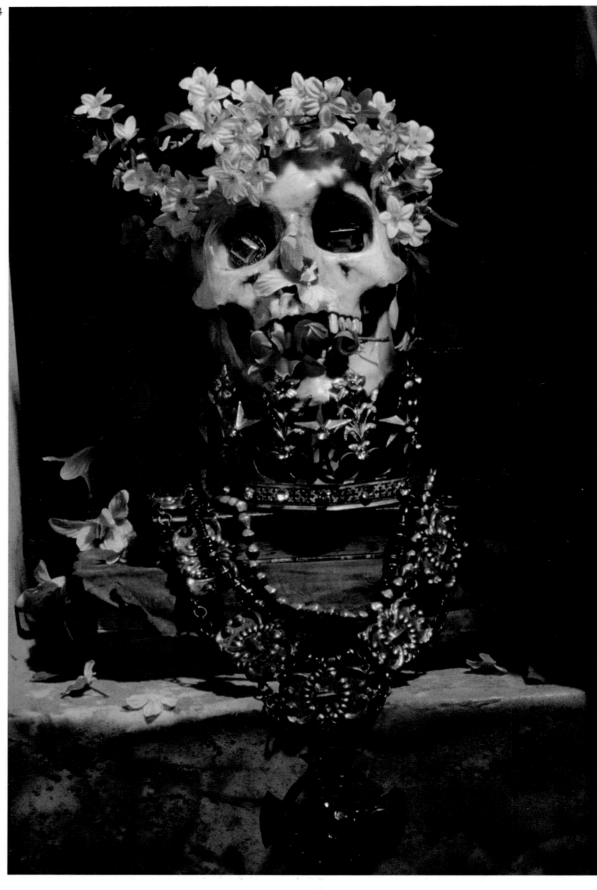

174

134

plate 134 *Untitled #272*
1992
plate 135 *Untitled #286*
1990/94

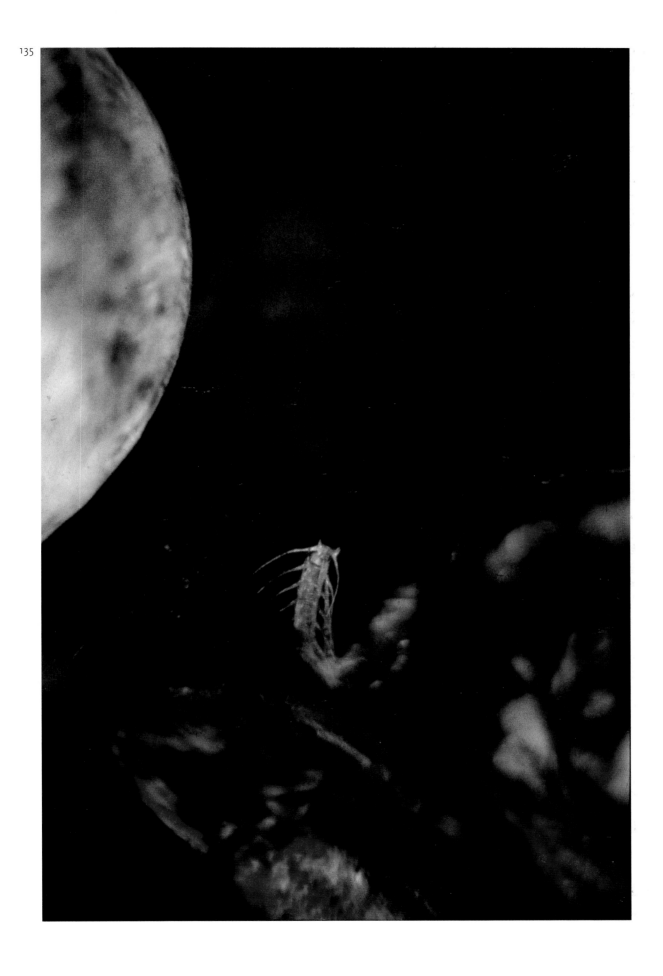

136

plate 136 *Untitled #290*
1990/94
plate 137 *Untitled #299*
1994

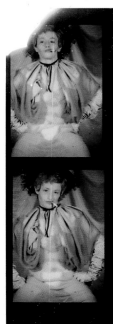

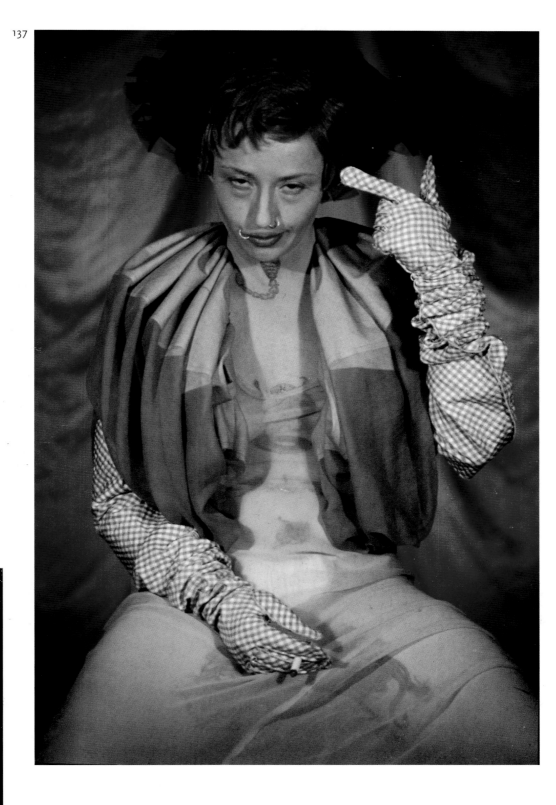

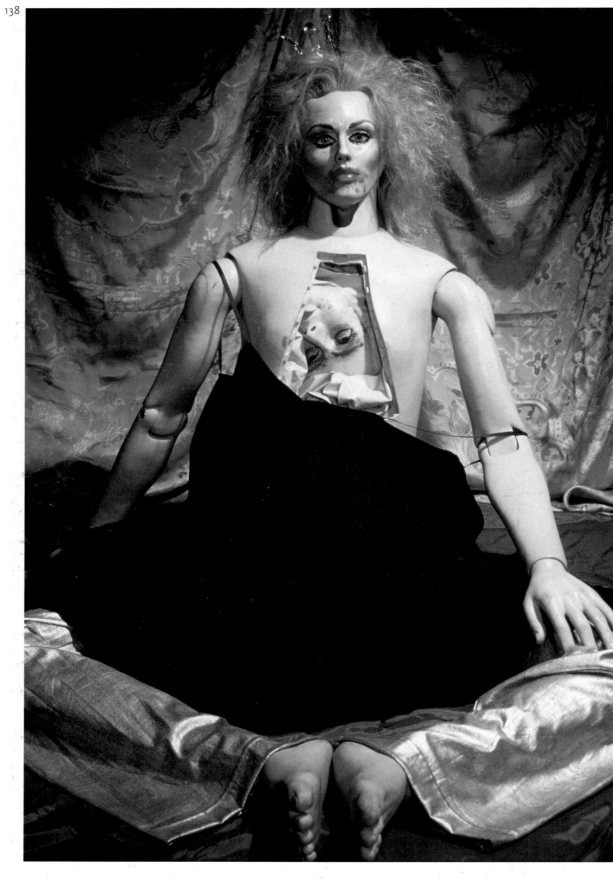

plate 138 *Untitled #302*
        1994
plate 139 *Untitled #303*
        1994

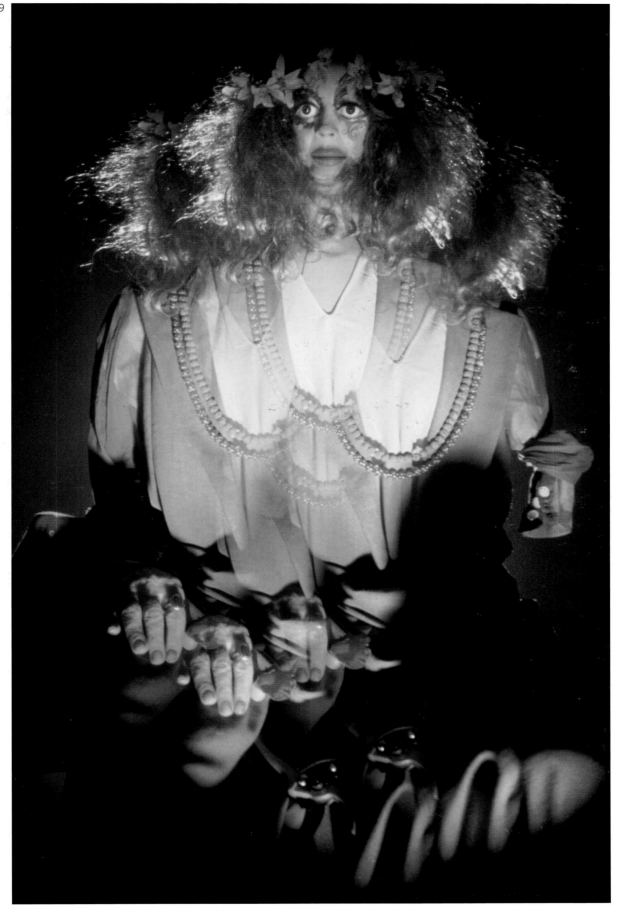

10/5/94

researching dada/surrealist photography
photomontage, etc.
with thoughts to try b/w, collage,
scratching negative (à la fortune teller),
or painting/hand coloring image

After doing polaroids of mannekins in
possible configurations, I realized that
that is (now) the easy part. Again,
what is it I'm trying to say w/ these
body parts? I don't want to be purely
decorative + make pretty, odd images.
If anything, that would be my criticism
of much of the old surrealist stuff.
It is really about esthetics, which, at that
time was groundbreaking in itself, but now
looks merely beautiful + stylish. Whenever
there is a female figure, she's still always
beautiful. It was such a macho movement,
yet even the women artists glorified their fellow female
forms.

140

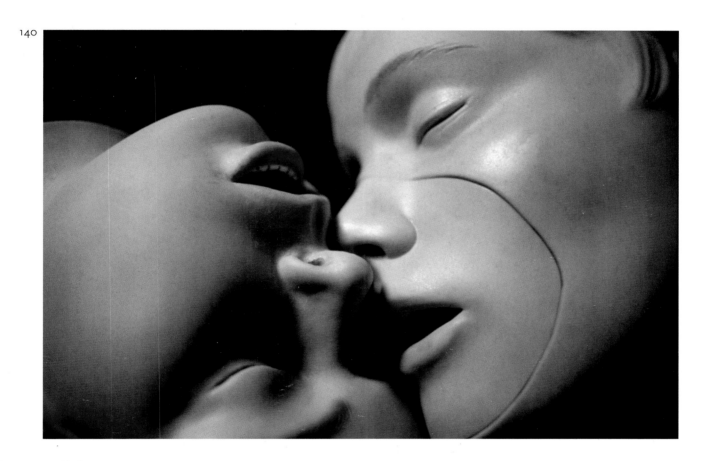

plate 140 *Untitled #305*
     1994

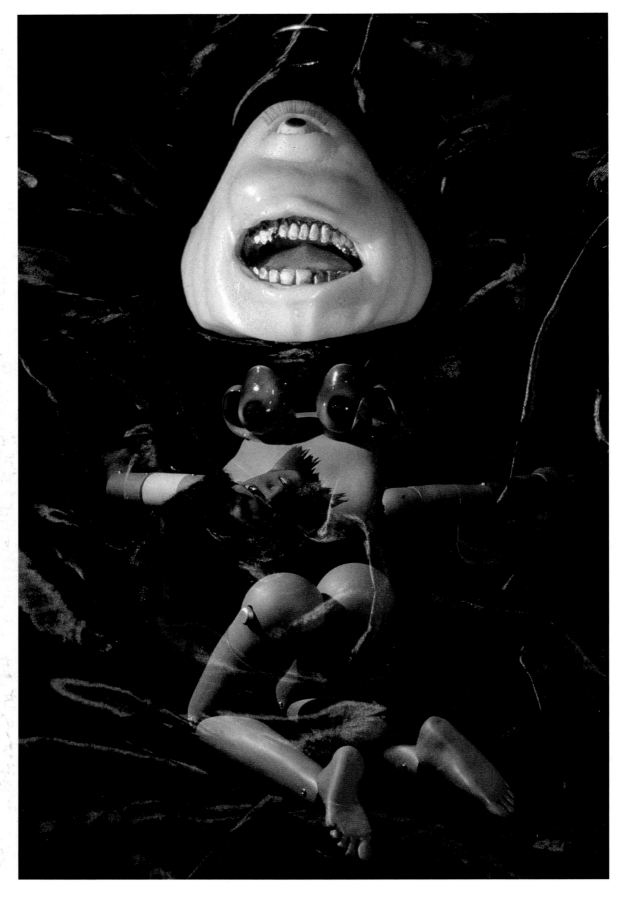

plate 141 *Untitled #308*
      1994
plate 142 *Untitled #311*
      1994

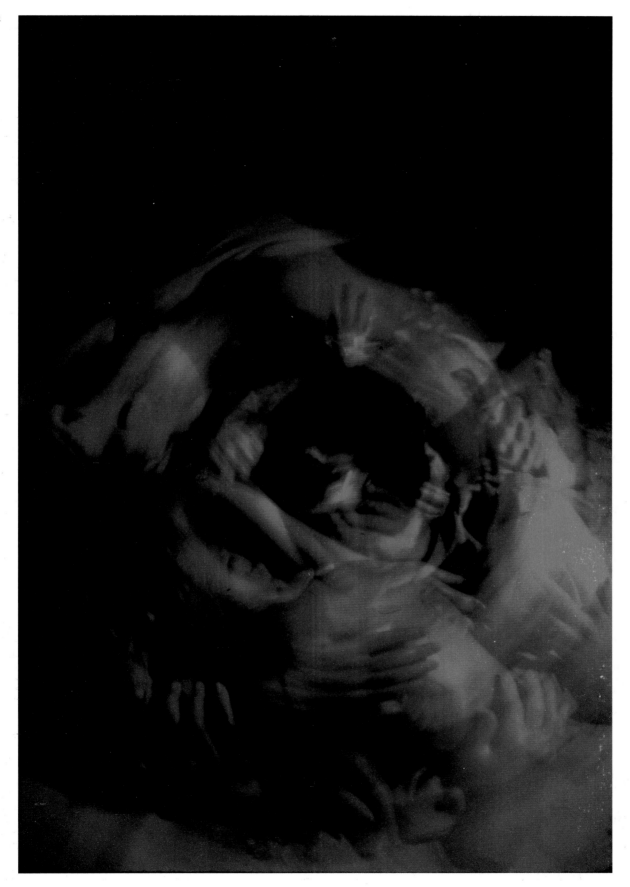

10/18  I'm having a hard time finding
a direction to move in. I guess I'm
not inspired yet. I've been doing
a lot of polaroids of stuff I'm
playing with. Perhaps that's keeping
me from really concentrating, although
I like the idea of it ~~acting~~ functioning like
"sketches"

I can't ~~help~~ ~~a~~ seem to keep from
making everything ~~here so far~~, ~~their~~
have a sexual, "political", or "heavy"
edge, which I don't exactly want
here  If anything, I'd rather make
the work seem politically incorrect. I was
thinking how the surrealists were very
much into de Sade + thus misogynistic
which rather intrequed me, I guess because
~~it never~~ the ~~only~~ main thing that bothered me
with their work was ~~how~~ in the beautification
of the women used, not how they were used
(Not to mention however, how ~~they~~ these men themselves seemed
rather piggish the way girlfriends, wives, etc. ~~etc~~

seem to have been treated, passed around, ~~th~~
used ~~tts~~ as models, while these women ~~themselves~~
were, often, artists themselves ~~themselves~~ & much younger.)

Anyway, I had wanted to explore a
violent, misogynistic direction, à la de Sade &
the boys; instead everything seems too
"loaded" about sex/violence. I guess that
the ~~surrealistic~~ successful surrealistic play
here would be to diffuse the ugly-reality
of misogyny ~~with~~ by twisting the reality - surreal!
                                                  — voilá! —

~~of~~ Theories, theories, theories ... It doesn't
seem to work for me. — Maybe because
it's <u>already</u> been <u>done</u>! That's why everything
seems trite & contrived!

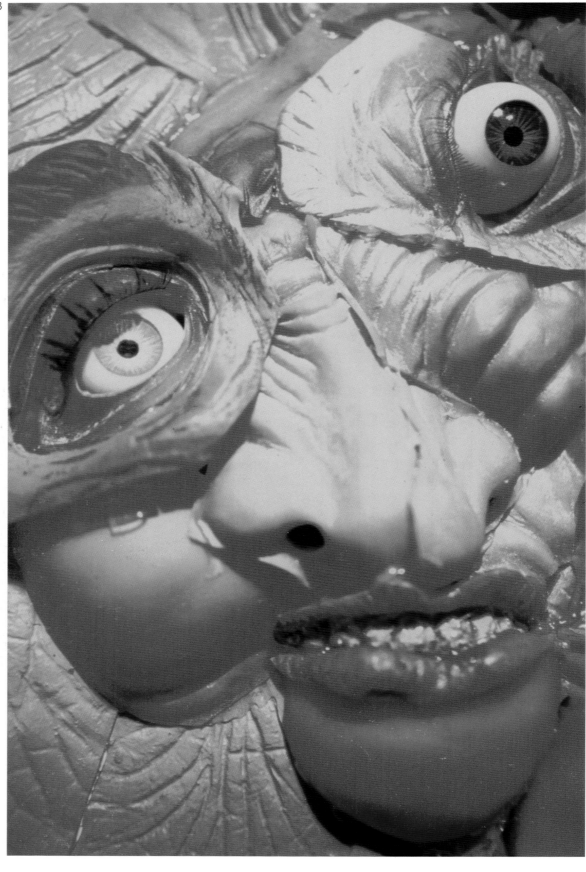

144

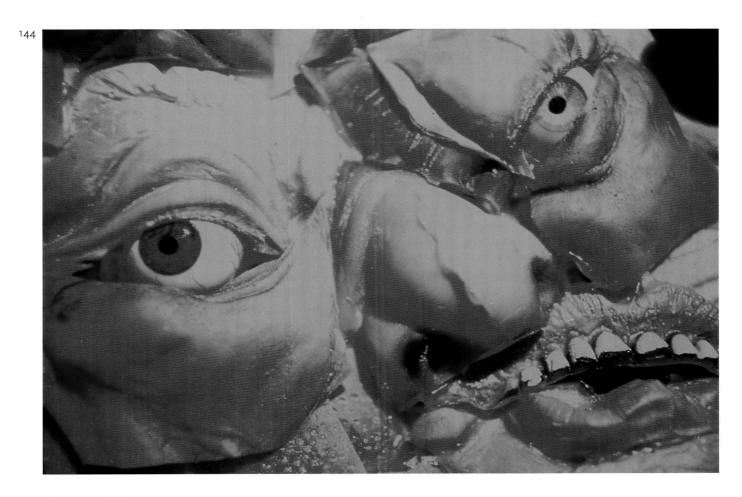

plate 143 *Untitled #314E*
        1994
plate 144 *Untitled #314F*
        1994

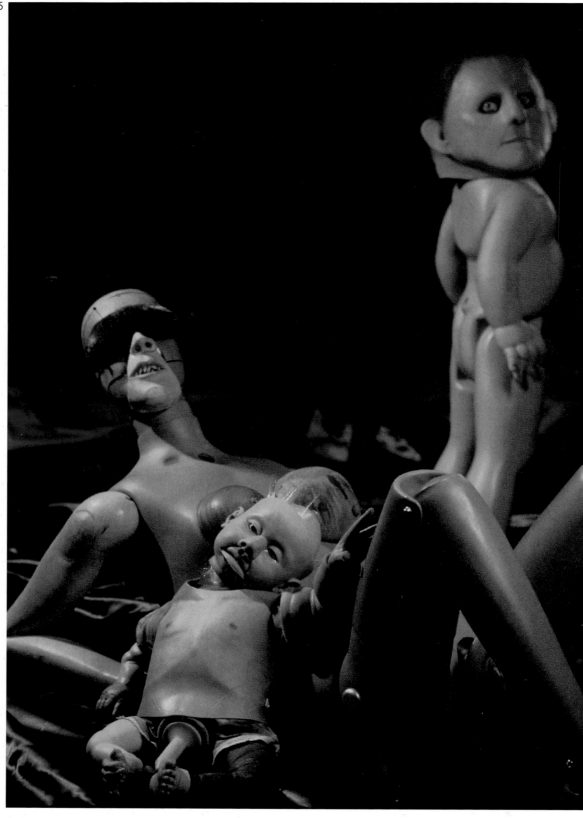

plate 145 *Untitled #312*
1994
plate 146 *Untitled #315*
1995

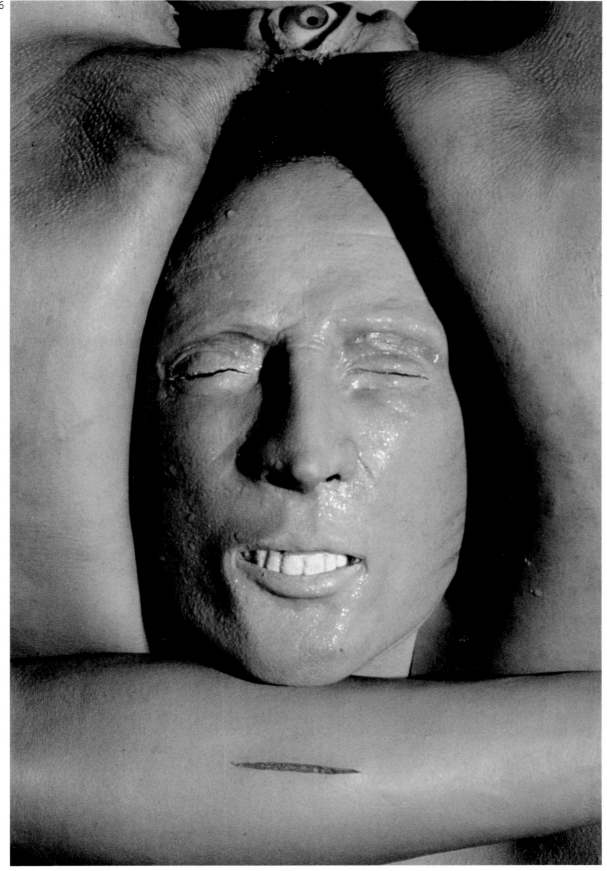

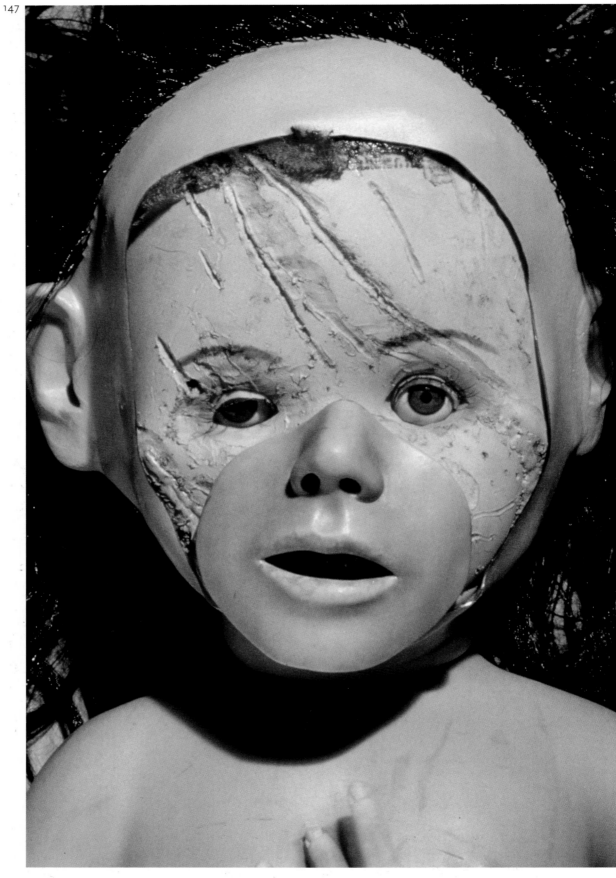

plate 147 *Untitled #316*
        1995
plate 148 *Untitled #317*
        1995

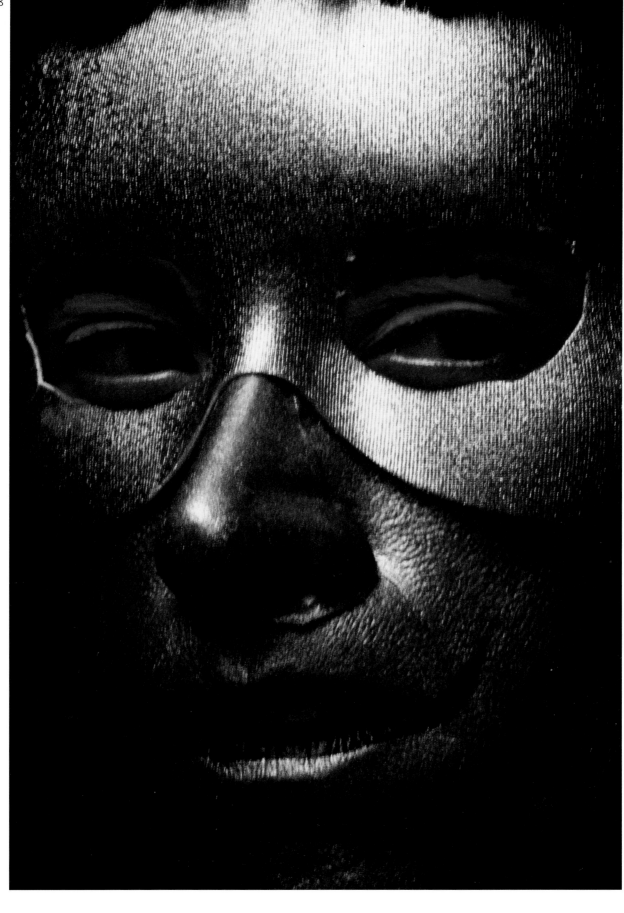

149

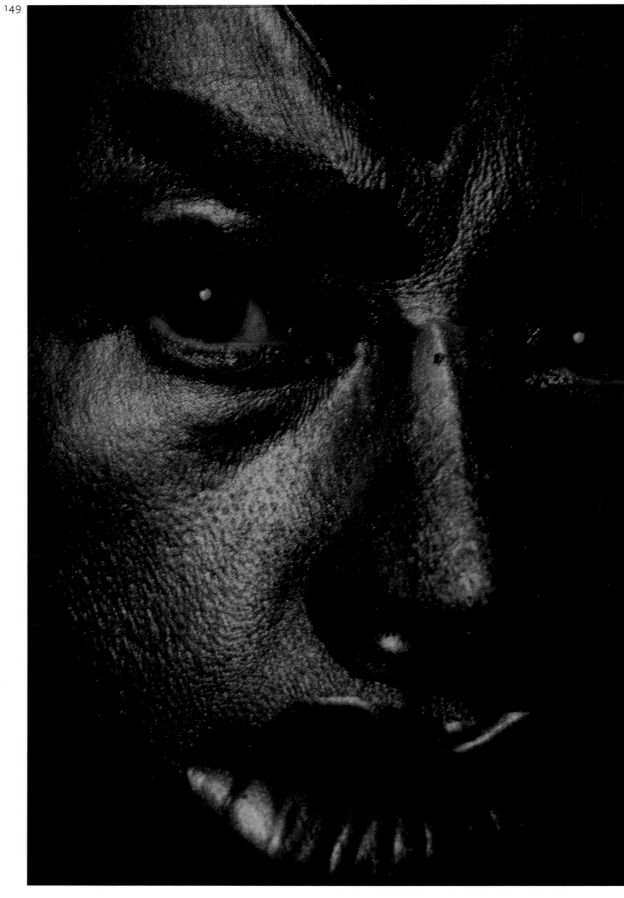

plate 149 *Untitled #323*
1995
plate 150 *Untitled #324*
1995

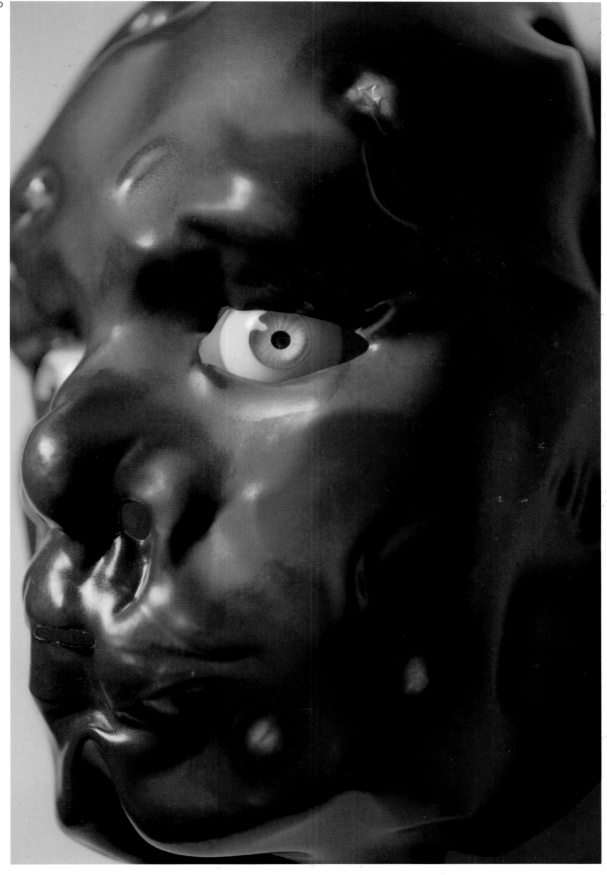

150

193

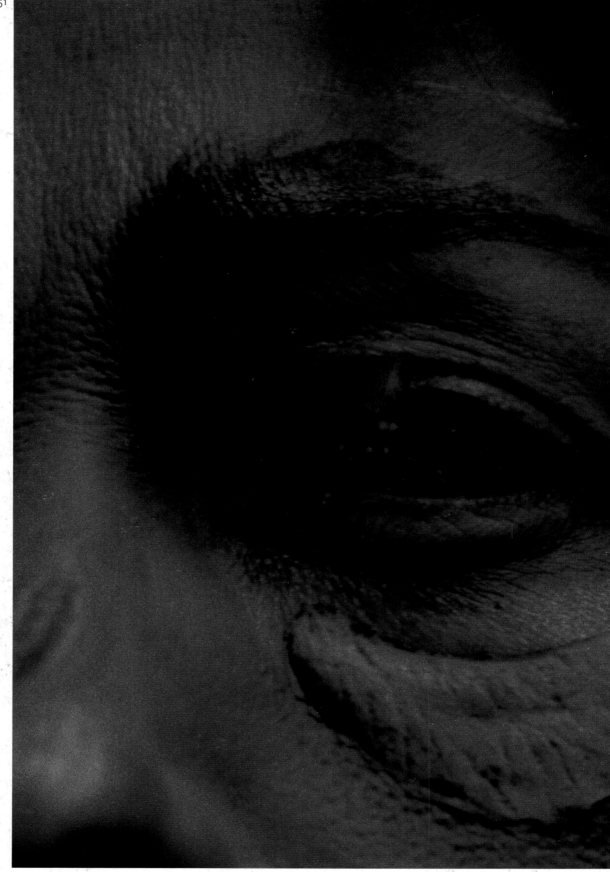

plate 151 *Untitled #326*
1995

# Checklist of the Exhibition

*Dimensions are listed in inches followed by centimeters in parentheses; height precedes width.*

*Untitled A*, 1975
Black-and-white photograph
20 x 16 (50.8 x 40.6)
Edition of 10
Collection Museum of
Contemporary Art, Chicago
Gift of Lannan Foundation

*Untitled B*, 1975
Black-and-white photograph
20 x 16 (50.8 x 40.6)
Edition of 10
Collection Museum of
Contemporary Art, Chicago
Gift of Lannan Foundation

*Untitled C*, 1975
Black-and-white photograph
20 x 16 (50.8 x 40.6)
Edition of 10
Collection Museum of
Contemporary Art, Chicago
Gift of Lannan Foundation

*Untitled D*, 1975
Black-and-white photograph
20 x 16 (50.8 x 40.6)
Edition of 10
Collection Museum of
Contemporary Art, Chicago
Gift of Lannan Foundation

*Untitled E*, 1975
Black-and-white photograph
20 x 16 (50.8 x 40.6)
Edition of 10
Collection Museum of
Contemporary Art, Chicago
Gift of Lannan Foundation

*Untitled Film Stills #1–#61,
#63–#65, #81–#84*
1977–1980
69 black-and-white
photographs
8 x 10 (20.3 x 25.4) each
Edition of 10
Collection of the artist
Courtesy Metro Pictures,
New York

*Untitled #66*, 1980
Color photograph
20 x 24 (50.8 x 61)
Edition of 5
Color photograph
Saatchi Gallery, London

*Untitled #72*, 1980
Color photograph
20 x 24 (50.8 x 61)
Edition of 5
Courtesy of the artist and
Metro Pictures

*Untitled #76*, 1980
Color photograph
20 x 24 (50.8 x 61)
Edition of 5
The Carol and Arthur Goldberg
Collection

*Untitled #88*, 1981
Color photograph
24 x 48 (61 x 121.9)
Edition of 10
The Museum of Contemporary
Art, Los Angeles
The Barry Lowen Collection

*Untitled #90*, 1981
Color photograph
24 x 48 (61 x 121.9)
Edition of 10
Collection of the artist
Courtesy Metro Pictures,
New York

*Untitled #92*, 1981
Color photograph
24 x 48 (61 x 121.9)
Edition of 10
The Eli and Edythe L. Broad
Collection, Los Angeles

*Untitled #93*, 1981
Color photograph
24 x 48 (61 x 121.9)
Edition of 10
Palm Collection, Inc.
Courtesy Per Skarstedt Fine
Art, New York

*Untitled #94*, 1981
Color photograph
24 x 48 (61 x 121.9)
Edition of 10
The Eli and Edythe L. Broad
Collection, Los Angeles

*Untitled #96*, 1981
Color photograph
24 x 48 (61 x 122)
Edition of 10
Collection of Robert and Jane
Rosenblum, New York

*Untitled #97*, 1982
Color photograph
45 x 30 (114.3 x 76.2)
Edition of 10
The Eli and Edythe L. Broad
Collection, Los Angeles

*Untitled #98*, 1982
Color photograph
45 x 30 (114.3 x 76.2)
Edition of 10
The Eli and Edythe L. Broad
Collection, Los Angeles

*Untitled #102*, 1981
Color photograph
49 x 24 (124.5 x 61)
Edition of 10
Collection of Eileen and
Michael Cohen, New York

*Untitled #105*, 1982
Color photograh
30 x 19 3/4 (76.2 x 50.2)
Edition of 10
Courtesy of the artist and
Metro Pictures

*Untitled #109*, 1982
Color photograph
36 x 36 (91.4 x 91.4)
Edition of 10
Collection of Ellen Kern,
New York

*Untitled #112*, 1982
Color photograph
45 1/4 x 30 (114.9 x 76.2)
Edition of 10
The Eli and Edythe L. Broad
Collection, Los Angeles

*Untitled #113*, 1982
Color photograph
45 1/4 x 30 (114.9 x 76.2)
Edition of 10
Collection of The Museum of
Modern Art, New York
Gift of Werner and Elaine
Dannheisser

*Untitled #114*, 1982
Color photograph
49 x 30 (124.5 x 76.2)
Edition of 10
The Eli and Edythe L. Broad
Collection, Los Angeles

*Untitled #116*, 1982
Color photograph
45 1/4 x 30 (114.9 x 76.2)
Edition of 10
The Eli and Edythe L. Broad
Collection, Los Angeles

*Untitled #119*, 1983
Color photograph
17 1/2 x 36 (44.5 x 91.4)
Edition of 18
The Eli and Edythe L. Broad
Collection, Los Angeles

*Untitled #120*, 1983
Color photograph
34 1/2 x 21 3/4 (87.6 x 55.2)
Edition of 18
The Eli and Edythe L. Broad
Collection, Los Angeles

*Untitled #122*, 1983
Color photograph
35 1/4 x 21 1/4 (89.5 x 54)
Edition of 18
The Eli and Edythe L. Broad
Collection, Los Angeles

*Untitled #131*, 1983
Color photograph
34 3/4 x 16 1/2 (88.3 x 41.9)
Edition of 18
The Eli and Edythe L. Broad
Collection, Los Angeles

*Untitled #132*, 1984
Color photograph
69 x 47 (175.3 x 119.4)
Edition of 5
Courtesy of the artist and
Metro Pictures

*Untitled #133*, 1984
Color photograph
71 1/4 x 47 1/2 (181 x 120.7)
Edition of 5
The Marieluise Hessel
Collection on permanent loan
to the Center for Curatorial
Studies, Bard College,
Annandale-on-Hudson,
New York

*Untitled #137*, 1984
Color photograph
70 1/2 x 47 3/4 (179.1 x 121.3)
Edition of 5
The Eli and Edythe L. Broad
Collection, Los Angeles

*Untitled #138*, 1984
Color photograph
71 x 48 1/2 (180.3 x 123.2)
Edition of 5
Collection of The Eli Broad
Family Foundation, Santa
Monica

*Untitled #140*, 1985
Color photograph
72 1/2 x 49 3/8 (184.2 x 125.4)
Edition of 6
Collection of Susan and Lewis
Manilow, Chicago

*Untitled #146*, 1985
Color photograph
72 1/2 x 49 3/8 (184.2 x 125.4)
Edition of 6
Collection of The Eli Broad
Family Foundation,
Santa Monica

*Untitled #147*, 1985
Color photograph
49 1/2 x 72 3/4 (125.7 x 184.8)
Edition of 6
Collection Museum of
Contemporary Art, Chicago
Gerald S. Elliott Collection

*Untitled #150*, 1985
Color photograph
49 1/2 x 66 3/4 (125.7 x 169.5)
Edition of 6
Per Skarstedt Fine Art,
New York

*Untitled #153*, 1985
Color photograph
65 1/2 x 47 1/2 (166.4 x 120.7)
Edition of 6
Collection Museum of
Contemporary Art, Chicago
Gift of Gerald S. Elliott by
exchange

*Untitled #154*, 1985
Color photograph
72 1/2 x 49 3/8 (184.2 x 125.4)
Edition of 6
Collection of Susan and Lewis
Manilow, Chicago

*Untitled #155*, 1985
Color photograph
72 1/2 x 49 1/4 (184.2 x 125.1)
Edition of 6
Per Skarstedt Fine Art,
New York

*Untitled #156*, 1985
Color photograph
49 1/2 x 72 1/2 (125.7 x 184.2)
Edition of 6
Saatchi Gallery, London

*Untitled #160*, 1986
Color photograph
50 1/8 x 33 3/8 (127.3 x 84.8)
Edition of 6
Courtesy of the artist and
Metro Pictures

*Untitled #166*, 1987
Color photograph
59 1/4 x 35 1/4 (150.5 x 89.5)
Edition of 6
Courtesy of the artist and
Metro Pictures

*Untitled #168*, 1987
Color photograph
85 x 60 (215.9 x 152.4)
Edition of 6
Collection of The Eli Broad
Family Foundation,
Santa Monica

*Untitled #175*, 1987
Color photograph
47 1/2 x 71 1/2 (120.7 x 181.6)
Edition of 6
Courtesy of the artist and
Metro Pictures

*Untitled #177*, 1987
Color photograph
47 1/3 x 71 1/3 (120.2 x 181.2)
Edition of 6
Collection of Mike Kelley,
Los Angeles

*Untitled #180*, 1987
Color photograph
96 x 120 (243.8 x 304.8) (two
parts; each 96 x 60, (243.8 x
152.4 ))
Edition of 6
Collection of The Eli Broad
Family Foundation,
Santa Monica

*Untitled #184*, 1988
Color photograph
59 1/4 x 89 1/4 (150.5 x 226.7)
Edition of 6
Robert Shiffler Collection and
Archive, Greenville, Ohio

*Untitled #186*, 1989
Color photograph
44 3/4 x 29 1/4 (113.7 x 74.3)
Edition of 6
Courtesy of the artist and
Metro Pictures

*Untitled #187*, 1989
Color photograph
71 x 46 1/2 (180.3 x 118.1)
Edition of 6
Courtesy of the artist and
Metro Pictures

*Untitled #188*, 1989
Color photograph
44 3/8 x 66 5/8 (112.7 x 169.2)
Edition of 6
Collection Museum of
Contemporary Art, Chicago
Gerald S. Elliott Collection

*Untitled #190*, 1989
Color photograph
92 1/2 x 71 (235 x 180.3) (two
parts; each 46 1/4 x 71 (117.5 x
180.3))
Edition of 6
Collection of The Eli Broad
Family Foundation,
Santa Monica

*Untitled #191*, 1989
Color photograph
90 x 60 (228.6 x 152.4)
Edition of 6
Collection of The Eli Broad
Family Foundation,
Santa Monica

*Untitled #204*, 1989
Color photograph
59 3/4 x 53 1/4 (151.8 x 135.3)
Edition of 6
Collection of Rita Krauss,
New York

*Untitled #211*, 1989
Color photograph
37 x 31 (94 x 78.7)
Edition of 6
The Eli and Edythe L. Broad
Collection, Los Angeles

*Untitled #213*, 1989
Color photograph
41 1/2 x 33 (105.4 x 83.8)
Edition of 6
Collection of The Birmingham
Museum of Art, Birmingham,
Alabama; Museum purchase
with funds provided by the
Acquisitions Fund and Rena
Hill Selfe

*Untitled #222*, 1990
Color photograph
60 x 44 (152.4 x 111.8)
Edition of 6
Collection of Raymond and
Elizabeth Goetz, Lawrence,
Kansas

*Untitled #223*, 1990
Color photograph
58 x 42 (147.3 x 106.7)
Edition of 6
Collection of Philip and
Beatrice Gersh, Beverly Hills

*Untitled #224*, 1990
Color photograph
48 x 38 (121.9 x 96.5)
Edition of 6
Collection of Linda and Jerry
Janger, Los Angeles

*Untitled #225*, 1990
Color photograph
48 x 33 (121.9 x 83.8)
Edition of 6
Collection of The Eli Broad
Family Foundation,
Santa Monica

*Untitled #227*, 1990
Color photograph
77 x 50 (195.6 x 127)
Edition of 6
Collection of Howard
Rachofsky, Dallas

*Untitled #236*, 1987/1990
Color photograph
90 x 60 (228.6 x 152.4)
Edition of 6
Courtesy of the artist and
Metro Pictures

*Untitled #244*, 1991
Color photograph
47 x 70 (119.4 x 177.8)
Edition of 6
Courtesy of the artist and
Metro Pictures

*Untitled #250*, 1992
Color photograph
50 x 75 (127 x 190.5)
Edition of 6
Collection of Sandra
Simpson, Toronto

*Untitled #252*, 1992
Color photograph
75 x 50 (190.5 x 127)
Edition of 6
Courtesy of the artist and
Metro Pictures

*Untitled #258*, 1992
Color photograph
68 x 45 (172.7 x 114.3)
Edition of 6
Collection of Barbara and
Howard Morse, New York

*Untitled #259*, 1992
Color photograph
60 x 40 (152.4 x 101.6)
Edition of 6
Collection of Charles-Henri
Filippi, Paris

*Untitled #263*, 1992
Color photograph
40 x 60 (101.6 x 152.4)
Edition of 6
Courtesy the artist and
Metro Pictures

*Untitled #264*, 1992
Color photograph
50 x 75 (127 x 190.5)
Edition of 6
Collection of The Eli Broad
Family Foundation,
Santa Monica

*Untitled #268*, 1992
Color photograph
26 1/2 x 40 (67.3 x 101.6)
Edition of 6
Courtesy of the artist and
Metro Pictures

*Untitled #270*, 1992
Color photograph
26 1/2 x 40 (67.3 x 101.6)
Edition of 6
Courtesy of the artist and
Metro Pictures

*Untitled #272*, 1992
Color photograph
26 1/2 x 40 (67.3 x 101.6)
Edition of 6
Courtesy of the artist and
Metro Pictures

*Untitled #286*, 1990/94
Color photograph
53 x 38 (134.6 x 96.5)
Edition of 6
Courtesy of the artist and
Metro Pictures

*Untitled #290*, 1990/94
Color photograph
38 x 53 (96.5 x 134.6)
Edition of 6
Courtesy of the artist and
Metro Pictures

*Untitled #299*, 1994
Color photograph
48 7/8 x 32 15/16 (124.1 x 83.7)
Edition of 6
Collection of Gary
Sibley, Dallas

*Untitled #302*, 1994
Color photograph
66 1/16 x 45 (167.8 x 114.3)
Edition of 6
Collection of Howard
Rachofsky, Dallas

*Untitled #303*, 1994
Color photograph
67 3/4 x 43 (172.1 x 109.2)
Edition of 6
Courtesy of the artist and
Metro Pictures

*Untitled #305*, 1994
Color photograph
49 3/4 x 73 1/2 (126.4 x 186.7)
Edition of 6
The Marieluise Hessel
Collection on permanent loan
to the Center for Curatorial
Studies, Bard College,
Annandale-on-Hudson,
New York

*Untitled #308*, 1994
Color photograph
69 1/2 x 47 (176.5 x 119.4)
Edition of 6
Courtesy of the artist and
Metro Pictures

*Untitled #311*, 1994
Color photograph
76 x 51 (193 x 129.5)
Edition of 6
Collection of The Eli Broad
Family Foundation, Santa
Monica

*Untitled #312*, 1994
Color photograph
61 x 41 1/2 (154.9 x 105.4)
Edition of 6
Courtesy of the artist and
Metro Pictures

*Untitled #314E*, 1994
Color photograph
44 x 30 (111.8 x 76.2)
Edition of 6
Courtesy of the artist and
Metro Pictures

*Untitled #314F*, 1994
Color photograph
30 x 40 (76.2 x 101.6)
Edition of 6
Courtesy of the artist and
Metro Pictures

*Untitled #315*, 1995
Color photograph
60 x 40 (152.4 x 101.6)
Edition of 6
Collection of The Eli Broad
Family Foundation, Santa
Monica

*Untitled #316*, 1995
Color photograph
48 x 32 (121.9 x 81.3)
Edition of 6
Courtesy of the artist and
Metro Pictures

*Untitled #317*, 1995
Color photograph
58 x 38 (147.3 x 96.5)
Edition of 6
Collection of Audrey and
Sydney Irmas

*Untitled #323*, 1995
Color photograph
57 7/8 x 39 (147 x 99.1)
Edition of 6
Collection of William and Ruth
True, Seattle

*Untitled #324*, 1995
Color photograph
58 x 38 (147.3 x 96.5)
Edition of 6
Collection of The Eli Broad
Family Foundation, Santa
Monica

*Untitled #326*, 1995
Color photograph
58 7/8 x 38 (149.5 x 96.5)
Edition of 6
Courtesy the artist and
Metro Pictures

# Biography

Born in Glen Ridge, NJ, 1954
Lives and works in New York, NY

**1976**
State University of New York at Buffalo, Buffalo, NY, BA

**1995**
MacArthur Grant

**Solo Exhibitions**

**1979**
Hallwalls Contemporary Arts Center, Buffalo, NY

**1980**
Contemporary Arts Museum, Houston, TX (also 1982)
The Kitchen, New York, NY
Metro Pictures, New York, NY (also 1995, 1992, 1990, 1989, 1987, 1985, 1983, 1982, 1981)

**1981**
Saman Gallery, Genoa, Italy
Young/Hoffman Gallery, Chicago, IL

**1982**
Galerie Chantal Crousel, Paris, France
Larry Gagosian Gallery, Los Angeles, CA
The Stedelijk Museum, Amsterdam, The Netherlands; (1982–1984) Gewad, Ghent, Belgium; Watershed Gallery, Bristol, England; John Hansard Gallery, University of Southampton, England; Palais Stutterheim, Erlangen, West Germany; Haus am Waldsee, West Berlin, West Germany; Centre d'Art Contemporain, Geneva, Switzerland; Sonja Henie-Niels Onstadt

Foundation, Copenhagen, Denmark; Louisiana Museum, Humlebaek, Denmark
Texas Gallery, Houston, TX (also 1993)

**1983**
Fine Arts Center Gallery, State University of New York at Stony Brook; Zilkha Gallery, Wesleyan University, Middletown, CT
Galerie Schellmann & Klüser, Munich, Germany
Musée d'Art et d'Industrie de Saint Etienne, France
Rhona Hoffman Gallery, Chicago, IL
The St. Louis Art Museum, St. Louis, MO

**1984**
Akron Art Museum; (1984–1986) Institute of Contemporary Art, Philadelphia, PA; Museum of Art, Carnegie Institute, Pittsburgh, PA; Des Moines Art Center, Des Moines, IA; The Baltimore Museum of Art, Baltimore, MD
Galerie Grita Insam, Vienna, Austria
Laforet Museum, Tokyo, Japan
Monika Sprüth Galerie, Cologne, Germany (also 1992, 1990, 1988)
Seibu Gallery of Contemporary Art, Tokyo, Japan

**1985**
Westfalischer Kunstverein, Münster, West Germany

**1986**
Galerie Crousel-Hussenot, Paris, France
Portland Art Museum, Portland, OR
The New Aldrich Museum, Ridgefield, CT
Wadsworth Atheneum, Hartford, CT

**1987**
Hoffman Borman Gallery, Los Angeles, CA
Provinciaal Museum, Hasselt, Belgium
Whitney Museum of American Art, New York, NY; The Institute of Contemporary Art, Boston, MA; The Dallas Museum of Art, Dallas, TX

**1988**
Galeria Comicos, Lisbon, Portugal
La Máquina Española, Madrid, Spain
Galeria Lia Rumma, Naples, Italy

**1989**
Galerie Crousel-Robelin, Paris, France
Galerie Der Wiener Secession, Vienna, Austria
Galerie Pierre Hubert, Geneva, Switzerland
National Art Gallery, Wellington, New Zealand; Waikato Museum of Art and History, New Zealand

**1990**
Linda Cathcart Gallery, Santa Monica, CA (also 1992)
Kunst-Station, St. Peter, Cologne, Germany
Padiglione d'arte contemporanea, Milan, Italy
University Art Museum, University of California, Berkeley, CA

**1991**
Basel Kunsthalle, Switzerland; Staatsgalerie Moderner Kunst, Munich, Germany; The Whitechapel Art Gallery, London, England
Studio Guenzani, Milan, Italy (also 1997)

Milwaukee Art Museum;
Center for the Fine Arts,
Miami, FL; The Walker Art
Center, Minneapolis, MN
Saatchi Collection, London,
England

**1992**
Galerie Six Friedrich, Munich,
Germany
Museo de Monterrey,
Monterrey, Mexico

**1993**
Galerie Ascan Crone,
Hamburg, Germany
Galerie Ghislaine Hussenot,
Paris, France
Galleri Susanne Ottesen,
Copenhagen, Denmark
Tel Aviv Museum of Art, Tel
Aviv, Israel
Wall Gallery, Fukuoka, Japan

**1994**
Galerie Borgmann Capitain,
Cologne, Germany
Comme des Garçons, New
York, NY
ACC Galerie, Weimar, Germany
Manchester City Art Gallery,
Manchester, England
Offshore Gallery, East
Hampton, NY
The Irish Museum of Modern
Art, Dublin, Ireland

**1995**
San Francisco Museum of
Modern Art, San Francisco,
CA
Norton Gallery and School of
Art, West Palm Beach, FL
Hirshhorn Museum and
Sculpture Garden,
Smithsonian Institution,
Washington, DC
Deichtorhallen Hamburg,
Germany; Malmö Konsthall,
Sweden
Ydessa Hendeles Art
Foundation, Toronto,
Canada
Museu de Arte Moderna de
São Paulo, Brazil

**1996**
PaceWildenstein, Los Angeles,
CA
Museum Boymans-van
Beuningen, Rotterdam, The
Netherlands; Museo
Nacional Centro de Arte
Reina Sofia, Madrid, Spain;
Sala Recalde, Bilbao, Spain;
Staatliche Kunsthalle,
Baden-Baden, Germany
Museum of Modern Art, Shiga,
Japan; Marugame Genichiro-
Inokuma Museum of
Contemporary Art, Kagawa,
Japan; Museum of
Contemporary Art, Tokyo,
Japan

**1997**
Museum of Modern Art, NY

**Selected Group Exhibitions**

**1976**
Albright-Knox Art Gallery,
Buffalo, NY
*Hallwalls,* Artists Space, New
York, NY

**1977**
Albright-Knox Art Gallery,
Buffalo, NY

**1978**
*Four Artists,* Artists Space, New
York, NY

**1979**
*Re-figuration,* Max Protetch
Gallery, New York, NY

**1980**
*Ils se Disent Peintres, Ils se
Disent Photographes,* Musée
National d'Art Moderne,
Paris, France
*Likely Stories,* Castelli
Graphics, New York, NY
*Opening Group Exhibition,*
Metro Pictures, New York,
NY

**1981**
*Autoportraits,* Musée National
d'Art Moderne, Centre
Georges Pompidou, Paris,
France

*Body Language: Figurative
Aspects of Recent Art,* Hayden
Gallery, Massachusetts
Institute of Technology,
Cambridge, MA; Fort Worth
Art Museum, Fort Worth,
TX; University of South
Florida, Tampa, FL;
Contemporary Arts Center,
Cincinnati, OH
*Erweiterte Fotografie, 5,* Wiener
Internationale Biennale,
Vienna Secession, Vienna,
Austria
*Il Gergo Inquieto,* Museo
Sant'Agostino, Genoa, Italy
*Photo,* Metro Pictures, New
York, NY
*Young Americans,* Allen
Memorial Art Museum,
Oberlin, OH

**1982**
*Art and the Media,* The
Renaissance Society at the
University of Chicago,
Chicago, IL
*Body Language,* Massachusetts
Institute of Technology,
Cambridge, MA
*Documenta 7,* Kassel, West
Germany
*Eight Artists: The Anxious Edge,*
The Walker Art Center,
Minneapolis, MN
*La Biennale di Venezia,* Venice,
Italy
*Lichtbildnisse: The Portrait in
Photography,* Rheinisches
Landesmuseum, Bonn, West
Germany
*New Figuration in America,*
Milwaukee Art Museum,
Milwaukee, WI
*Recent Color,* San Francisco
Museum of Modern Art, San
Francisco, CA
*Faces Photographed,* Grey Art
Gallery, New York University,
New York, NY
*The Image Scavengers:
Photography,* Institute of
Contemporary Art,
Philadelphia, PA
*20th Century Photographs from
the Museum of Modern Art,*
Seibu Museum of Art, Tokyo;
University of Hawaii Art
Gallery, Honolulu, HI
*Urban Kisses,* Institute of
Contemporary Art, London,
England

**1983**

Back to the U.S.A.,
Kunstmuseum Luzern,
Lucerne, Switzerland;
Rheinisches Landesmuseum,
Bonn, Germany;
Württembergischer
Kunstverein, Stuttgart,
Germany

Faces Since the 50s, The Center
Gallery Bucknell University,
Lewisberg, PA

Big Pictures by Contemporary
Photographers, The Museum
of Modern Art, New York,
NY

Directions 1983, Hirshhorn
Museum and Sculpture
Garden, Smithsonian
Institution, Washington, DC

Drawings Photographs, Leo
Castelli Gallery, New York,
NY

Presentation: Recent Portrait
Photography, Taft Museum,
Cincinnati Institute of Fine
Arts, Cincinnati, OH

Facets of the Collection: Recent
Acquisitions, San Francisco
Museum of Modern Art,
San Francisco, CA

1983 Biennial Exhibition,
Whitney Museum of
American Art, New York, NY

The New Art, The Tate Gallery,
London, England

**1984**

Alibis, Musée National d'Art
Moderne, Centre Georges
Pompidou, Paris, France

Color Photographs: Recent
Acquisitions, The Museum of
Modern Art, New York, NY

Content: A Contemporary Focus,
1974–1984, Hirshhorn
Museum and Sculpture
Garden, Smithsonian
Institution, Washington, DC

La Narrativa Internacional de
Hoy, Museo Rufino Tamayo,
Mexico City, Mexico; The
Institute for Contemporary
Art, P.S. 1 Museum, Long
Island City, NY

The Heroic Figure,
Contemporary Arts Museum,
Houston, TX; Brooks
Memorial Art Gallery,
Memphis, TN; Alexandria
Museum, Alexandria, LA;
The Santa Barbara Museum
of Art, Santa Barbara, CA

The Fifth Biennial of Sydney,
Private Symbol: Social
Metaphor, Art Gallery of New
South Wales, Sydney,
Australia

Sex-Specific: Photographic
Investigations of
Contemporary Sexuality, The
School of The Art Institute of
Chicago, Chicago, IL

Umgang mit der Aura,
Stadtische Galerie
Regensburg, West Germany

**1985**

Anniottanta, Galleria Comunale
d'Arte Moderna, Bologna,
Italy

Autoportrait a l'Epoque de la
Photographie, Musée
Cantonal des Beaux-Arts,
Lausanne, France;
Württembergischer
Kunstverein, Stuttgart,
Germany

1985 Carnegie International,
Museum of Art, Carnegie
Institute, Pittsburgh, PA

American Images: Photography
1945–1980, The Barbican Art
Gallery, London, England

Eau de Cologne, Monika Sprüth
Galerie, Cologne, Germany

Figuring It Out: Exploring the
Figure in Contemporary Art,
Laguna Gloria Art Museum,
Austin, TX

1985 Biennial Exhibition,
Whitney Museum of
American Art, New York, NY

New York 85, ARCA Centre d'Art
Contemporain, Marseilles,
France

Self-Portrait, The Museum of
Modern Art, New York, NY

**1986**

Jenny Holzer/Cindy Sherman,
The Contemporary Arts
Center, Cincinnati, OH

Altered Egos: Samaras,
Sherman, Wegman, Phoenix
Art Museum, Phoenix, AZ

Art and Its Double: A New York
Perspective, Fundació Caixa
de Pensions, Barcelona,
Spain and Fundació Caixa de
Pensions, Madrid, Spain

Eve and the Future, Hamburger
Kunsthalle, Hamburg,
Germany

Individuals: A Selected History of
Contemporary Art, 1945–1986,
The Museum of
Contemporary Art,
Los Angeles, CA

La Magie de l'Image, Musée
d'Art Contemporain de
Montréal, Montreal, Canada

Prospect 86, Frankfurter
Kunstverein, Frankfurt,
Germany

Staging the Self: Self-Portrait
Photography 1840s–1980s,
National Portrait Gallery,
London, England; Plymouth
Arts Centre, Plymouth,
England; John Hansard
Gallery, Southhampton,
England; Ikon Gallery,
Birmingham, England

Stills: Cinema and Video
Transformed, Seattle Art
Museum, Seattle, WA

The American Exhibition, The
Art Institute of Chicago,
Chicago, IL

**1987**

Art Against AIDS, Metro
Pictures, New York, NY

Avant-Garde in the Eighties, Los
Angeles County Museum of
Art, Los Angeles, CA

Implosion: A Postmodern
Perspective, Moderna
Muséet, Stockholm, Sweden

L'Epoque, la Mode, la Morale,
La Passion: Aspects de l'art
d'aujourd'hui, 1977–1987,
Musée National d'Art
Moderne, Centre Georges
Pompidou, Paris, France

Photography and Art: Interaction
Since 1946, Los Angeles
County Museum of Art;
Museum of Art, Fort
Lauderdale, FL; Queens
Museum, New York, NY;
Des Moines Art Center, Des
Moines, IA

Aspects of Conceptualism in
American Work, Part II, Ave B
Gallery, New York, NY

This Is Not A Photograph:
Twenty Years of Large-Scale
Photography, 1966–1986, The
John and Mable Ringling
Museum of Art, Sarasota,
FL; The Akron Art Museum,
Akron, OH; The Chrysler
Museum, Norfolk, VA

203

**1988**

*Matris*, Malmö Konsthall, Sweden

*1988: The World of Art Today*, Milwaukee Art Museum, Milwaukee, WI

*Just Like a Woman*, Greenville County Museum of Art, Greenville, SC

*Presi Per Incantamento*, Padiglione d'Arte Contemporanea di Milano, Milan, Italy

Two-person exhibition with Louise Lawler, Studio Guenzani, Milan, Italy

*The Pop Project*, The Clocktower, New York, NY

*Visions/Revisions: Contemporary Representation*, Marlborough Gallery, New York, NY

**1989**

*A Forest of Signs: Art in the Crisis of Representation*, The Museum of Contemporary Art, Los Angeles, CA

*Bilderstreit*, Mense Rhineside Halls, Cologne, Germany

*Encore II: Celebrating Fifty Years*, The Contemporary Arts Center, Cincinnati, OH

*Image World: Art and Media Culture*, Whitney Museum of American Art, New York, NY

*Re-Presenting the 80s*, Simon Watson, New York, NY

*Invention and Continuity in Contemporary Photography*, The Metropolitan Museum of Art, New York, NY

*Making Their Mark: Women Artists Move into the Mainstream, 1970–85*, Cincinnati Art Museum, Cincinnati, OH; New Orleans Museum of Art, New Orleans, LA; Denver Art Museum, Denver, CO; Pennsylvania Academy of the Fine Arts, Philadelphia, PA

*Moscow—Vienna—New York*, The Vienna Festival, Vienna, Austria

*Peinture Cinema Peinture*, Centre de la Vielle Charité, Musée de Marseilles, Marseilles, France

*Photography Now*, The Victoria and Albert Museum, London, England

*Surrogate Selves*, The Corcoran Gallery of Art, Washington, DC

*The Art of Photography: 1839–1989*, The Museum of Fine Arts, Houston, TX; Ministry of Culture of the Soviet Union; Royal Academy of Arts, London, England

*Tenir l'image a distance*, Musée d'Art Contemporain de Montréal, Montreal, Canada

*Three Decades: The Oliver Hoffman Collection*, Museum of Contemporary Art, Chicago, IL

*The Photographer's Eye: A Selection by Chris Kellep*, The Victoria and Albert Museum, London, England

*The Photography of Invention: American Pictures of the 1980s*, National Museum of American Art, Smithsonian Institution, Washington, DC; Museum of Contemporary Art, Chicago, IL; The Walker Art Center, Minneapolis, MN

**1990**

*Affinities and Intuitions: The Gerald S. Elliott Collection of Contemporary Art*, The Art Institute of Chicago, Chicago, IL

*Culture and Commentary: An Eighties Perspective*, The Hirshhorn Museum and Sculpture Garden, Smithsonian Institution, Washington, DC

*Energies*, The Stedelijk Museum, Amsterdam, The Netherlands

*Figuring the Body*, Museum of Fine Arts, Boston, MA

*Fotografie*, Galerie Max Hetzler, Cologne, Germany

*Louise Lawler, Cindy Sherman, Laurie Simmons*, Metro Pictures, New York, NY

*Je EST un Autre*, Galeria COMICOS/LUIS SERPA, Lisbon, Portugal; Fundaçao de Serralves, Porto, Portugal

*Photography Until Now*, The Museum of Modern Art, New York, NY

*The Art of Photography: 1839–1989*, Sezon Museum of Art, Tokyo, Japan

*The Decade Show*, The Museum of Contemporary Hispanic Art, The New Museum, and the Studio Museum of Harlem, New York, NY

*The Readymade Boomerang*, Eighth Biennial of Sydney, Australia, Art Gallery of New South Wales, Sydney, Australia

*To Be and Not to Be*, Centre d'Art Santa Monica, Barcelona, Spain

**1991**

*Art That Happens to be Photography*, The Texas Gallery, Houston, TX

*1991 Biennial Exhibition*, Whitney Museum of American Art, New York, NY

*Art of the 1980s: Selections from the Collection of the Eli Broad Family Foundation*, Duke University Museum of Art, Durham, NC

*Metropolis*, Martin-Gropius-Bau, Berlin, Germany

*Self-Portraits of Women in the Eighties*, Tokyo Metropolitan Museum of Photography, Tokyo, Japan

*Places with a Past: New Site-Specific Art in Charleston*, Spoleto Festival, Charleston, SC

*First International Foto-Triennale Esslingen*, Villa Merkel; Bahnwartehaus; Schwarhaus, Altes Rathaus; Galerie im Heppacher; Esslingen, Germany

*Devil on the Stairs: Looking Back on the Eighties*, Institute of Contemporary Art, Philadelphia, PA; Newport Harbor Art Museum, Newport Beach, CA

*A Visage Decouvert*, Fondation Cartier, Jouy-en-Josas, France

*Displacements*, Centro Atlantico de Arte Moderno, Canary Islands, Spain

*Carroll Dunham, Mike Kelley, Cindy Sherman*, Metro Pictures, New York, NY

*Art & Art*, Castello di Rivoli, Turin, Italy

*Altrove: Fra immagine e identita fra identita e tradizione*, Centro per l'Arte Contemporanea Luigi Pecci, Prato, Italy

*Just What Is It That Makes Today's Home So Different, So Appealing,* The Hyde Collection, Glens Falls, NY

*Adam and Eve,* The Museum of Modern Art, Saitama, Japan

**1992**

*Quotations. The Second History of Art,* The Aldrich Museum of Contemporary Art, Ridgefield, CT

*Pleasures and Terrors of Domestic Comfort,* The Museum of Modern Art, New York, NY

*More Than Photography,* The Museum of Modern Art, New York, NY; Galerie Max Hetzler, Cologne, Germany

*Ars Pro Domo,* Museum Ludwig, Cologne, Germany

*Post Human,* Musée d'Art Contemporain, Lausanne, Switzerland; Castello di Rivoli, Turin, Italy; Deste Foundation, Athens, Greece; Deichtorhallen, Hamburg, Germany; Israel Museum, Jerusalem, Israel

*Dirty Data,* Schürmann Sammlung, Ludwig Forum für Internationale Kunst, Aachen, Germany

*Dirt and Domesticity,* Whitney Museum of American Art, Equitable Center, New York, NY

*Art in Embassies Program,* American Embassy in Prague, Czech Republic

*Imagenes de Guerra,* Centro Cultural Arte Contemporanea, Mexico City, Mexico

*Erotiques,* A.B. Galerie, Paris, France

*Perils et Coleres,* capc, Musée d'art Contemporain de Bordeaux, Bordeaux, France

*Hollywood, Hollywood: Identity Under the Guise of Celebrity,* Art Center College of Design, Pasadena, CA

*Not For Sale,* Tel Aviv Museum of Art, Tel Aviv, Israel

*American Art of the 80s,* Museo d'Arte Moderna e Contemporanea di Trento, Trento, Italy

*Selected Works from the Early Eighties,* K-Raum Daxer, Munich, Germany

*Spiellholle, Asthetik und Gewalt,* Akademie der Künste und Wissenschaften, Frankfurt, Germany; Grazer Kunstverein, Graz, Austria; Galerie Sylvana Lorenz, Paris, France

**1993**

*Louise Lawler, Cindy Sherman, Laurie Simmons,* Kunsternes Hus, Oslo, Norway; Museum of Contemporary Art, Helsinki, Finland

*1993 Biennial Exhibition,* Whitney Museum of American Art, New York, NY

*Body Doubles,* The Friends of Photography, Ansel Adams Center for Photography, San Francisco, CA

*American Art of This Century,* Martin-Gropius-Bau, Berlin, Germany; Royal Academy of Arts, London, England

*The Uncanny,* Sonsbeek '93, Gementemuseum, Arnhem, The Netherlands

*Commodity Image,* International Center for Photography, New York, NY; Institute of Contemporary Art, Boston, MA

*Vivid: Intense Images of American Photographers,* Raab Galerie, Berlin, Germany; Galerie Ursula Schurr, Stuttgart, Germany

*Cindy Sherman, Laurie Simmons,* Fay Gold Gallery, Atlanta, GA

*The Legacy of Hans Bellmer,* Jan Turner Gallery, Los Angeles, CA

*1920. The Subtlety of Subversion, the Continuity of Intervention,* Exit Art, New York, NY Metro Pictures, New York, NY

Studio Guenzani, Milan, Italy

*Daydream Nation,* Luhring Augustine Gallery, New York, NY

*Konstruktion Zitat,* Sprengel Museum, Hannover, Germany *Strange Hotel,* Aarhus Kunstmuseum, Denmark

*l'Envers des Choses,* Musée National d'Art Moderne, Centre Georges Pompidou, Paris, France

*Das Bild des Korpers,* Frankfurter Kunstverein, Frankfurt, Germany

*8 American Artists,* Galerie Bernd Klüser, Munich, Germany

*Up in Smoke,* Knoedler & Company, New York, NY

*Network,* Kunsternes Hus, Oslo, Norway

*Diskurse der Bilder: Photokunstlerishe Reprisen kunsthistorisher Werke,* Kunsthistorisches Museum, Vienna, Austria

*Real Sex,* Salzburg Kunstverein, Salzburg, Austria

**1994**

*Pictures of the Real World (In Real Time),* Paula Cooper Gallery, New York, NY

*World Morality,* Kunsthalle, Basel, Germany; Galerie Samia Saouma, Paris, France

*Against All Odds: The Healing Powers of Art,* The Ueno Royal Museum and The Hakone Open-Air Museum, Hakone-machi, Japan

*Body and Soul,* The Baltimore Museum of Art, Baltimore, MD

*Dialogue with the Other,* Kunsthallen Brandts Klaedefabrik, Denmark

*Ike + de Ander - Dignity for All: Reflections on Humanity,* Beurs van Berlage, Amsterdam, The Netherlands

*Art in the Present Tense: The Aldrich's Curatorial History 1964–1994,* The Aldrich Museum of Contemporary Art, Ridgefield, CT

*Opera Prima,* Ex Opificio Gaslini, Pescara; Italy; Flash Art Museum of Contemporary Art, Trevi, Italy; Cankarjev Dom, Slovenija

*The Century of the Multiple: From Duchamp to the Present,* Deichtorhallen, Hamburg, Germany

*Jurgen Klauke—Cindy Sherman*, Sammlung Goetz, Munich, Germany

*Genres in Painting*, Centro Atlantico de Arte Moderno, Canary Islands, Spain

*Transformers: The Art of Multiphrenia*, Minnesota Museum of American Art, St. Paul, MN

*Facts and Figures*, Lannan Foundation, Los Angeles, CA

*Quotation: Re-Presenting History*, Winnipeg Art Gallery, Winnipeg, Canada

*Virtual Reality: Contemporary Art*, National Gallery of Australia, Canberra, Australia

*Fotografinnen der Gegenwart*, Museum Folkwang Essen, Germany

*After Art: Rethinking 150 Years of Photography*, Henry Art Gallery, University of Washington, Seattle, WA; The Friends of Photography, Ansel Adams Center for Photography, San Francisco, CA; Portland Art Museum, Portland, ME

*It's How You Play the Game*, Exit Art/The First World, NY

*Suture-Phantasmen der Volkommenheit*, Salzburger Kunstverein, Salzburg, Austria

**1995**

Feature, New York

*Call it Sleep*, Witte de With, Rotterdam, The Netherlands

*1995 Biennial Exhibition*, Whitney Museum of American Art, New York, NY

*Photography Today*, Sonje Museum of Contemporary Art, Kyungsangbuk-Do, Korea

*Zeichen & Wunder*, Kunsthaus Zurich, Switzerland

*Alternatives: 20 Years of Hallwalls Contemporary Art Center 1975–1995*, Burchfield-Penny Art Center, Buffalo, NY

*Komix*, Brooke Alexander Editions, New York, NY

*XLVI Esposizione Internazionale d'Arte 1995*, La Biennale di Venezia, Venice, Italy

*Regards croisés*, ELAC, Centre d'Echanges de Perrache, Lyon, France

*Large Body*, Pace MacGill, New York, NY

*Die Muse?: Transforming the Image of Women in Contemporary Art*, in conjunction with Salzburger Festival, Galerie Thaddaeus Ropac, Paris, France

*Histoire de l'infamie*, Biennale de Venise, Cercle de l'Arsenal, Venice, Italy

*Autres Victoires*, Montiucon, Chateau de la Louviere, Paris, France; S. L. Simpson Gallery, Toronto, Canada

*The Monster Show*, Museum of Contemporary Art, North Miami, FL

*Mode et Art: 1960–1990*, Palais des Beaux-Arts, Brussels, Belgium

*femininmasculin: le sexe de l'art?*, Musée National d'Art Moderne, Centre Georges Pompidou, Paris, France

*L'Effet Cinéma*, Musée d'Art Contemporain de Montréal, Montreal, Canada

*Laughter Ten Years After*, Center for the Arts, Wesleyan University, CT; Houghton House Gallery, Hobart and William Smith Colleges, Geneva, NY; Beaver College Art Gallery, Glenside, PA

*1995 Carnegie International*, The Carnegie Museum of Art, Pittsburgh, PA

*Imaginary Beings*, Exit Art, New York, NY

*Playtime: Artists and Toys*, Whitney Museum of American Art at Champion, Stamford, CT

*Passions Privée*, Musée d'Art Moderne de la Ville de Paris, Paris, France

**1996**

*Everything that's interesting is new: The Dakis Joannou Collection* (organized by the DESTE Foundation in conjunction with The Museum of Modern Art, Copenhagen, Denmark); Athens School of Fine Arts, Athens, Greece

*Empty Dress*, The Rubelle & Norman Schafler Gallery, Pratt Institute, Brooklyn, NY

*Controfigura*, Studio Guenzani, Milan, Italy

*TECHNIK: FOTOGRAFIE. Teil 2*, Busche Galerie, Berlin, Germany

*Altered and Irrational: Selections From the Permanent Collection*, Whitney Museum of American Art, New York, NY

*Sex & Crime: On Human Relationships*, Sprengel Museum, Hannover, Germany

*Deformations: Aspects of the Modern Grotesque*, The Museum of Modern Art, New York, NY

*Prospect 96: Photographie in der Gegenwartskunst*, Frankfurter Kunstvereins im Steinernen Haus und der Schirn Kunsthalle, Frankfurt, Germany

*L'Informe: le Modernisme à Rebours*, Musée National d'Art Moderne, Centre Georges Pompidou, Paris, France

*Sexual Politics: Judy Chicago's Dinner Party and Feminists in Art History*, UCLA Armand Hammer Gallery, Los Angeles, CA

*Nudo & Crudo: Sensitive Body, Visible Body*, Claudia Gian Ferrari Arte Contemporanea, Milan, Italy

*Multiple Pleasure*, Tanya Bonakdar Gallery, New York, NY

*Hall of Mirrors: Art and Film Since 1945*, The Museum of Contemporary Art, Los Angeles, CA; The Wexner Center for the Arts, Columbus, OH; Palazzo delle Esposizioni, Rome, Italy; Museum of Contemporary Art, Chicago, IL

*Laughter Ten Years After*, Houghton House Gallery, Hobart and William Smith Colleges, Geneva, NY; Beaver College Art Gallery, Glenside, PA; Galeria 56, Budapest, Hungary

*New York 'Unplugged II'*, Gallery
  Cotthem, Knokke-Zoute,
  Belgium
*Radical Images*, Second
  Austrian Triennial on
  Photography 1996, Neue
  Galerie am Landesmuseum
  Joanneum, Graz, Austria
*Doll House*, Illinois State
  University, Normal, IL
*Lobby*, Arizona State University
  Art Museum, Tempe, AZ
*Fragments*, Museu d'Art
  Contemporani, Barcelona,
  Spain
*New Persona/New Universe*,
  Biennale di Firenze,
  Florence, Italy
*Picasso: A Contemporary
  Dialogue*, Galerie Thaddeus
  Ropac, Salzburg,
  Austria/Paris, France
*Metamorphosis: Cindy Sherman
  Photographs*, The Cleveland
  Museum of Art, Cleveland,
  OH
*Jocaste en Arcadie a Madame de
  Sevigne—une evocation
  contemporaine du XVIIe
  siècle*, Chateau des Adhemar,
  Montélimar, France; Chateau
  de Grignan; FRAC Rhone-
  Alpes, Lyons, France
*Face Value: American Portraits*,
  The Parrish Art Museum,
  Southampton, NY; Wexner
  Center for the Arts,
  Columbus, OH; Tampa Art
  Museum, Tampa, FL
*A/drift*, Center for Curatorial
  Studies, Bard College, New
  York, NY

**1997**
*Making it Real*, The Aldrich
  Museum of Contemporary
  Art, Ridgefield, CT; The
  Reykjavík Municipal Art
  Musuem, Reykjavík, Iceland;
  Portland Museum of Art,
  Portland, ME; Bayly Art
  Museum, University of
  Virginia, Charlottesville, VA

# Selected Bibliography

208

**1978**

*Four Artists.* Exhibition catalogue. New York: Artists Space.

**1979**

Crimp, Douglas. "Pictures." *October* 8 (spring): 75–88.

Tatransky, Valentine. "Cindy Sherman, Artists Space." *Arts Magazine* 53, no. 5 (January): 19.

**1980**

Bishop, Joseph. "Desperate Character." *Real Life Magazine*, no. 4 (summer): 8–10.

Cathcart, Linda. *Cindy Sherman: Photographs.* Exhibition brochure. Houston: Contemporary Arts Museum.

Nuridsany, Michel. *Ils se Disent Peintres, Ils se Disent Photographes.* Exhibition catalogue. Paris: ARC/Musée d'Art Moderne.

Owens, Craig. "The Allegorical Impulse: Toward a Theory of Postmodernism, Part 2." *October* 13 (summer): 59–80.

Shore, Michael. "Punk Rocks the Art World." *Artnews* 79, no. 9 (November): 78–85.

Solomon-Godeau, Abigail. "Sexual Difference: Both Sides of the Camera." *CEPA Quarterly* (spring/summer): 17–24.

Tatransky, Valentine. "Cindy Sherman." *Arts Magazine* 54, no. 10 (June): 27.

**1981**

Crimp, Douglas. *Young Americans.* Exhibition catalogue. Oberlin, Ohio: Allen Memorial Art Museum.

Crimp, Douglas. "The Photographic Activity of Postmodernism." *October* 15 (winter): 99–102.

Flood, Richard. "Cindy Sherman, Metro Pictures." *Artforum* 19, no. 7 (March): 80.

Grundberg, Andy. "Cindy Sherman: A Playful and Political Post Modernist." *New York Times*, 22 November, sec. 2, p. 35.

Klein, Michael. "Cindy Sherman." *Arts Magazine* 55, no. 7 (March): 5.

Zelavansky, Lynn. "Cindy Sherman, Metro Pictures." *Flash Art* 14, no. 102 (March/April): 43.

**1982**

*Autoportraits Photographiques.* Exhibition catalogue. Paris: Centre Pompidou-Editions Herscher.

Barents, Els. *Cindy Sherman.* Exhibition catalogue. Amsterdam: The Stedelijk Museum; Munich, Schirmer/Mosel.

"Cindy Sherman." (six-page portfolio) *File Magazine* 5, no. 3 (spring): 22–25.

"Cindy Sherman *Untitled Film Stills*" (six-page portfolio) *Paris Review* 82 (November): 133–139.

Gambrell, Jamey. "Cindy Sherman, Metro Pictures." *Artforum* 20, no. 6 (February): 85–86.

Handy, Ellen. "Cindy Sherman, Metro Pictures." *Arts Magazine* 57, no. 4 (December): 33.

Heartney, Eleanor. "Anxiety Show at the Walker." *New Art Examiner* 9, no. 9 (June): 12.

Knight, Christopher. "Photographer with an Eye on Herself." *Los Angeles Herald Examiner*, 10 October, p. E-5.

Lifson, Ben. *Faces Photographed: Contemporary Camera Images.* Exhibition catalogue. New York University: Grey Art Gallery.

Linker, Kate. "Melodramatic Tactics." *Artforum* 21, no. 1 (September): 30–32.

Lyons, Lisa. *Anxious Edge.* Exhibition catalogue. Minneapolis: The Walker Art Center.

Marincola, Paula. *Image Scavengers: Photography.* Exhibition catalogue. Philadelphia: Institute of Contemporary Art.

Martinson, Dorothy. *Recent Color.* Exhibition catalogue. San Francisco: San Francisco Museum of Modern Art.

Pouvreau, Paul and Jacques Ristorcelli. "Les Autoportraits de Cindy Sherman." *Cahiers du Cinema* (Paris) (February): 13–14.

Schjeldahl, Peter. "Shermanettes." *Art in America* 70, no. 3 (March): 110–111.

Schjeldahl, Peter and Russell Bowman. *New Figuration in America.* Exhibition catalogue. Milwaukee: Milwaukee Art Museum.

Schlatter, Christian. "De l'Avant-garde, avant toute chose." *Vogue* (Paris) (October): 88.

Smith, Roberta. *Body Language.* Exhibition catalogue. Cambridge: Committee for the Visual Arts, Massachusetts Institute of Technology.

Squires, Carol. "The Difference Between Fibs and Fictions." *Village Voice,* 2 November, p. 8.

Szarkowski, John. *20th Century Photographs from the Museum of Modern Art.* Exhibition catalogue. New York: The Museum of Modern Art; Tokyo: Seibu Museum.

**1983**

*1983 Biennial Exhibition.* Exhibition catalogue. New York: Whitney Museum of American Art.

Caujolle, Christian. *Cindy Sherman.* Exhibition catalogue. Saint-Etienne: Musée d'Art et d'Industrie.

Cowart, Jack. Exhibition catalogue. *Currents 20: Cindy Sherman.* St. Louis: St. Louis Art Museum.

Damsker, Matt. "Portrait of an Artist." *The Hartford Courant,* 16 January, p. 4–5.

Davis, Douglas. "Big Pix." *Newsweek* (May 2): 80.

Goldberg, Vicki. "Portrait of a Photographer as a Young Artist." *New York Times,* 23 October, sec. 2, p. 29.

Hapgood, Susan. "Cindy Sherman/Metro Pictures." *Flash Art* 16, no. 110 (January): 63.

Honnef, Klaus. *Back to the U.S.A.* Exhibition catalogue. Bonn: Kunstmuseum Luzern and Rheinisches Landesmuseum.

Honnef, Klaus. "Cindy Sherman." *Kunstforum International* (Cologne) no. 60 (April): 105–121.

Jacobs, Joseph. *Faces Since the 50s.* Exhibition catalogue. Lewisberg, PA: The Center Gallery, Bucknell University.

Lescaze, Lee. "Making Faces: A Photographer Dresses Up for Success." *Wall Street Journal,* 15 November, p. 32.

Lichtenstein, Therese. "Cindy Sherman." *Arts Magazine* 57, no. 5 (January): 3.

Linker, Kate. "Cindy Sherman, Metro Pictures." *Artforum* 21, no. 5 (January): 79.

Marzorati, Gerald. "Imitation of Life." *Artnews* 82, no. 7 (September): 78–87.

Nilson, Lisbet. "Q & A: Cindy Sherman." *American Photographer* (September): 70–77.

"Openings: Cindy Sherman." *Esquire Magazine* 100, no. 1 (July): 115.

Rosenzweig, Phyllis. *Directions 1983.* Exhibition catalogue. Washington, DC: Hirshhorn Museum and Sculpture Garden, Smithsonian Institution.

Schjeldahl, Peter. "Falling in Style: The New Art and Our Discontents." *Vanity Fair* 46, no. 3 (March): 115–116, 252.

Smith, Roberta. "Art." *Village Voice,* 29 November, p. 119.

Starenko, Michael. "What's an Artist to Do? A Short History of Postmodernism and Photography." *Afterimage* 10 (January): 4–5.

Thompson, Thom. *Cindy Sherman.* Exhibition catalogue. Stony Brook: Fine Arts Center, State University of New York.

Williamson, Judith. "Images of 'Woman': The Photographs of Cindy Sherman." *Screen* (London) (November/December): 102–116.

Zelavansky, Lynn. "Cindy Sherman, Metro Pictures." *Artnews* 82, no. 1 (January): 145–146.

**1984**

Blistene, Bernard, et. al. *Alibis.* Exhibition catalogue. Paris: Centre Georges Pompidou, Musée National d'Art Moderne.

Cathcart, Linda. *A Figura Heroica: Treze Artistas dos EUA.* Exhibition catalogue. Houston: Museum of Contemporary Art and USIS.

*Cindy Sherman.* Exhibition catalogue. Tokyo: Laforet Museum.

*Cindy Sherman.* Exhibition catalogue. New York: Pantheon Books.

*Cindy Sherman.* Exhibition catalogue. Tokyo: The Seibu Contemporary Art Gallery.

Cone, Michelle. "Cindy Sherman, Metro Pictures." *Flash Art* 17, no. 116 (March): 39.

Cornand, Brigitte. "Cindy Sherman: La Star-Cameleon." *Public* (Paris) (May–October): 49.

Evans-Clark, Phillipe. "Cindy Sherman, Metro Pictures." *Art Press* (Paris) (January): 46.

Faucett, Anthony and Jane Withers. "Expo: Photographer's Gallery." *The Face* (London) (March): 44–50.

Fernandes, Joyce. *Sex-Specific: Photographic Investigations of Contemporary Sexuality.* Exhibition catalogue. Chicago: The School of The Art Institute of Chicago.

Fox, Howard N. et. al. *Content: A Contemporary Focus 1974–1984*. Exhibition catalogue. Washington, DC: Hirshhorn Museum and Sculpture Garden, Smithsonian Institution Press.

Gambrell, Jamey. "Marginal Acts." *Art in America* 72, no. 3 (March): 114–119.

Grundberg, Andy. "Self-Portraits Minus Self." *New York Times Book Review*, 22 July, p. 11–12.

Handy, Ellen. "Cindy Sherman." *Arts Magazine* 58, no. 5 (January): 56.

Kallfelz, Andreas. "Cindy Sherman: Ich Mache Keine Selbsportraits." *Wolkenkratzer Art Journal* (Cologne) (September/October): 44–49.

Langer, Freddy. "Cindy Sherman." *Frankfurter Allgemeine Magazin*, (September): 10–18.

Liebman, Lisa. "Books, Books, Books: Cindy Sherman." *Artforum* 23, no. 4 (December): 74.

Liebman, Lisa. "Cindy Sherman, Metro Pictures." *Artforum* 22, no. 7 (March): 95.

Lopez, Alaine and Anne DeMargerie. "Moi Cindy Sherman." *Liberation* (Paris), (August 12): 25.

Morris, Diana. "Cindy Sherman." *Women Artists' News* 10, no. 1 (November): 18–19.

Owens, Craig and Linda Cathcart. *The Heroic Figure*. Exhibition catalogue. Houston: Contemporary Arts Museum.

Ratcliff, Carter. *The Fifth Biennale of Sydney, Private Symbol: Social Metaphor*. Exhibition catalogue. Sydney, Australia: Art Gallery of New South Wales.

Ravenal, John B. "Cindy Sherman." *Arts Magazine* 58, no. 5 (January): 21.

Robotham, Rosemary. "One-Woman Show: Cindy Sherman Puts Her Best Face Forward." *Life Magazine* (June): 14–22.

Sturman, John. "The Art of Becoming Someone Else." *Artnews* 83, no. 9 (November): 35.

**1985**

*1985 Biennial Exhibition*. Exhibition catalogue. New York: Whitney Museum of American Art.

*Anniottanta*. Exhibition catalogue. Milan: Nuove edizioni Gabriele Mazzotta.

Badger, Gerry. *American Images: Photography 1945–1980*. Exhibition catalogue. London: The Barbican Art Gallery.

Davis, Douglas. "Seeing Isn't Believing." *Newsweek* 105, no. 22 (June 3): 69.

Grundberg, Andy. "Cindy Sherman's Dark Fantasies Evoke a Primitive Past." *New York Times*, 20 October, sec. 2, p. 31.

Handy, Ellen. "Cindy Sherman, Metro Pictures." *Arts Magazine* 60, no. 4 (December): 116.

Indiana, Gary. "Enigmatic Makeup." *Village Voice*, 22 October, p. 41.

*L'Autoportrait*. Exhibition catalogue. Lausanne: Musée Cantonal des Beaux-Arts.

Mazeroti, Gerald. "Self-Possessed." *Vanity Fair* 48, no. 10 (October): 112–113.

*New York 85*. Exhibition catalogue. Marseilles: ARCA Centre d'Art Contemporain.

Polak, Maralyn Lois. "She Shoots Herself (sort of)." *The Philadelphia Inquirer Magazine* (January 13): 7–8.

Rosenthal, Mark. *Art of Our Time: The Saatchi Collection*. London: Lund Humphries; New York: Rizzoli.

Sischy, Ingrid. "On Location: Cindy Sherman's Camera Kabuki." *Artforum* 24, no. 4 (December): 4–5.

Stockebrand, Marianne. *Cindy Sherman*. Exhibition catalogue. Munster: Westfalischer Kunstverein.

Sturman, John. "Cindy Sherman, Metro Pictures." *Artnews* 84, no. 10 (December): 117.

Sussler, Betsy. "Cindy Sherman interview." *Bomb* 12 (spring/summer): 30–33.

Taylor, Paul. "Cindy Sherman." *Flash Art* 18, no. 124 (October/November): 78–79.

Van Damme, Leo. "Cindy Sherman: I Don't Want to Be a Performer." *Arte Factum* (Antwerp), (June–August): 15–21.

**1986**

Arnason, H. *History of Modern Art*. Third edition. New York: Harry N. Abrams.

Benezra, Neal and A. James Speyer. *Seventy-Fifth American Exhibition*. Exhibition catalogue. Chicago: The Art Institute of Chicago.

Cameron, Dan. *Art and Its Double: A New York Perspective*. Exhibition catalogue. Barcelona: Fundacio Caixa de Pensions.

Cloudman, Ruth. *Perspective 4: Cindy Sherman*. Exhibition brochure. Portland, OR: Portland Art Museum.

Drier, Deborah. "Cindy Sherman at Metro Pictures." *Art in America* 74, no. 1 (January): 136–137.

Frascella, Larry. "Cindy Sherman's Tales of Terror." *Aperture*, no. 103 (summer): 48–53.

Gagnon, Paulette. *La Magie de l'Image*. Exhibition catalogue. Montreal: Musée d'Art Contemporain de Montréal.

Melville, Stephen W. "The Time of Exposure: Allegorical Self-Portraiture in Cindy Sherman." *Arts Magazine* 60, no. 5 (January): 17–21.

Miller-Keller, Andrea. *Cindy Sherman.* Exhibition brochure. Hartford, CT: Wadsworth Athenaeum.

Perl, Jed. "Starring Cindy Sherman." *The New Criterion* 4, no. 5 (January): 14–25.

Power, Mark. "Cindy Sherman's Multiple Exposures." *The Washington Post,* 14 July, p. C1, C4.

*Prospect 86.* Exhibition catalogue. Frankfurt: Frankfurter Kunstverein, Schirn Kunsthalle.

Singerman, Howard, ed. *Individuals: A Selected History of Contemporary Art, 1945–1986.* Exhibition catalogue. Los Angeles: The Museum of Contemporary Art; New York: Abbeville Press.

*Staging the Self: Self-Portrait Photography 1840s–1980s.* Exhibition catalogue. London: National Portrait Gallery.

Steinbach, Alice. "Cindy Sherman's Photos Make Her Art and Artist." *The Baltimore Sun,* 3 June, p. 1C.

Stevens, Elizabeth. "New Approach to Self-Portraits." *The Baltimore Sun,* 3 June, p. 1C, 2C.

**1987**

Bender, Gretchen. "Interview with Cindy Sherman." *Bomb Magazine* 43 (winter): 20–24.

Brenson, Michael. "Art: Whitney Shows Cindy Sherman Photos." *New York Times,* 24 July, p. C31.

*Cindy Sherman.* Exhibition catalogue. Tokyo: Parco Co., Ltd.

Cottingham, Laura. "Cindy Sherman." *Flash Art* 20, no. 136 (October): 97.

Danto, Arthur C. "Art: Cindy Sherman." *The Nation* 245, no. 4 (August 15–22): 134–137.

Fox, Howard N. *Avant-Garde in the Eighties.* Exhibition catalogue. Los Angeles: Los Angeles County Museum of Art.

Garber, Fredrick. "Generating the Subject. The Images of Cindy Sherman." *Genre XX* (fall/winter): 359–382.

Gauss, Kathleen McCarthy and Andy Grundberg. *Photography and Art: Interactions Since 1946.* Exhibition catalogue. Fort Lauderdale: Museum of Art; Los Angeles: Los Angeles County Museum of Art.

Grundberg, Andy. "The 80s Seen Through a Postmodern Lens." *New York Times,* 5 July, sec. 2, p. 25, 29.

Haus, Mary Ellen. "Cindy Sherman: Metro Pictures, Whitney Museum of American Art." *Artnews* 86, no. 8 (October): 167–168.

Heartney, Eleanor. "Two or Three Things I Know About Her." *Afterimage* 15, no. 3 (October): 18.

Heiferman, Marvin and Joseph Jacobs. *This Is Not a Photograph: Twenty Years of Large-Scale Photography 1966–1986.* Exhibition catalogue. Sarasota, Florida: The John and Mable Ringling Museum of Art.

Indiana, Gary. "Untitled (Cindy Sherman Confidential)." *Village Voice,* 2 June, p. 87.

Johnson, Ken. "Cindy Sherman and the Anti-Self: An Interpretation of Her Imagery." *Arts Magazine* 62, no. 3 (November): 47–53.

Kissel, Howard. "The Ego Has Landed." *The Daily News,* 10 July, p. 61.

Kuspit, Donald. "Inside Cindy Sherman." *Artscribe* (London), (September/October): 41–43.

Larson, Kay. "Who's That Girl?" *New York Magazine* (August 3): 52–53.

*L'Epoque La Mode La Morale La Passion.* Exhibition catalogue. Paris: Musée National d'Art Moderne, Centre Georges Pompidou.

Marzorati, Gerald. "Sherman's March." *Vanity Fair* 50, no. 8 (August): 135.

Mifflin, Margot. "The Fine Art of Shooting Oneself: Cindy Sherman." *Elle* (July): 26.

Nairne, Sandy. *State of the Art: Ideas & Images in the 1980s.* London: Chatto and Windus Ltd.

Nittve, Lars, Germano Celant, Kate Linker, and Craig Owens. *Implosion: A Postmodern Perspective.* Exhibition catalogue. Stockholm: Moderna Muséet.

Phillips, Lisa and Peter Schjeldahl. *Cindy Sherman.* Exhibition catalogue. New York: Whitney Museum of American Art.

Small, Michael. "Photographer Cindy Sherman Shoots Her Best Model—Herself." *People* (November 30): 157–160.

Smith, Roberta. "Art: Cindy Sherman at Metro Pictures." *New York Times,* 8 May, p. C27.

Tillim, Sidney. "Cindy Sherman at Metro Pictures and Whitney Museum." *Art in America* 75, no. 12 (December): 162–163.

Wollheim, Peter. "Photography and Politics: The Post-Modern Perspective." *Center Quarterly* 8, no. 3 (spring): 4–6.

**1988**

Bowman, Russell. *The World of Art Today.* Exhibition catalogue. Milwaukee: Milwaukee Art Museum.

Brea, L. "Cindy Sherman: Uno Es Siempre Otro." *Sur Expres* (Madrid), (December/January): 97–101.

*Contemporary Art from New York.* Exhibition catalogue. Seoul, South Korea: National Museum of Contemporary Art.

Garber, Frederick. *Repositionings: Readings of Contemporary Poetry, Photography, and Performance Art.* Pennsylvania: The University of Oklahoma Press.

Guiliano, Charles. "Cindy Sherman." *Art New England* (December/January): 8–9.

Hoy, Anne H. *Fabrications: Staged, Altered and Appropriated Photographs*. New York: Abbeville Press, Inc.

Hunter, Sam. *Visions/Revisions: Contemporary Representation*. Exhibition catalogue. New York: Marlborough Gallery.

Inman, Sue Lile et al. *Just Like a Woman*. Exhibition catalogue. Greenville, SC: Greenville County Museum of Art.

Iverson, Margaret. "Fashioning the Feminine Identity." *Art International* 2 (spring): 52–57.

Jefferson, Margo. "The Image Culture: Michael Jackson, Cindy Sherman and the Art of Self Manipulation." *Vogue* (March): 122–127.

Marini, Paolo. "Mass-Media Manipulation." *Contemporanea* 1, no. 1 (May/June): 117–121.

*Matris*. Exhibition catalogue. Sweden: Malmö Kunsthall.

*Modern Dreams*. Exhibition catalogue. New York: The Institute for Contemporary Art; Cambridge, MA: MIT Press.

Olivares, Javier. "Les Cindy De Sherman." *La Luna de Madrid* (December/January): 32–37.

Perez-Minquez, Pablo. "Las Obsesiones de mi Prima Cindy." *La Luna de Madrid* (December/January): 32–37.

*Presi X Incantamento*. Exhibition catalogue. Milan: Padiglione d'Arte Contemporanea, Giancarlo Politi.

*Three Decades: The Oliver Hoffman Collection*. Exhibition catalogue. Chicago: Museum of Contemporary Art.

## 1989

*A Forest of Signs: Art in the Crisis of Representation*. Exhibition catalogue. Los Angeles: The Museum of Contemporary Art; Cambridge, MA: MIT Press.

Artner, Alan G. "Sherman Photos Halfway into New Subject." *Chicago Tribune*, 21 July, sec. 7, p. 51.

Ball, Edward. "The Beautiful Language of My Century." *Arts Magazine* 63, no. 5 (January): 65–72.

Celant, Germano. *Unexpressionism: Art Beyond the Contemporary*. New York: Rizzoli.

Coleman, A.D. "Postmodern but, Surprisingly, Both Beautiful and Unnerving." *New York Observer*, 23 January, p. 14.

Cottingham, Laura. "The Feminine De-Mystique." *Flash Art* 22, no. 147 (summer): 91–95.

Danto, Arthur. "Women Artists, 1970–85." *The Nation* 249, no. 22 (December 25): 794–798.

Equi, Elaine. "Cindy Sherman." *Arts* 64, no. 1 (September): 72.

Faust, Wolfgang Max. "Kunst mit Fotografie heute." *Wolkenkratzer Art Journal* (January/February): 24–45.

Foresta, Merry A. and Joshua Smith. *The Photography of Invention*. Exhibition catalogue. Washington, DC: National Museum of American Art, Smithsonian Institution; Cambridge, MA: MIT Press.

Garber, Frederick. "Generating the Subject: The Images of Cindy Sherman," in *Postmodern Genres*, ed. Marjorie Perloff. Norman, OK: University of Oklahoma Press.

Grundberg, Andy. "The Galleries: Cindy Sherman." *New York Times*, 31 March, p. C1, C26.

Harrison, Katherine. "Cindy Sherman, Metro Pictures." *Flash Art* 22, no. 147 (summer): 146.

Hayt-Atkins, Elizabeth. "Cindy Sherman, Metro Pictures." *Artnews* 88, no. 7 (September): 170–171.

Hayworth-Booth, Mark. *Photography Now*. Exhibition catalogue. London: Dirk Nishen Publishing and The Victoria and Albert Museum.

Hughes, Robert. "Mucking with Media." *Time* 134, no. 26 (December 23): 93.

Indiana, Gary et. al. *Re-Presenting the 80s*. Exhibition catalogue. New York: Simon Watson.

Lacayo, Richard. "Drawn by Nature's Pencil." *Time* 133, no. 9 (February 27): 64–67.

Liebman, Lisa. "About Face: Cindy Sherman's Self-transformations . . ." *Mirabella* (October): 45.

Phillips, Lisa and Marvin Heiferman. *Image World: Art and Media Culture*. Exhibition catalogue. New York: Whitney Museum of American Art.

Pitts, Priscilla and Robert Leonard. *Cindy Sherman*, The National Art Gallery, New Zealand.

Plagens, Peter. "Into the Fun House." *Newsweek* 114, no. 8 (August 21): 52–57.

Rimanelli, David. "New York: Cindy Sherman, Metro Pictures." *Artforum* 28, no. 10 (summer): 165.

Rosen, Randy. *Making Their Mark: Women Artists Move into the Mainstream, 1970–85*. Exhibition catalogue. New York: Abbeville Press Publishers; London: Royal Academy of Arts.

Schjeldahl, Peter. "Little Show of Horrors." *7 Days* (April 12) 64–65.

Schor, Mira. "From Liberation to Lack." *Heresies* 6, no. 4 15–21.

Sultan, Terrie. *Surrogate Selves: David Levinthal, Cindy Sherman, Laurie Simmons*. Exhibition catalogue. Washington, DC: Corcoran Gallery of Art.

Weaver, Michael and Daniel Wolf. *The Art of Photography 1839–1989*. Exhibition catalogue. New Haven: Yale University Press.

Weiley, Susan. "The Darling of the Decade." *Artnews* 88, no. 4 (April): 143–150.

Woodward, Richard B. "Documenting an Outbreak of Self-Presentation." *New York Times*, 22 January, sec. 2, p. 31.

Woodward, Rick. "Film Stills." *Film Comment* 25, no. 2 (March): 51–54.

**1990**

Adams, Brooks. "Cindy Sherman at Metro Pictures." *Art in America* 78, no. 6 (June): 172.

*Affinities and Intuitions: The Gerald S. Elliott Collection of Contemporary Art.* Exhibition catalogue. Chicago: The Art Institute of Chicago.

Bloch, Rene. *The Readymade Boomerang: The Eighth Biennial of Sydney.* Exhibition catalogue. Sydney: Art Gallery of New South Wales.

Cameron, Dan et. al. *To Be and Not to Be.* Exhibition catalogue. Barcelona: Centre d'Art Santa Monica.

Coleman, A. D. "Sherman Effects Tour de Force in Mature and Funny Show." *New York Observer*, 22 January, p. 17.

Collins, Glenn. "A Portraitist's Romp through Art History." *New York Times*, 2 February, p. C17, C20.

Cottingham, Laura. "Cindy Sherman." *Contemporanea* 3, no. 5 (May): 93.

Cyphers, Peggy. "Cindy Sherman." *Arts Magazine* 64, no. 8 (April): 111.

Danto, Arthur C. "The State of the Art World: The Nineties Begin." *The Nation* 251, no. 2 (July 9): 64–68.

Danto, Arthur. *Untitled Film Stills: Cindy Sherman.* Munich: Schirmer Mosel; New York: Rizzoli.

*Energies.* Exhibition catalogue. Amsterdam: The Stedelijk Museum.

Grundberg, Andy. "Photography: Images of the Past and Future." *New York Times*, 12 January, p. C29.

Halbreich, Kathy. *Culture and Commentary: An Eighties Perspective.* Exhibition catalogue. Washington, DC: The Hirshhorn Museum and Sculpture Garden, Smithsonian Institution.

Heartney, Eleanor. "Cindy Sherman, Metro Pictures." *Artnews* 89, no. 5 (May): 207–208.

"Insert: Cindy Sherman." *Parkett*, no. 24: 119–133.

Jenkins, Steven. "The Metamorphosed Self." *Artweek* 21 (September 20): 11–12.

Kandel, Susan. "Cindy Sherman at Linda Cathcart." *Art Issues*, no. 13 (September/October): 36.

Knight, Christopher. "Cindy Sherman: A Painted Lady." *Los Angeles Times*, 8 June, p. F1, F18.

Larsen, Kay. "Art: Cindy Sherman's Latest Series . . ." *New York Magazine* 23 (January 29): 59.

Schjeldahl, Peter. "Portrait: She is a Camera." *7 Days* (March 28): 17–19.

Smith, Roberta. "A Course in Portraiture by an Individualist with a Camera." *New York Times*, 5 January, p. C19.

Sullivan, Constance, ed. *Women Photographers*, New York: Harry N. Abrams, Inc.

Szarkowski, John. *Photography Until Now.* Exhibition catalogue. New York: The Museum of Modern Art.

Tarshis, Jerome. "One Woman Plays Many Parts." *Christian Science Monitor* (November 8): 17.

van der Ploeg, Kees. "Spotlight: Cindy Sherman." *Flash Art* 23, no. 153 (summer): 142.

**1991**

*1991 Biennial Exhibition.* Exhibition catalogue. New York: Whitney Museum of American Art.

Anderson-Spivy, Alexandra. "Who is that Girl, Anyway?" *Esquire* 115, no. 2 (February): 86.

Bryson, Norman. "The Ideal and the Abject." *Parkett*, no. 29: 91–102.

Carvalho, John M. "Repetitions. Appropriation Representation in Contemporary Art." *Philosophy Today* 35, no. 4 (winter): 307–323.

*Currents 18: Cindy Sherman.* Exhibition brochure. Milwaukee: Milwaukee Museum of Art.

Danto, Arthur C. *History Portraits.* New York: Rizzoli; Munich: Schirmer/Mosel.

Dickhoff, Wilfried. "Untitled Nr. 179." *Parkett* no. 29: 103–111.

Gandee, Charles. "Art a la Carte." *House and Garden* (November): 198–200.

Graham-Dixon, Andrew. "The Self and Other Fictions." *The Independent Magazine* (London), (January 19): 42–43.

Grundberg, Andy. *Crisis of the Real. Writings on Photography, 1974–1989.* New York: Aperture.

Heller, Nancy G. *Women Artists. An Illustrated History.* New York: Abbeville Press.

Jauch, Ursula Pia. "I am Always the Other." *Parkett*, no. 29: 74–80.

Jelinek, Elfriede. "Sidelines." *Parkett*, no. 29: 82–90.

Kellein, Thomas. *Cindy Sherman.* Basel Kunsthalle, Basel: Whitechapel Art Gallery, London.

Klinger, Linda S. "Where's the Artist? Feminist Practice and Poststructural Theories of Authorship." *Art Journal* 50, no. 2 (summer): 39–47.

Mulvey, Laura. "A Phantasmagoria of the Female Body: The Work of Cindy Sherman." *New Left Review*, no. 188 (July/August): 136–151.

Nemett, Barry. *Images, Objects and Ideas: Viewing the Visual Arts.* San Diego: Harcourt Brace and Jovanovich.

Sischy, Ingrid. "Photography: Let's Pretend." *The New Yorker* 67, no. 11 (May 6): 86–96.

213

Solomon-Godeau, Abigail. "Suitable for Framing." *Parkett*, no. 29: 112–121.

Taylor, Paul. "Cindy Sherman, Old Master." *Art & Text*, no. 39 (May): 38.

Williams, Hugo. "Her Dazzling Career—The Saatchi Collection by Cindy Sherman." *Times Literary Supplement* (London), January 11, 10.

Yenawine, Philip. *How to Look at Modern Art.* New York: Harry N. Abrams, Inc.

**1992**

Avgikos, Jan. "Welcher Natur ist dieses Begehren?" *Texte zur Kunst* (June): 159–163.

Barrie, Lita. "On the Scene: Los Angeles." *Artspace* (September/October): 66–67.

Bronfen, Elizabeth. *Over Her Dead Body.* Routledge, New York: Manchester University Press.

D'Amato, Brian. "Cindy Sherman: Limbless Hermaphrodites and Dismembered Devil Dolls." *Flash Art* 25, no. 165 (summer): 107.

Decter, Joshua. "Cindy Sherman aus der Sicht des männlichen, sich selbst beobachtenden Betrachters." *Texte zur Kunst* (June): 157–159.

Deitch, Jeffrey. *Post Human.* Exhibition catalogue. Lausanne, Switzerland: Musée d'Art Contemporain; Turin: Castello di Rivoli; Athens: Deste Foundation; Hamburg: Deichtorhallen; Jerusalem: Israel Museum.

Fehlau, Fred and Anne Friedberg, Michael Lassell, David Robbins. *Hollywood, Hollywood: Identity Under the Guise of Celebrity.* Exhibition catalogue. Pasadena, CA: Art Center College of Design.

Francblin, Catherine. "Cindy Sherman: Personage très ordinaire." *Art Press* 165 (January): 12–19.

Gomez, David S. "Photographer Cindy Sherman Assaults the Flesh at Metro Pictures." *Splash* (spring): 24–25.

Hagen, Charles. "Cindy Sherman at Metro Pictures." *New York Times*, 24 April, p. C32.

Heartney, Eleanor. "Cindy Sherman at Metro Pictures." *Art in America* 80, no. 9 (September): 127–128.

Hess, Elizabeth. "Sherman's Inferno." *Village Voice*, 5 May, p. 107–108.

Kandel, Susan. "Cindy Sherman at Linda Cathcart." *Art Issues*, no. 24 (September/October): 43.

Kandel, Susan. "Madonnarama." *Artspace* (December): 42–43.

Kurtz, Bruce D. *Contemporary Art 1965–1990.* New Jersey: Prentice Hall.

Kuspit, Donald. *Périls et Colères.* Exhibition catalogue. Bordeaux: capc, Musée d'Art Contemporain de Bordeaux.

MacAdam, Alfred. "Cindy Sherman at Metro Pictures." *Artnews* 91, no. 7 (September): 112–113.

Pagel, David. "Going for Effects." *Los Angeles Times*, 28 May, p. F4.

Petry, Michael. "Letter from New York II." *Arts Review* 44 (June): 249–250.

Pinto, Robert. "Cindy Sherman, Le Case D'Arte Studio Guenzani." *Flash Art* 25, no. 162 (March/April): 127.

Saltz, Jerry. *Art of the Eighties* Exhibition catalogue. Trento, Italy: Museo d'Arte Moderna e Contemporanea di Trento, Italy.

Schwabsky, Barry. "Shamelessness." *Sculpture* (July/August): 44–45.

Slesin, Susan. "Oh, So Traditional, Oh, So Subversive." *New York Times*, 5 November, p. C1–5.

Ward, Frazer et al. *Dirt & Domesticity: Constructions of the Feminine.* Exhibition catalogue. New York: Whitney Museum of American Art.

Williamson, Judith. "Images of 'Woman': The Photography of Cindy Sherman," in *Knowing Women: Feminism and Knowledge.* Great Britain: The Open University, 222–225.

**1993**

*1993 Biennial Exhibition.* Exhibition catalogue. New York: Whitney Museum of American Art.

Acker, Kathy. *Meine Mutter: Damonologie.* Berlin: MASS Verlag.

Avgikos, Jan. "Cindy Sherman: Burning Down the House." *Artforum* 31, no. 5 (January): 74–79.

Gibson, Pamela Church and Roma Gibson, eds. *Dirty Looks: Women, Pornography, Power.* London: BFI Publishing.

Hainer, Cathy. "For Cindy Sherman, art has many guises." *USA Today*, 18 November, p. 6D.

Hindry, Ann. "Les Images et Les Mots." Interview with Rosalind Krauss, *Art Press* (France) (September): 42–47; original English version, pages E21–E25.

Knight, Christopher. "Crushed by Its Good Intentions." *Los Angeles Times*, 10 March, p. F1, F8–F9.

Krauss, Rosalind E. "Cindy Sherman's Gravity: A Critical Fable." *Artforum* 32, no. 1 (September): 163–164, 206.

Krauss, Rosalind E., and Norman Bryson. *Cindy Sherman 1975–1993.* New York: Rizzoli.

Larson, Kay. "What a Long, Strange Trip." *New York* 26, no. 12 (March 22): 71–72.

Lewis, Jim. "The New Cindy Sherman Collection." *Harper's Bazaar* (May): 144–149.

*Louise Lawler, Cindy Sherman, Laurie Simmons.* Exhibition catalogue. Oslo: Kunsternes Hus; Helsinki: Museum of Contemporary Art.

Plagens, Peter. "Fade from White." *Newsweek* 121, no. 11 (March 15): 72–73.

Prudhon, Francoise-Claire. "Cindy Sherman at Ghislaine Hussenot." *Flash Art* 26, no. 173 (November/December): 119.

Smith, Roberta. "A Whitney Biennial with a Social Conscience." *New York Times*, 5 March, p. C1, C27.

Solomon, Deborah. "A Showcase for Political Correctness." *The Wall Street Journal*, 5 March, p. A7.

Wallach, Amei. "Art with an Attitude." *New York Newsday*, 5 March, p. 52–53.

Wallach, Amei. "Sherman Going Extreme." *New York Newsday*, 12 April, p. 47, 57.

### 1994

Avgikos, Jan. "To Hell and Back Again." *Women's Art*, no. 59: 38–39.

Belting, Hans. *Das Ende der Kunstgeschichte*. Munich: Verlag C. H. Beck.

Braff, Phyllis. "Photography as a Tool for the Artist." *New York Times*, 23 October, sec. 13LI, 26.

Cheff, Michel V. et al. *Quotation: Re-Presenting History*. Exhibition catalogue. Winnipeg, Canada: Winnipeg Art Gallery.

Craven, Wayne. *American Art: History and Culture*. New York: Brown & Benchmark and Harry N. Abrams, 639–640.

De Cecco, Emmanuela. "Opera Prima." *Flash Art International* 26, no. 173 (December): 55.

Dietrich, Andrea and Cindy Sherman. *Cindy Sherman: New York Photographien*. Exhibition catalogue. Weimar, Germany: ACC Galerie.

Drucker, Johanna. *Theorizing Modernism: Visual Art and the Critical Tradition*. New York: Columbia University Press.

Eiblmayer, Silvia. *Die Frau als Bild*. Berlin: Dietrich Reimer Verlag, 190–196.

Ewing, William. *The Body*. London: Thames and Hudson Ltd.

Freudenheim, Betty. "Dinnerware, Noted Names and Chuckles." *New York Times*, 3 December, sec. 13NJ, p. 21.

Greenberg, Emily B. "Cindy Sherman and the Female Grotesque." *Art Criticism* 9, no. 2: 49–55.

Lane, John R. and Kara Kirk, eds. *The Making of a Modern Museum*. San Francisco: San Francisco Museum of Modern Art.

Lingemann, Susanne. "7 starke Frauen in New York." *Art* 12 (December): 22–25.

Lucie-Smith, Edward. *Race, Sex and Gender in Contemporary Art*. London: Art Books International.

Menard, Andrew. "Cindy Sherman: The Cyborg Disrobes." *Art Criticism* 9, no. 2: 38–48.

Mitchell, Jeremy and Richard Maidment, eds. *Culture: The United States in the Twentieth Century*. Great Britain: The Open University.

Nochlin, Linda. *The Body in Pieces: The Fragment as Metaphor of Modernity*. London: Thames and Hudson.

Rosenblum, Naomi. *A History of Women Photographers*. New York: Abbeville Press.

Russo, Antonella. "Picture This." *Art Monthly*, no. 181 (November): 8–11.

Spindler, Amy. "The Lure of the Ugly." *New York Times*, 14 June, p. B10.

Stacen, Jackie. *Star Gazing: Hollywood Cinema and Female Spectatorship*. New York: Routledge.

Szulakowska, Urszula. "Rose Farrell and George Parkin: Art History and 'Primitivism' in Contemporary Australian Performance Photography." *Continuum* 8, no. 1: 396–401.

Ward, Frazer. "Abject Lessons." *Art + Text*, no. 48 (May): 50.

"Why is Cindy Sherman Such a Key Figure for Women Photographers?" *Women's Art*, no. 59: 40.

### 1995

*XLVI Esposizione Internazionale d'Arte 1995*. Exhibition catalogue. Venice: La Biennale di Venezia.

Arenson, Karen W. "Relief Expert Missing in Chechnya Is Among MacArthur Grant Recipients." *New York Times*, 13 June, p. A22.

Arnaud, Michel. "The Show of Shows." *Harper's Bazaar* (March): 331–333.

Basualdo, Carlos. *Cindy Sherman: The Self Which Is Not One*. Exhibition catalogue. São Paolo, Brazil: Museu de Arte Moderna de São Paulo.

Baur, Eva Gesine. "Ich befurchte, irgenduo bin ich romantische." *Suddeutsche Zeitung* (May 26): 22–27.

Baur, Eva Gesine. *Meisterwerke der erotischen Kunst*. Cologne: DuMont Buchverlag Koln, 47–48.

Blair, Dike. "Cindy Sherman— Metro Pictures." *Flash Art* 28, no. 181 (March–April): 103.

Carvalho, Mario Cesar. "Arte brasileira para a globaliza cao." *Terca Feira*, 28 March, section 5, p. 1.

Clearwater, Bonnie. *The Monster Show*. Exhibition catalogue. North Miami, FL: Museum of Contemporary Art.

Czoppan, Gabi. "Künstler des jahres." *Focus* (Germany), (October): 146–150.

Davis, Keith. *An American Century of Photography: The Hallmark Photographic Collection*. New York: Harry N. Abrams, Inc.

De Salvo, Donna, et al. *Face Value: American Portraits*. Exhibition catalogue. South Hampton, NY: The Parrish Art Museum.

*Die Muse?: Transforming the Image of Women in Contemporary Art*. Exhibition catalogue. Paris: Galerie Thaddaeus Ropac in con junction with Salzburger Festival.

Felix, Zdenek et al. *Cindy Sherman: Photoarbeiten 1975–1995*. Exhibition catalogue. Malmö: Deichtorhallen Hamburg; Konsthall: Kunstmuseum Luzern.

*femininmasculin: le sexe de l'art?* Exhibition catalogue. Paris: Musée National d'Art Moderne, Centre Georges Pompidou.

Fleury, Jean-Christian. "Cindy Sherman: Portrait d'une inconnue." *Camera International*, no. 40 (summer): 62–69.

Hagen, Charles. "Cindy Sherman." *New York Times*, 3 February, p. C27.

"Here's the Money. Now Go Make Some Art." *New York Times*, 25 June, p. H31.

Howell, George. "Anatomy of an Artist." *Art Papers* (July/August): 2–7.

Johnson, Ken. "Cindy Sherman." *Art in America* 83, no. 5 (May): 112–113.

Jones, Joyce. "Sherman: Making Movies." *Washington Post*, 24 March, p. 55.

Kertess, Klaus, et al. *1995 Biennial Exhibition*. Exhibition catalogue. New York: Whitney Museum of American Art.

Kimmelman, Mike. "Portraitist in the Halls of Her Artistic Ancestors." *New York Times*, 19 May, p. C1, C7.

Kutner, Janet. "Multiple artists, singular viewpoints." *The Dallas Morning News*, 16 April, p. 1C, 8C.

*Laughter Ten Years After*. Exhibition catalogue. Wesleyan University, CT: Center for the Arts; Hobart and William Smith Colleges: Beaver College Art Gallery.

*L'Effet Cinéma*. Exhibition catalogue. Montreal, Canada: Musée d'Art Contemporain de Montréal.

Lewis, Jo Ann. "How She Ought to Be in Pictures." *Washington Post*, 2 April, p. G4.

Lippard, Lucy. *The Pink Glass Swan: Selected Feminist Essays On Art*. New York: The New Press.

Lobacheff, Georgia. "A arte abjeta de Cindy Sherman." *Jornal Da Tarde*, 24 June, p. 1.

Lobacheff, Georgia. "Todas as Mulheres de Cindy Sherman." *Jornal da Tarde/SP*, 2 January, p. 12A.

Losel, Anja. "Die Frau, die mit der Gansehaut spielt." *Stern Magazine* (May): 200–201.

Lucie-Smith, Edward. *Artoday*. London: Phaidon Press.

McWilliams, Martha. "Women's Work." *Washington City Papers*, 19 May, p. 44–45.

Miller, Donald. "Out With the Old." *Pittsburgh Post-Gazette*, 3 November, p. 14.

Muchnic, Suzanne. "Interactive? It's Virtually a Reality." *Los Angeles Times*, 26 November, p. 58, 61.

Neumaier, Diane, ed. *Reframings: New American Feminist Photographies*. Philadelphia: Temple University Press, 214–217.

Oates, Joyce Carol. *Die unsicht baren Narben Roman*. Munich: Deutscher Taschenbuch Verlag.

Paice, Kim. "Cindy Sherman." *Frieze*, no. 22 (May): 60.

Pedersen, Victoria. "Gallery Go 'Round." *Paper* (February): 111.

Piza, Daniel. "Sherman faz rir do que e aterrorizante." *Folha De São Paulo* (Brazil), 26 June, p. 4.

Pultz, John. *The Body and the Lens: Photography 1839 to the Present*. New York: Harry N. Abrams, Inc.

"Quest for Lost Image 15." *Seven Seas* 79 (March): 172–175.

Reis, Paulo. "O ano da fotografia." *Jornal Do Brasil*, 20 March, p. B1.

Richard, Paul. "Cindy Sherman's Moving Pictures." *Washington Post*, 2 April, p. G4.

Schjeldahl, Peter. "Master Class." *Village Voice*, 7 February, p. 77.

Schneider, Christa. *Cindy Sherman: History Portraits*. Munich: Autorin und Schirmer/Mosel Munchen.

Sederowsky, Ben. "Cindy Sherman: Forklaudnadens Mastrinna." *Manadens Femina Magasin*, no. 9 (September 9): 106–110.

Squiers, Carol. "Lingerie: A Brief History." *American Photo* 6, no. 5 (September/October): 46–49.

Staniszewski, Mary Anne. *Believing Is Seeing: Creating the Culture of Art*. New York: Penguin Books.

Stoddard, Alexandra. "Around Town in May." *WETA Magazine* (May): 2.

Taylor, Paul. *After Andy: SoHo in the Eighties*. Victoria, Australia: Schwartz City.

Todd, Stephen. "Photo Finished." *NOT ONLY Black + White* (Australia), (October): 86–94.

Tyson, Janet. "Focus on Photography." *Fort Worth Star Telegram*, 16 April, p. F1, F4.

Wakefield, Neville. "Cindy Sherman." *Artforum* 33, no. 8 (April): 89.

Wallach, Amei. "Cindy Sherman's Demonology of Dolls." *New York Newsday*, 20 January, p. B6.

Warner, Marina. "The Unbearable Likeness of Being." *tate*, no. 7 (winter): 41–47.

## 1996

*100 Photographs from the Collection of the Stedelijk Museum Amsterdam*, Amsterdam, The Netherlands: THOTH Publishers Bussum, Stedelijk Museum.

Adato, Allison. "Camera At Work." *Life* 19, no. 14 (May): 120–124.

Als, Hilton. "The Talk of the Town: She Came From SoHo." *New Yorker* 72, no. 9 (April 22): 38–39.

Blair, Dike. "A Chat With Cindy Sherman." *Flash Art* 29, no. 187 (March/April): 82.

Blom, Ina. "Mike Kelley." *Material* (Stockholm), no. 28: 11–12.

Bois, Yve-Alain and Rosalind Krauss. *L'Informe: le Modernisme à Rebours*. Exhibition catalogue. Paris: Musée National d'Art Moderne, Centre Georges Pompidou.

Bonami, Francesco and Roberto Pinto. "MoMA Buys Cindy Sherman's Film Stills." *Flash Art* 29, no. 187 (March/April): 39.

Brougher, Kerry et al. *Hall of Mirrors: Art and Film Since 1945*. Exhibition catalogue. Los Angeles: The Museum of Contemporary Art.

Carrier, David. "Carnegie International." *Artforum* 34, no. 5 (January): 88.

*Cindy Sherman*. Exhibition catalogue. Shiga, Japan: Museum of Modern Art; Marugame Genichiro-Inokuma Museum of Contemporary Art; Tokyo: Museum of Contemporary Art.

*Collective Vision: Creating a Contemporary Art Museum*. Chicago: Museum of Contemporary Art.

Cotter, Holland. "Cindy Sherman," *New York Times*, 15 November, p. C21.

Czoppan, Gabi and Tine Nehler. "Kunstler des Jahres." *Focus*, no. 43 (October 21): 148–155.

Danto, Arthur C. *Playing With the Edge: The Photographic Achievement of Robert Mapplethorpe*. Berkeley and Los Angeles: University of California Press, 55–57.

D'Arcy, David. "Screen Romance." *Art and Auction* (October 1996): 124–131.

Durand, Régis. "Cindy Sherman: The Melancholy and Chameleonic Film Stills." *Art Press* 210 (February): 50–55.

Ehmke, Ronald, ed., with Elizabeth Licata. *Consider the Alternatives: 20 Years of Contemporary Art at Hallwalls*. Buffalo, NY: Hallwalls, Inc.

"Film Stills by Cindy Sherman." *Sotheby's* 1, no. 2 (September/October): 7.

*Fragments*. Exhibition catalogue. Barcelona: Museu d'Art Contemporani.

Greenfield-Sanders, Timothy. *Timothy Greenfield-Sanders: Selected Portraits*. Cologne: Kunst-Station Saint Peter.

Haarmann, Fritz and Ulrich Krempel. *Sex & Crime: On Human Relationships*. Exhibition catalogue. Hannover: Sprengel Museum.

Hagen, Charles. "An Undiminished Wave of Interest and Excitement." *Artnews* 95, no. 2 (February): 116–119.

Hindry, Ann. "Operating With the 'Informe.'" interview by Rosalind Krauss, *Art Press*, no. 213 (May): 34–41.

Jones, Amelia et al. *Sexual Politics: Judy Chicago's Dinner Party in Feminists Art History*. Exhibition catalogue. Los Angeles: UCLA Armand Hammer Gallery.

Kimmelman, Michael. "Rediscovering Upstate Collections." *New York Times*, 12 July, p. C24.

Lacher, Irene. "Putting Yet Another Face on Her Career." *Los Angeles Times*, 10 February, p. F1, F13.

Landi, Ann. "Art Talk: 'Art Stalk.'" *Artnews* 95, no. 4 (April): 34.

Lei, Bonita Y. "Cindy Sherman." *Hsiung Shih Art Monthly* (Taiwan) no. 312, (April): 93–96.

Lind, Maria. "Retracing the Steps of Cindy Sherman," *Material* (Stockholm) no. 28: 5.

Lunenfeld, Peter. "Technofornia." *Flash Art* 29, no. 187 (March/April): 69–71.

Luscombe, Belinda. "People: Seen & Heard." *Time* 147, no. 19 (February 26): 71.

Mapplethorpe, Robert. "Everything That Lives, Eats." *Aperture*, no. 143 (spring): 19.

McAllister, Jackie. "Cindy Sherman: 'Untitled,'" portfolio by the artist, *Grand Street* 2 (fall): 15, 168–176.

Meskimmon, Marsha. *The Art of Reflection*. London: Scarlet Press.

Pagel, David. "Art." *Los Angeles Times*, 15 February, p. F10.

*Picasso: A Contemporary Dialogue*. Exhibition catalogue. Salzburg/Paris: Galerie Thaddeus Ropac.

*Prospect 96: Photographie in der Gegenwartskunst*. Exhibition catalogue. Frankfurt: Frankfurter Kunstvereins im Steinernen Haus und der Schirn Kusnthalle.

*Radical Images*. Exhibition catalogue. Graz: Second Austrian Triennial on Photography 1996, Neue Galerie am Landesmuseum Joanneum.

Scott, Whitney. "Creep Show." *Manhattan File* (October): 69.

Smith, Liz. "'Killer' Role for Tripplehorn." *Los Angeles Times*, 22 March, p. F2.

Smith, Paul. "Rei Kawakubo: The First Lady of Fashion." *Dazed & Confused*, no. 16: 45–49.

Smith, Roberta. "A Neo-Surrealist Show With a Revisionist Agenda." *New York Times*, 12 January, p. C23.

Smith, Roberta. "Modern Museum Buys Sherman Photo Series." *New York Times*, 23 January, p. C16.

Van Garrel, Betty et al. *Cindy Sherman*. Exhibition catalogue. Rotterdam: Museum Boymans-van Beuningen.

Wallach, Amei. "Genre Busters." *Village Voice*, 26 November, p. 45–46.

**1997**

Foster, Hal. "The Real Thing." *Inter Communication* (England), no. 19: 48–53.

Hirsch, Robert. *Exploring Color Photography*. Third edition. Buffalo: State University of New York, 170, 244.

Hoban, Phoebe. "Sherman's March." *Vogue* 187, no. 2 (February): 240–243, 278.

Smith, Roberta. "Starlet Cliches, Real and Artificial at the Same Time." *New York Times*, 27 June, p. B1, B25.

# Acknowledgments

218

We would like to thank numerous people on the staffs of LA MOCA and MCA, Chicago, who worked together to produce this exhibition. Foremost among these were MOCA Director Richard Koshalek and MCA Director Kevin E. Consey, who provided support and guidance from the inception of this project.

At MOCA, we thank Robert Hollister, Registrar, for his skillful and patient handling of logistics relative to the exhibition's transportation and care throughout the tour. Assistant Curator Alma Ruiz and Assistant Director Kathleen S. Bartels provided crucial guidance and help with matters surrounding the tour. Exhibition Production Manager John Bowsher and the MOCA preparators installed the works with their usual care and expertise. Dawn Setzer, Assistant Director of Communications, Media Relations, expertly coordinated publicity for the exhibition, as did Director of Education Kim Kanatani and her staff with regard to educational programming. Erica Clark, Director of Development; Ed Patuto, Associate Director of Development; Jody Rassell, Corporate Gifts Manager; Chris McCabe, Grants Manager; and Kathleen Johnson, Grants Associate all contributed to the generation of funding for the exhibition. Additional thanks are extended to Paul Schimmel, Chief Curator, for his encouragement and support. Curatorial Associate Colette Dartnell deserves foremost thanks for her role in overseeing loans and coordinating numerous matters pertaining to research and organization of this project.

At the MCA, Associate Director and Chief Operating Officer Janeanne Upp and Chief Financial Officer Janet Alberti gave crucial financial advice. Former Director of Development Carolyn Stolper Friedman, Director of Development Greg Cameron, and Deputy Director of Development Christopher Jabin and their staff vigorously pursued funding sources. Lori Kleinerman, Director of Marketing; Maureen King, Director of Public Relations; and Michael Thomas, Assistant Director of Public Relations promoted the exhibition. Director of Education Wendy Woon and her staff produced imaginative public programs. The Collections and Exhibition Divisions under Lela Hersh, Director, Collections and Exhibitions, deserve thanks for handling the registrarial details of

Manager of Exhibition Installation Don Meckley, Senior Preparator
Mykl Ruffino, and their crew installed the show with their usual skill, and
Museum Technical Specialist Dennis O'Shea lit it beautifully. Assistant
Curator Dominic Molon proved invaluable, as always, for his work
on countless details. Curatorial Interns Joshua Hirsch and Rebecca Kunin
provided research assistance.

For their excellent editorial and design efforts on this publication,
we are grateful to Donald Bergh, Director of Design and Publications;
Amy Teschner, Associate Director of Publications; Jennifer Boeder,
Editorial Coordinator; Kari Dahlgren, Editorial Assistant; Meredith
Bergman, Editorial Intern; and Margaret Kujawa, Design Intern.

Our special thanks go to Janelle Reiring, Helene Winer, Tom Heman,
and Jeff Gauntt of Metro Pictures for their assistance on so many fronts.
Michael Scalisi deserves our gratitude for his help.

Our warmest thanks go to Cindy Sherman, whose generosity, humor,
and thoughtfulness made working on this exhibition an absolute joy and
whose work it is an honor to present.

AMADA CRUZ
*Manilow Curator of Exhibitions*
Museum of Contemporary Art, Chicago

ELIZABETH A. T. SMITH
*Curator*
The Museum of Contemporary Art, Los Angeles